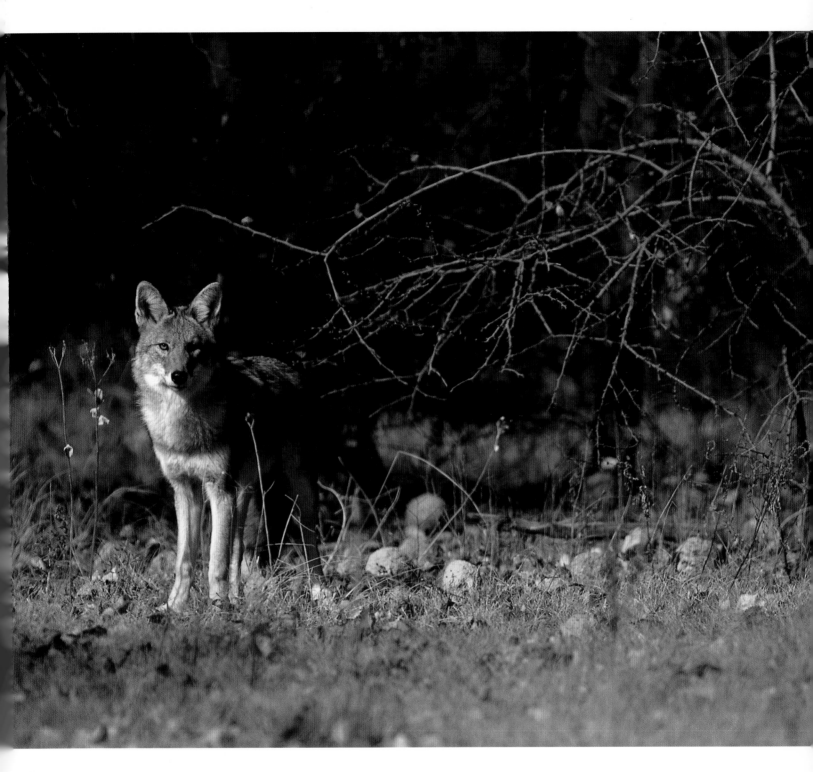

Faces of the Great Plains

Faces of the

Photographs and Field Notes by

BOB GRESS

Text by

PAUL A. JOHNSGARD

Foreword by

CHARLES G. KOCH

Great Plains

PRAIRIE WILDLIFE

Publication of *Faces of the Great Plains* made possible in part by a grant from Koch Industries, Inc.

UNIVERSITY PRESS OF KANSAS

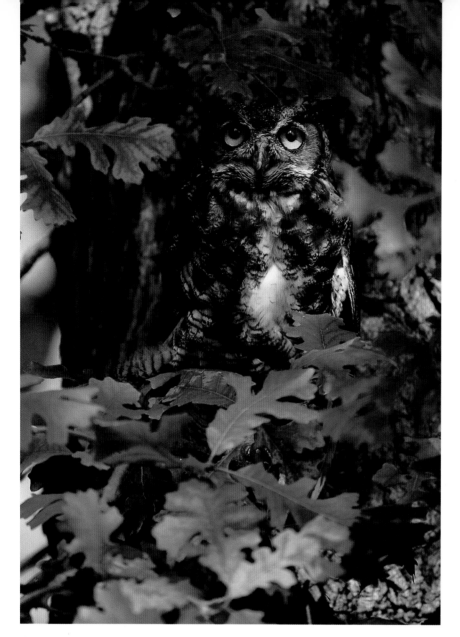

Page i: **COYOTES** RARELY GIVE HUMANS A CLEAR VIEW, AS THEIR SURVIVAL DEPENDS ON WARINESS.

Pages ii and iii: ORIGINALLY AN ANIMAL OF THE OPEN PRAIRIE, **ELK** ARE NOW PRIMARILY FOUND IN WESTERN FOOTHILLS AND MOUNTAINS. THESE BULLS SPAR FOR DOMINANCE AT FORT NIOBRARA NATIONAL WILDLIFE REFUGE, NEBRASKA.

Left: THE **GREAT HORNED OWL'S** MOTTLED PLUMAGE MAKES IT DIFFICULT TO SPOT IN ITS DAYTIME ROOST. IT HIDES HERE TO AVOID HARASSMENT FROM CROWS AND OTHER BIRDS.

Opposite: MIGRANT **SNOW GEESE** BLANKET MISSOURI'S SQUAW CREEK NATIONAL WILDLIFE REFUGE.

© 2003 by the University Press of Kansas
Photographs ©2003 by Bob Gress

Published by the University Press of Kansas (Lawrence, Kansas 66049), which was organized by the Kansas Board of Regents and is operated and funded by Emporia State University, Fort Hays State University, Kansas State University, Pittsburg State University, the University of Kansas, and Wichita State University

Library of Congress Cataloging-in-Publication Data

Gress, Bob.
 Faces of the Great Plains. Prairie wildlife / photographs and field notes by Bob Gress; text by Paul A. Johnsgard; foreword by Charles G. Koch.
 p. cm.
 ISBN 0-7006-1265-3
 1. Wildlife photography—Great Plains. 2. Zoology—Great Plains—Pictorial works.
3. Zoology—Great Plains. 4. Gress, Bob. I. Johnsgard, Paul A. II. Title.
 TR729.W54G74 2003
 779'.32'.0978—dc21 2003006869

British Library Cataloguing-in-Publication Data is available.

Printed in China

10 9 8 7 6 5 4 3 2 1

The paper used in this publication meets the minimum requirements of the American National Standard for Permanence of Paper for Printed Library Materials Z39.48-1984.

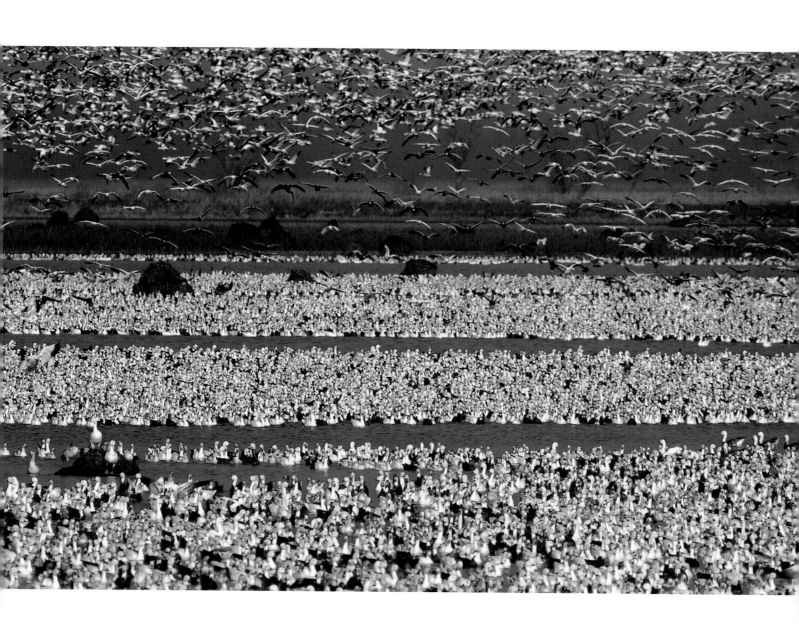

TO ALL THOSE WHO KNOW
THE VALUE OF
WILD PLACES AND WILD THINGS

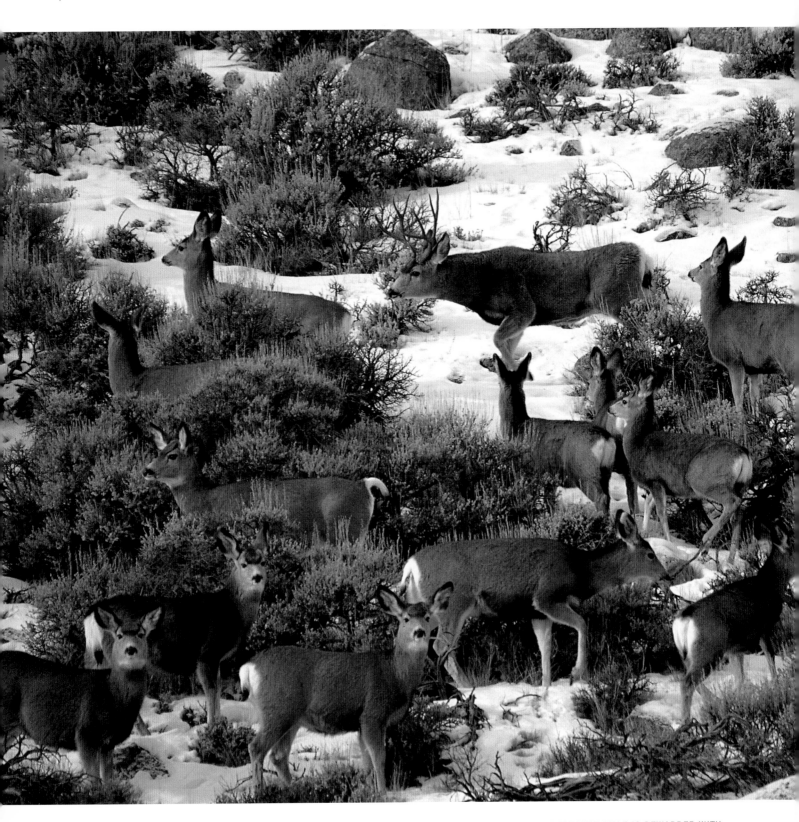

During the autumn rut, the most dominant **MULE DEER** male is rewarded with most of the breeding.

CONTENTS

FOREWORD

My father and mother, Fred C. and Mary R. Koch, were avid patrons of the outdoors. They shared a love of hunting, fishing, and ranching along with a keen respect for our natural resources.

As the beneficiaries of their love and teaching, my family and I are advocates for improving cultural, educational, outdoor, and artistic opportunities for Kansans and for visitors to our part of the country.

There are many naturalists who foster initiatives and organizations that advance an awareness and appreciation for our environment. One of those individuals is the talented, experienced, and dedicated naturalist, Bob Gress.

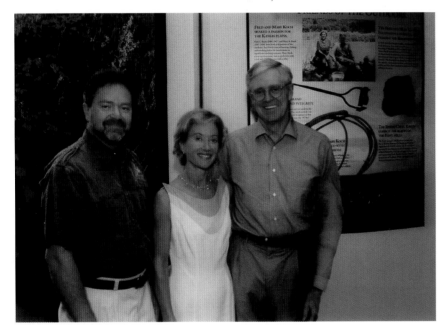

BOB GRESS WITH ELIZABETH AND CHARLES KOCH AT THE GRAND OPENING OF THE KOCH

HABITAT HALL, GREAT PLAINS NATURE CENTER, SEPTEMBER 2000.

I first had the opportunity to meet Bob Gress when the Fred C. and Mary R. Koch Foundation assisted with the construction of Koch Habitat Hall at the Great Plains Nature Center. Gress and his associates have created exhibits, programs, and an outdoor classroom that offer an educational environment in which we can learn about and enjoy the natural beauty of our region.

What's more, Bob's new book, *Faces of the Great Plains: Prairie Wildlife*, unquestionably complements the Great Plains Nature Center, providing readers—through its stunning photographs and enlightening text by the noted writer, Paul Johnsgard—a front-row experience of the "wild" side of the Great Plains.

For those of us who avidly appreciate the Great Plains' wildlife, this book makes it abundantly clear that Bob Gress and Paul Johnsgard share our passion. My family and I are honored to have assisted in this display of spectacular photography and engaging field notes. We salute Bob and Paul's ability to capture the "wild places and wild things" which the Great Plains has to offer.

—Charles G. Koch
Chairman and CEO
Koch Industries, Inc.
Wichita, Kansas

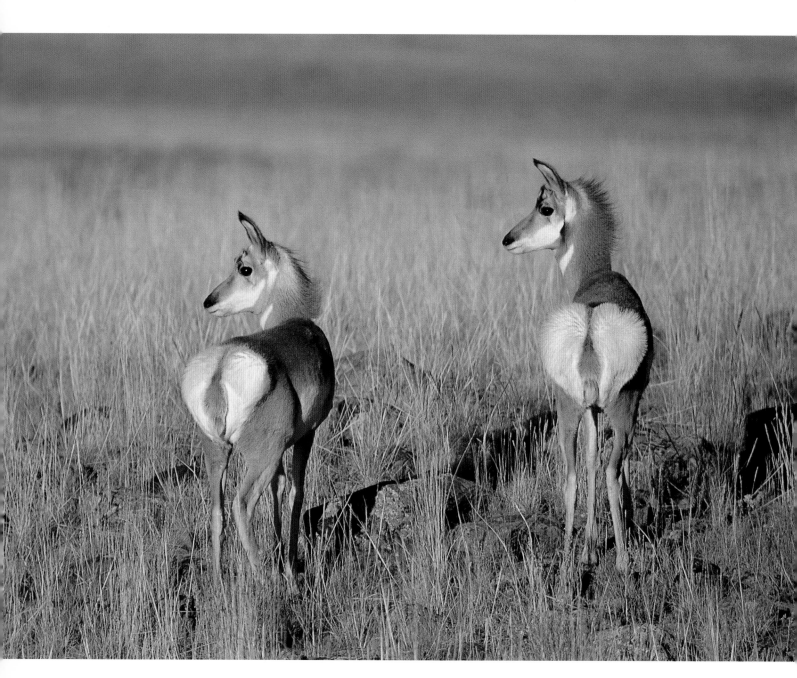

PRONGHORN TWINS PAUSE FOR A QUICK LOOK BEFORE RACING ACROSS THE PRAIRIE.
THE ERECTED WHITE RUMP PATCHES SIGNAL THEIR ALERTNESS.

PREFACE

The wildlife of the Great Plains tends to get overlooked, like its grass-land landscapes. This book serves to lessen that undeserved neglect by enhancing the reader's appreciation of some of the animals that can be found in the region, which encompasses parts of thirteen states and some five hundred thousand square miles.

For twenty-five years, wildlife photography has been my excuse to spend time with wildlife. It grew out of an earlier passion for hunting. With photography, however, there are no restrictions, seasons, or limits. While waiting in a photo blind, I often get the opportunity to observe wildlife for long periods of time. Through observations comes insight into behaviors, adaptations, and habitat requirements that vary among species.

Big mammals, colorful birds, and venomous snakes typically garner the most attention. But over the years I've come to realize that some of the most fascinating animals are often the most overlooked—like many species of mice, sparrows, and toads. The hunting behavior of grasshopper mice, the habitat requirements for Henslow's sparrows, and the breeding biology of Great Plains narrowmouth toads attest to the prairie's amazing diversity. Photographing a Sprague's pipit is much more challenging and rewarding to me than photographing a pronghorn. The more I learn about these insignificant animals, the more significant they become.

Despite the great diversity of life found in the Great Plains, many biologists fear these grasslands are one of our nation's most threatened ecosystems. Not that long ago, our prairies looked different. With vast herds of bison, along with elk, pronghorns, wolves, and grizzly bears, North America's Great Plains rivaled the wildlife spectacle of Africa's Serengeti. With the invention of the steel plow, European settlers quickly converted prairie to cropland. Today, only about 30 percent of shortgrass and mixed-grass prairies and less than 5 percent of tall-grass prairies remain. As prairie disappears, so does the wildlife. Prairie birds are believed to be the most rapidly declining group of birds in North America. Such circumstances point to the importance of education. If we learn to value wildlife in its many forms, both the charismatic and the ordinary, then we are more likely to apprehend the significance and uniqueness of the Great Plains.

A conservation ethic and educational mission inform this book. I am committed to both. In addition to photographing wildlife, I direct the Great Plains Nature Center in Wichita, Kansas, which opened in

August 2000 after years of planning, fund-raising, and construction. Visitors come to the center to learn about the Great Plains and its associated wildlife. This book, then, is an extension of the center. After a decade of photographing Great Plains wildlife, I proposed the project to the University Press of Kansas in spring 2001, seeking help in locating a writer whose prose would enhance my photographs.

—Bob Gress

In late June 2001 I received a note from Fred Woodward, director of the University Press of Kansas, asking me if I might be interested in writing the text for a planned book on the wildlife of the Great Plains. This book was to be built around the color photographs of Bob Gress. An admirer of his photography, I replied that I would be delighted to consider such a project and immediately began organizing thoughts and references that might be relevant. I thought that the wildlife of the Great Plains region should at least include its most characteristic breeding birds, its corresponding most typical mammals, and some of the region's more conspicuous reptiles and amphibians ("herptiles")— the kinds of animals one is likely to encounter and want to learn more about when afield.

The book clearly could not serve as an identification guide, even for the included groups; a wide choice of field guides is already available for all of them. From among the nearly 600 species of birds, mammals, reptiles, and amphibians that occur within the region it was necessary to select a nuclear group of about 125 to 150 species for individual discussion and illustration. Luckily, Bob Gress had already photographed about 90 percent of them. It took him almost another year to round out the few additional species that we considered as critical for inclusion. This book is largely built around these especially typical, rare, or highly charismatic animals, the natural trademark species of the Great Plains.

It is my hope that through a greater knowledge and appreciation of the natural heritage of the Great Plains our readers will value these fragile treasures highly enough to make personal efforts to preserve them. We would do well to recall the words of Baba Dioum, the Senegalese ecologist: "In the end, we will conserve only what we love. We will love only what we understand. We will understand only what we are taught."

—Paul A. Johnsgard

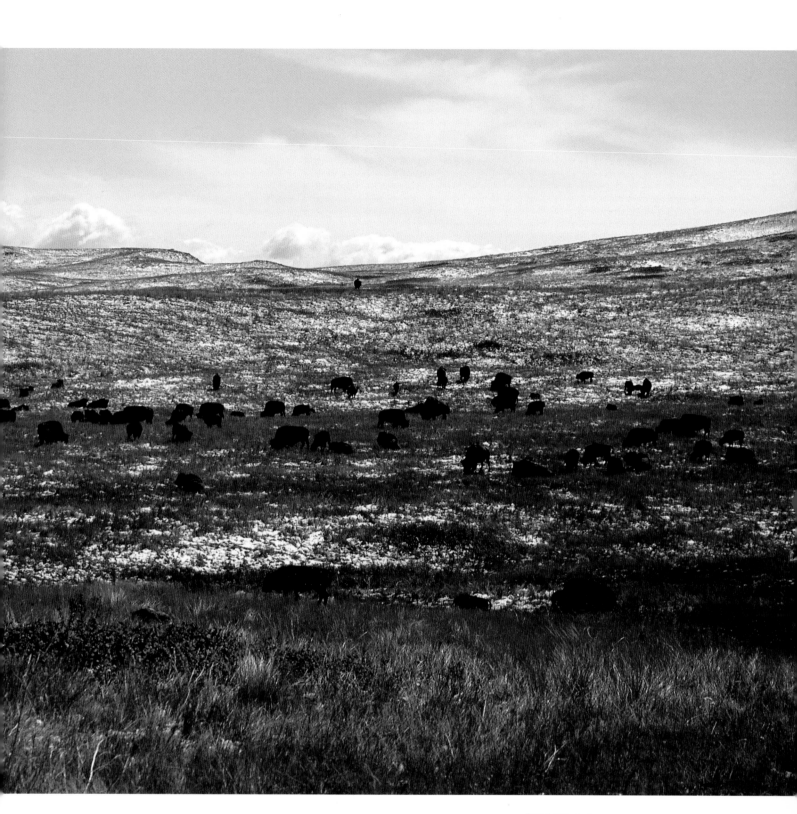

ONCE ESTIMATED TO HAVE COVERED THE
PLAINS WITH AS MANY AS 60 MILLION
ANIMALS, **BISON** TODAY ARE FOUND
ONLY IN MANAGED HERDS LIKE THIS ONE
IN CUSTER STATE PARK, SOUTH DAKOTA.

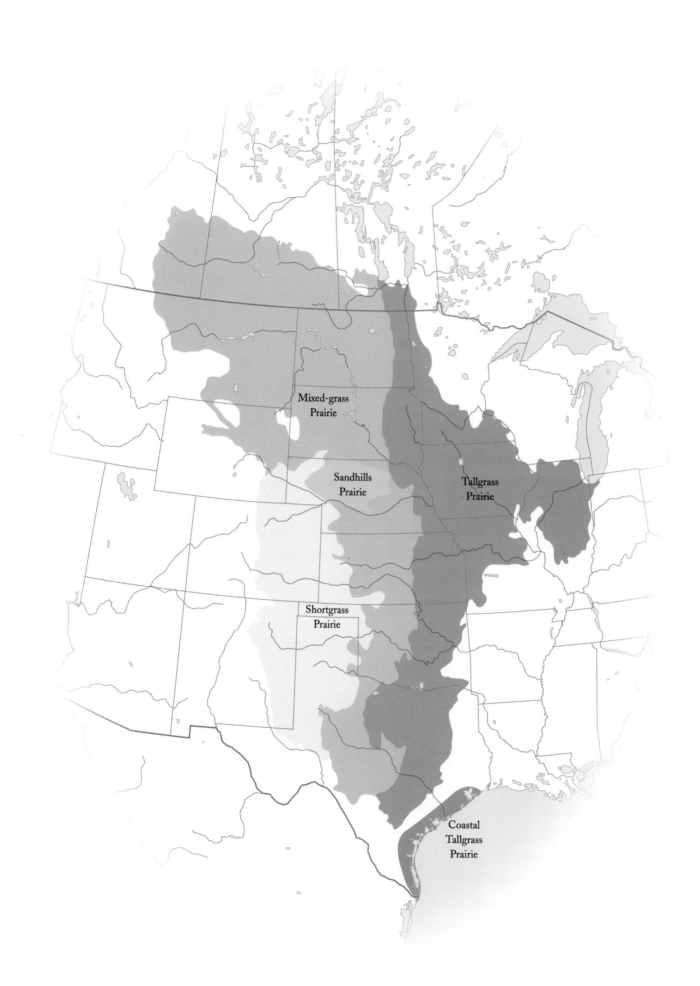

Mixed-grass
Prairie

Sandhills
Prairie

Tallgrass
Prairie

Shortgrass
Prairie

Coastal
Tallgrass
Prairie

HISTORIC GRASSLAND ECOSYSTEMS OF THE

GREAT PLAINS AND CENTRAL LOWLANDS.

THE
GREAT PLAINS

Few geographic regions of North America offer a greater capacity for the imagination to run free rein than the Great Plains. The region evokes visions of bison covering the landscape from horizon to horizon, the sweep of endless blue skies painted over limitless fields of grass waving hypnotically in the breeze, the smell of newly wet black soil and fresh ozone in the air after a sky-shattering thunderstorm, and the warmth of the bronzy color of bluestem and Indian grass in late fall. There is also the confident feeling that a person might hike in any direction for an entire day, without making detours or ever losing sight of the place he has left or the one he is headed toward. People who have grown up in the mountains or forests might feel slightly exposed in the plains—where can you hide from rain, hail, lightning, or tornadoes? The simple fact is, you can't. I have watched tornado funnels dance across the landscape with the ominous force of an approaching army, tossing aside everything they encounter in their paths, and have crouched helplessly on the grass while being pelted with hailstones and driving rain. But these storms pass quickly; a half hour later the sun may be shining and the birds singing as if nothing at all had happened.

The Great Plains of North America both begin and end rather indefinitely. Unlike the major North American mountains or its coastlines, for which quite precise lines can be drawn on a map, the Great Plains are more notable for what they are not than for what they are. At their northern extremes, the Great Plains merge with the arctic coastal plain of northwestern Canada, and at their southern edge they blend with the coastal plain of the Gulf of Mexico. To the east, they are likewise gradually transformed into the central lowlands of the Missouri, Mississippi, and Ohio river valleys. Only along their western borders, where they sometimes quite suddenly encounter the Rocky Mountains, or at least the Rocky Mountain piedmont, can we establish fairly clear-cut points that tell us we have reached the end of our geographic measuring stick.

The Great Plains thus impinge upon us gradually, not with a sudden bang but with a quiet whisper. To understand and enjoy them fully we must be sensitive to whispers and expect to encounter neither forbidding mountains nor spectacular shorelines. Instead, the long, unencumbered vistas are an invitation to look inwardly to the soul as well as outwardly toward the horizon, to look down on tiny prairie wildflowers and up to endless cerulean skies with equal appreciation,

and to listen to the silent spirit within as well as to the audible and visible life without.

For most people, flying over the Great Plains at thirty thousand feet and peering down onto a vast flatland is to experience an understanding of the term "flyover country." Grasslands are never best appreciated from afar; distance might well lend enchantment to mountains, but prairies require close and personal contacts to deliver their subtle brand of magic. It is better simply to walk among them, dragging your fingers through the soft tassels of bluestem, letting its golden pollen gild your clothes, and to imagine that you are surrounded by endless prairie grasses and countless bison. Imagination is required—such a scene no longer really exists.

Although enormous changes have occurred that have profoundly affected the presettlement vegetation of the region, numerous historical records and sufficient remnant communities still exist to provide a reasonable basis for mapping the original distribution of vegetation types throughout the region. Using such criteria, it is likely that the primary Great Plains region, extending from the Canadian border south through the Dakotas, Nebraska, Kansas, Oklahoma, and the Texas panhandle, was once made up of about 80 percent of native grasslands, 13 percent hardwood deciduous forest or forest-grassland mosaic, 3 percent sage-scrub grasslands, and 2 percent coniferous forest or scrubby coniferous woodland. The remaining approximate 1 percent of this approximate five hundred thousand-square-mile expanse is now covered by surface water, predominantly resulting from fairly recent river impoundments.

The tallest and most species-rich of the native American grasslands are the tallgrass bluestem prairies of the eastern Dakotas, western Minnesota and Iowa, and portions of eastern Nebraska and Kansas, terminating in northern Oklahoma. Nearly all of this once-vast prairie is now gone; the roughly five thousand square miles of the Kansas Flint Hills are the last, best remnants of it.

To the west of the bluestem prairies in the Dakotas lies the mixed-grass prairie. The dominant plants are shorter than those of bluestem prairie, but a large number of flowering forbs are also characteristic. Approximately 15 to 30 percent of it may still survive, based on some recent estimates. From southern Nebraska south to northern Oklahoma, a southern component of mixed grasses occurs, the bluestem-grama prairie. It is shorter in average vegetational height and intermediate in geographic location between the tall bluestem prairies to the east and the still drier grama–buffalo-grass prairies to the west. Roughly 10 to 35 percent of it may still exist. Much of this midgrass community type is developed over windblown loess materials that ar-

rived and were deposited as rolling upland plains in the last million years, often during interglacial intervals. In several areas, extensive regions of sandy soil or sand dunes have greatly affected the vegetation, modifying both the structure and composition of a basically mixed-grass prairie. The largest of these is the Nebraska Sandhills region, where the vegetation is mainly widely spaced bunchgrasses, with the intervening areas either unvegetated or sparsely vegetated. Smaller areas of sandhills locally occur farther south, such as along the Arkansas and Cimarron Rivers of Kansas and Oklahoma.

The short-grass prairie, or grama–buffalo-grass association, occurs on localized slopes and dry exposures in the western Dakotas and over extensive portions of the region from western Nebraska southward to the Staked Plain of Texas. This high plains biota is adapted for considerable aridity, and its array of both plants and animals is somewhat restricted. Probably more than half of the historic short-grass prairies of the Great Plains still remains in mainly grassland vegetation, but most of these prairies have been degraded beyond recognition by overgrazing and an invasion of exotic weeds.

Communities dominated by deciduous or hardwood tree species are diverse and are particularly abundant in the eastern and southeastern parts of the region. The northern deciduous forest communities of western Minnesota and eastern North Dakota are a composite of types often dominated by oaks, maples, and basswood. Along the river systems of the Dakotas, Nebraska, and Kansas, a distinctive riverine or gallery forest, sometimes called the northern floodplain forest, provides an extremely important forest corridor linking eastern and western biotas. The significance of these river systems as gene-flow corridors has been established by a variety of studies on hybridization between western and eastern species of birds. Of all these east-west suture zones, those of the Platte and Niobrara Rivers in Nebraska are among the most important, for both of these rivers provide unbroken ecological gradients from eastern deciduous to Rocky Mountain piedmont coniferous forests.

From the Missouri Valley of the Nebraska-Iowa border southward, a forest type dominated by oaks and hickories tends to replace the northern floodplain forests along major river systems and also extends to the uplands in moister sites. Over much of eastern Kansas the oak-hickory forest occurs as a mosaic community with bluestem prairies, with dominance of one or the other dependent on local conditions of soil, slope, and exposure. In southern Kansas and eastern Oklahoma this mosaic pattern is replaced by the "cross timbers" community of oaks in extensive groves or growing singly, interspersed with medium-tall grasses such as bluestems and other prairie-grass species. In the

wetter portions of southeastern Oklahoma, the forest becomes denser, and the oaks are supplemented with hickories and pines, resulting in an extensive oak-hickory-pine community in the southeastern United States and the Atlantic piedmont.

The coniferous-dominated communities of the region are relatively few and distinctive. A few elements of Canada's boreal forests creep into northern North Dakota in places such as the Turtle Mountains, where northern-oriented animals such as moose forage and common loons nest in beaver-made impoundments. The Black Hills coniferous forest, together with the other ponderosa pine forests of southwestern North Dakota and western Nebraska, provides the most typically Rocky Mountain biota to be found in the entire region. In northeastern New Mexico and the adjoining Black Mesa country of Oklahoma, a woodland community type dominated by low junipers and arid-adapted pines occurs on uplands and along dry river channels. Like the Niobrara and Platte valleys farther north, it is in such places that east meets west, with Rocky Mountain flora and fauna coming into contact with species more typically found in the southeastern forests and mountains.

The Great Plains are thus a biological meeting place for northern, southern, eastern, and western elements, acquiring a kind of collective uniqueness simply by virtue of their central position, thereby becoming a sort of melting pot into which plants and animals have seeped from around all the edges. Like America itself, the Great Plains represent a kind of composite or self-defined assemblage, whose strength lies in their diversity and whose remnants must be treasured and protected, if only in fragmentary pieces and locations. Perhaps this book will aid people in appreciating the Great Plains even more and in recognizing that what is left of them must be carefully tended and preserved if they are to continue to support the wonderful wildlife illustrated here.

THE
Wildlife

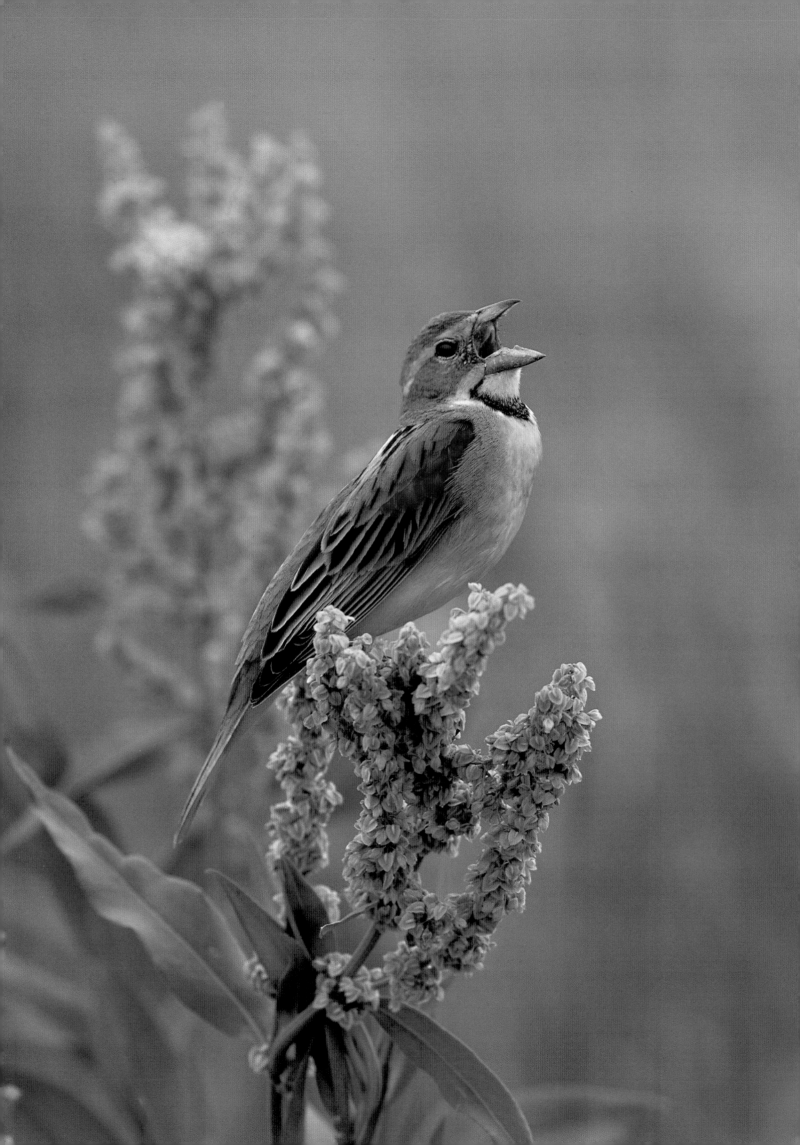

TALLGRASS PRAIRIE

The original tallgrass prairies once stretched downward across the plains of central North America like a slightly drawn bow. Its top end curved gracefully in a southeastward direction across the southern part of Manitoba, following the valleys of the Red and James Rivers of North and South Dakota, continuing south through the eastern thirds of Nebraska, Kansas, and Oklahoma, and tapering to a tip in east-central Texas. To the east, across Iowa, northern Missouri, Illinois, and parts of a few peripheral states, fragments of tallgrass prairie also occurred, at least periodically, wherever and whenever the frequency of fires prevented the eastern deciduous forests from wresting dominance away from the small but fast-growing and deep-rooted perennial grasses.

Birds

Greater prairie-chickens might have been given a slightly more mellifluous name; perhaps prairie grouse or even prairie spirit might have been more appealing. They are indeed rather spiritlike inasmuch as they seem to disappear completely each year after their spring booming season, remaining almost invisible in summer, fall, and winter, then reappearing the following spring, as soon as the melting snow begins to expose their traditional display sites. There is something reassuring about their certain annual regularity and likewise something soothing about the males' main mating calls. Although called "booming," their notes have the soft texture and smoothness of a mourning dove's notes and the melancholic aspect of some lost soul seeking forgiveness. Like a distant foghorn, their calls might make a listener think of other times and other places, but for those observers who know them well they will create the desire to be present in the very center of their activity, wrapped in the gilt-edged light of dawn and caught up in the sexual energy of the moment.

There was a time not long ago when observers began to express great fears as to the future of dickcissels, partly because of habitat losses on their Great Plains breeding grounds and partly owing to massive pesticide spraying of the birds on their South American wintering grounds, where they are a serious pest to cultivated crops.

WITH A COLOR PATTERN THAT RESEMBLES A MEADOWLARK, THIS SPARROW-SIZED **DICKCISSEL** RECEIVED ITS NAME FROM ITS SONG, *DICK, DICK, DICK-CISSEL*. MALE DICKCISSELS SING THROUGHOUT THE SUMMER FROM EXPOSED GRASSLAND PERCHES AND ARE EQUALLY AT HOME IN AGRICULTURAL AREAS LIKE WHEAT FIELDS AND HAY MEADOWS.

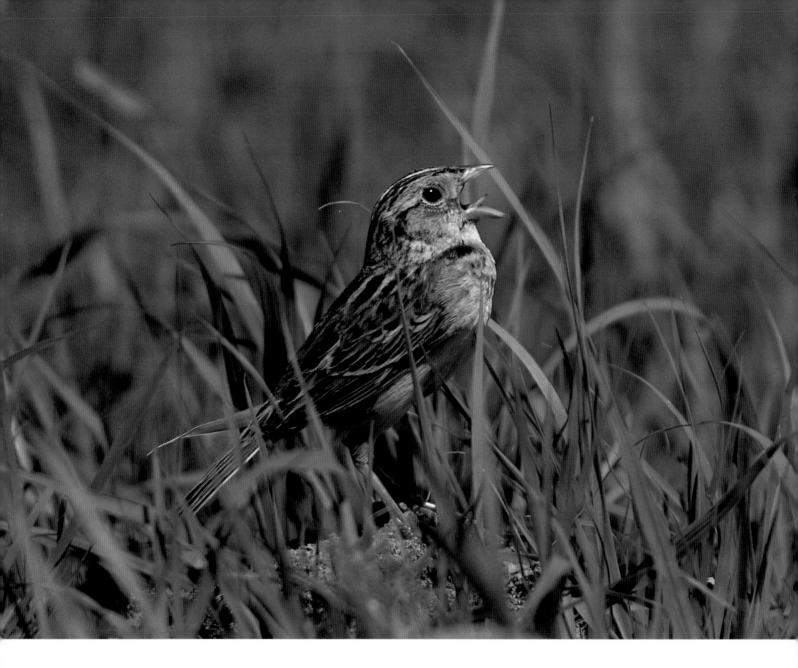

Those threats have not diminished, and it is true that dickcissel populations are declining, if not at the predicted rates. Beyond these two threats is a third one that dickcissels in the Great Plains must deal with: their great vulnerability to nest parasitism by brown-headed cowbirds. Although dickcissels hide their nests remarkably well, their favored breeding habitats of taller grasslands with scattered bushes or low trees correspond exactly with those of cowbirds. The brown-speckled whitish eggs of cowbirds are poor color matches for the unspotted and pale bluish eggs of dickcissels, and yet the dickcissels seemingly accept them without exception.

The Great Plains grasslands are a kind of sparrow heaven; of the thirty-plus Great Plains endemic birds, roughly half are sparrows, which have all evolved stubby, seed-eating beaks that can effectively gather and crush the tiny seeds typical of grasses and sedges. At least in ecological theory, every sparrow species has a slightly different

WITH ITS INSECTLIKE SONG ACCOMPANIED BY WING FLUTTERING, THE **GRASS-HOPPER SPARROW** CLAIMS ITS TERRITORY. IF APPROACHED, THE BIRD WILL SOMETIMES RUN THROUGH GRASS RATHER THAN FLY. IT FEEDS PRIMARILY ON INSECTS, ESPECIALLY SMALL GRASSHOPPERS.

foraging and breeding ecology from all the others that breed in the same region—otherwise, over time some would be outcompeted for the same resources and disappear. The theory is hard to prove, as ecological differences need only be statistical rather than absolute to be effective in reducing competition over time, but the large number of similar-sized and coexisting grassland sparrows would tend to bear this idea out. The two most abundant of typical tall-grass prairie sparrows are the dickcissel and the grasshopper sparrow, with the Savannah sparrow close behind. However, the eastern and western meadowlarks are often at least as common as these sparrows and are far more conspicuous.

THE **HENSLOW'S SPARROW** IS AN ELUSIVE BIRD, EVEN FOR DEDICATED BIRDERS. ITS HABITAT REQUIREMENTS ARE RESTRICTED. IN TALLGRASS PRAIRIES IT IS FOUND ONLY IN AREAS THAT HAVE NOT BEEN BURNED OR GRAZED FOR SEVERAL YEARS.

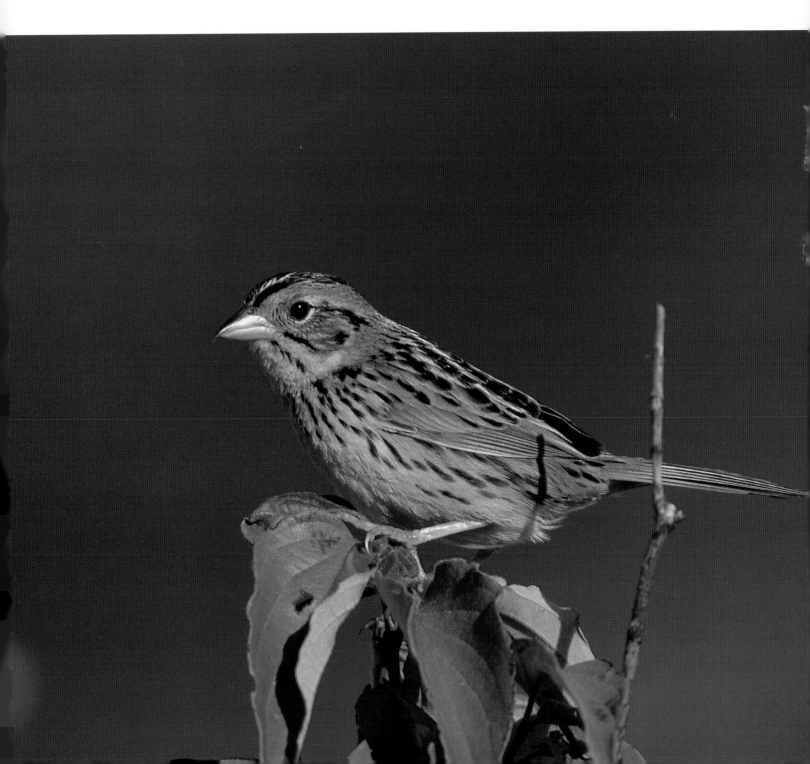

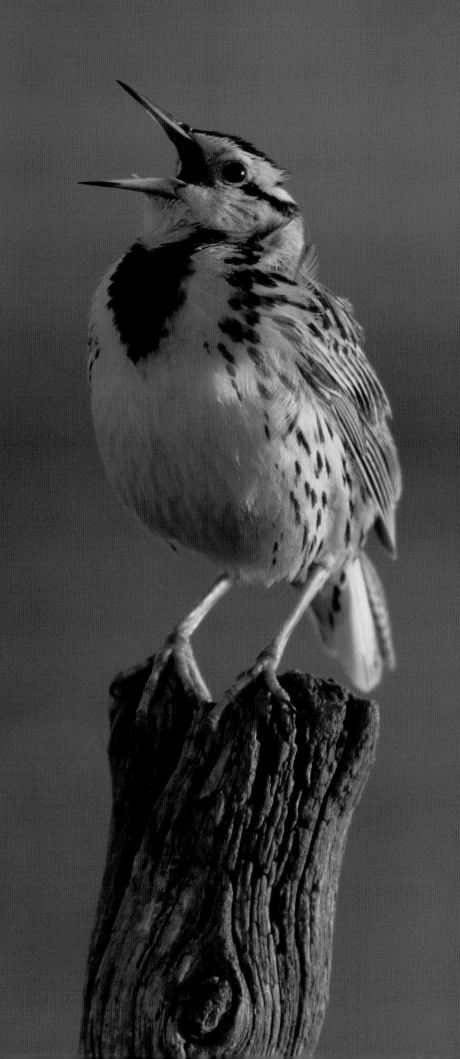

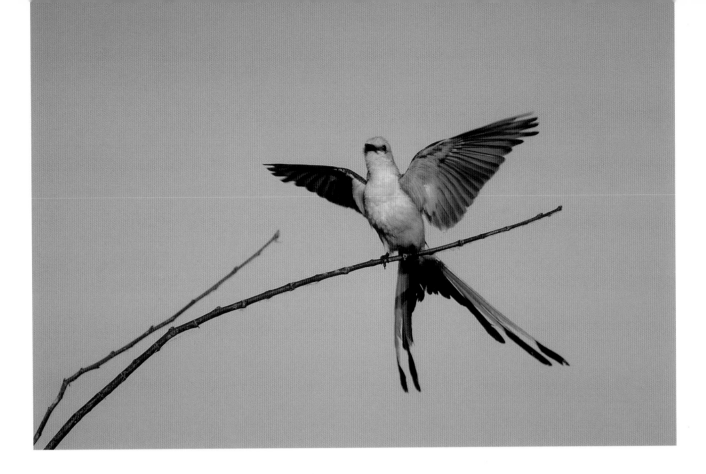

The western meadowlark is largely associated with shortgrass and mixed-grass prairies, but the eastern meadowlark is essentially confined in the Great Plains to the tallgrass prairie region. The amount of geographic and ecologic overlap between the species is surprisingly small, considering that the two species are essentially identical in size, beak and foot structure, and even in plumage. It is only by their very different advertising songs that males of the two species can be easily distinguished. The vicinity of Lincoln, Nebraska, is unusual in that it is located in one of the few geographic areas where the two species are almost equally abundant. Here, one can often find places where the songs of both species can be heard almost simultaneously. Frequently, among the hilly glacial moraines where small reservoirs have been formed, eastern meadowlarks are to be found in the taller grasses and moister soils near the shoreline while western meadowlarks sing from the nearby hilltops, where the grasses are lower and more scattered.

The flycatchers constitute the largest family of songbirds in the world and one that is limited to the New World. Most occur south of the U.S.–Mexican border, and bird identification in Latin America

THE DISTINCTIVE **SCISSOR-TAILED FLYCATCHER** IS KNOWN FOR ITS EXTREMELY LONG TAIL. THE MALE WILL OFTEN SHOW OFF HIS TAIL FEATHERS WHILE PERFORMING AN UNDULATING, ZIGZAG FLIGHT FOR THE FEMALE. THIS LANDING BIRD ALSO SHOWS THE SALMON-COLORED WING LININGS.

THE **EASTERN MEADOWLARK'S** CLEAR WHISTLING CALL IS SUNG LOUDLY FROM PROMINENT PERCHES. WHEN ALARMED IT WILL FLASH ITS WHITE OUTER TAIL FEATHERS AS IT TAKES FLIGHT.

is not made easier by the tremendous diversity of flycatcher species that often surrounds the observer. Fortunately, the scissor-tailed flycatcher is an exception. People are not likely to forget the first scissor-tailed flycatcher that they ever saw, and it is one of the great pleasures of the southern Great Plains states, from central Kansas south, to watch the antics of these spectacular birds on their breeding grounds. They are perhaps a species of grassland-woodland edges rather than grasslands as such, and they seem especially at home on wire fences and telephone wires, where they can be on the lookout for aerial insect prey.

WITH ITS IRREGULAR, DARTING FLIGHT, THE **COMMON NIGHTHAWK** IS OFTEN SEEN HUNTING FOR HIGH-FLYING INSECTS. IT IS ACTIVE DURING LATE AFTERNOONS, NIGHTS, AND EARLY MORNINGS. IT RESTS ON HORIZONTAL BRANCHES OR WOODEN FENCE POSTS.

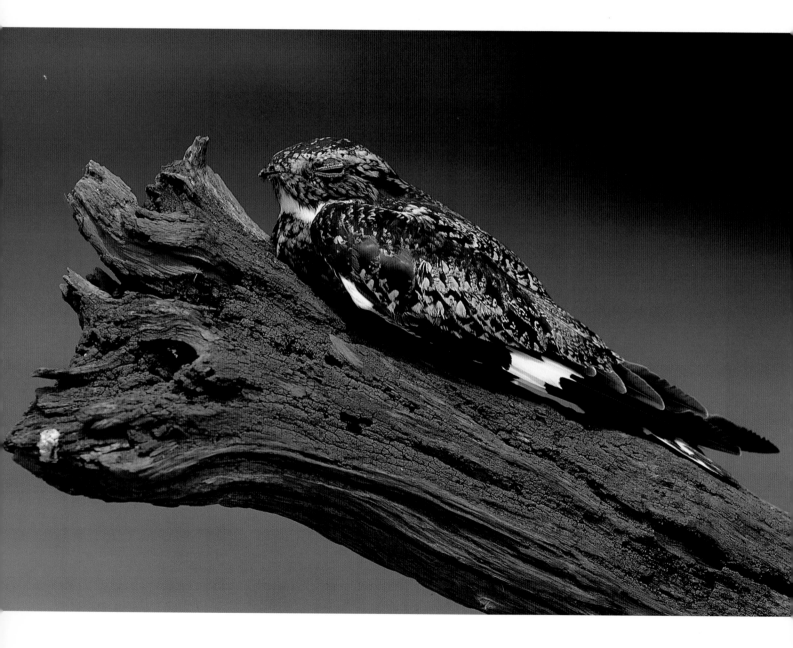

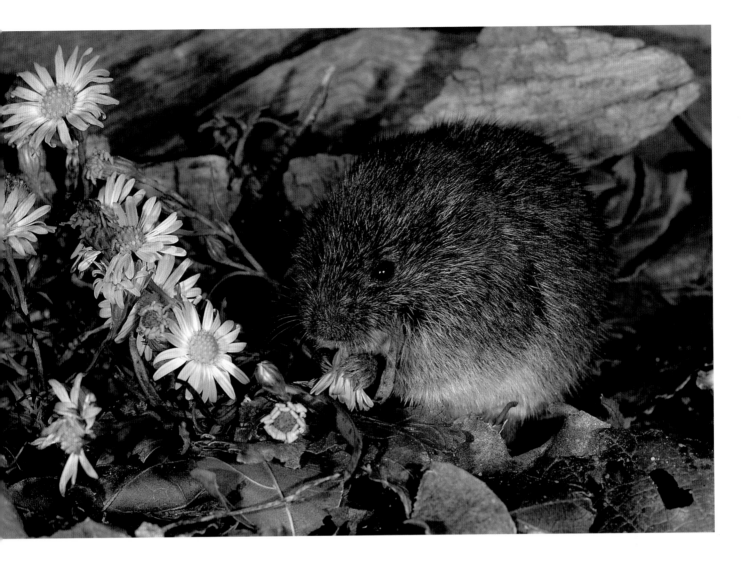

Mammals

Prairie voles are among our most common native rodents, and yet most people might claim never to have seen one. Often, a rustling of leaves in a dense grassy meadow or the presence of small runways resembling tiny subways at ground level or slightly below it may be the only obvious signs of these inconspicuous creatures. Such surface runways are often marked by bare and packed soil, or they may be somewhat cushioned by grass clippings produced in the process of constructing the passageways. The animals live almost entirely on green stems and leaves of grasses, sedges, and forbs, supplementing these at times with roots, seeds, bark, and tubers. Overhead cover is important to their survival, but simple invisibility from above does not protect them from such sharp-eared or keen-nosed enemies as northern harriers, owls, coyotes, foxes, shrews, and a host of other predators.

Chances are good that most people who have lived in the grasslands of North America have seen the workings of pocket gophers but prob-

PRAIRIE VOLES ARE HIGHLY PROLIFIC, WITH FEMALES USUALLY HAVING A LITTER OF FOUR OR FIVE YOUNG AFTER A THREE-WEEK GESTATION. THEY ARE WEANED WITHIN A MONTH, AND FEMALES CAN BREED AT FIVE WEEKS.

ably not the animals themselves. Collectively, the plains and northern pocket gophers extend across the entire region covered by this book, with the northern species mostly occurring to the north and west of the plains and differing in being smaller and in having smooth upper incisors instead of vertically grooved ones. Both have external furred cheek pouches that, like those of kangaroo rats and pocket mice, are used for carrying food. The upper incisors pierce the lips, producing a distinctive buck-toothed appearance, and allow the animal to dig its way through earth without getting soil into its mouth. In the course of their prodigious digging behavior, pocket gophers mix and aerate soils and generate distinctive mounds of soils that are pushed to the surface. As many as two and a half tons of earth may be moved in a single year by an adult pocket gopher.

THE **FRANKLIN'S GROUND SQUIRREL** MAY BE UP TO SIXTEEN INCHES LONG, INCLUDING ITS SIX-INCH TAIL. IT HIBERNATES THROUGH THE WINTER, AND AS MUCH AS 90 PERCENT OF ITS LIFE MAY BE SPENT UNDERGROUND. ABOVE GROUND, IT IS MOST ACTIVE ON BRIGHT, SUNNY DAYS.

PLAINS POCKET GOPHERS HAVE LONG, STURDY CLAWS POWERED BY MUSCULAR FRONT LEGS. BEADY EYES, TINY EARS, HUGE FRONT INCISORS, AND EXTERNAL CHEEK POUCHES FOR CARRYING FOOD ARE OTHER NOTABLE FEATURES. THEIR ANATOMY IS IDEALLY SUITED FOR DIGGING AND DEVOURING PLANT ROOTS, STEMS, AND LEAVES, WHICH THEY HAUL BACK TO UNDERGROUND STORAGE CHAMBERS.

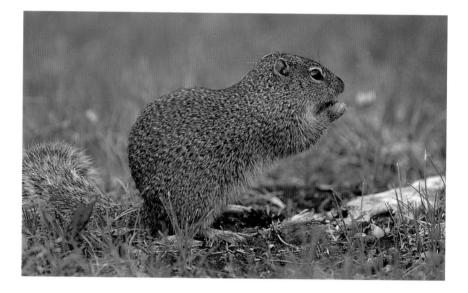

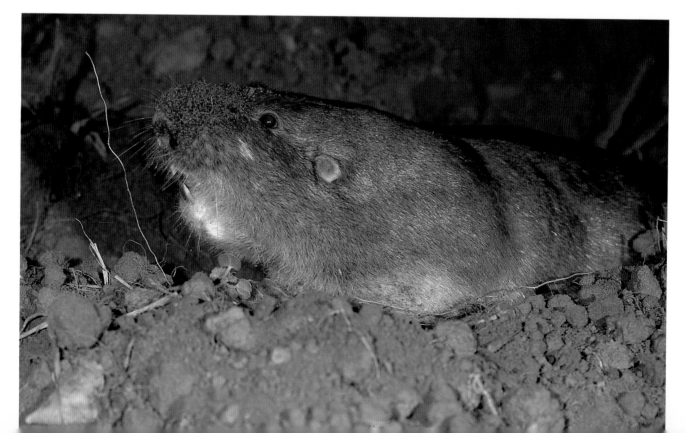

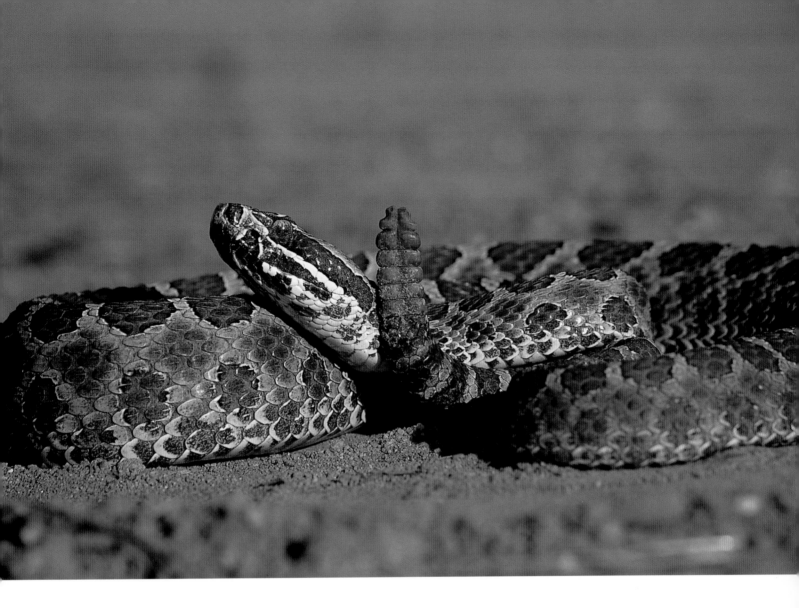

Reptiles and Amphibians

The massasauga is one of the smallest of our native rattlesnakes; adults rarely if ever reach three feet in length. It is the only venomous snake likely to be found in remnant tallgrass prairies and now is so rare that even with diligent searching a person is unlikely to encounter one during an entire lifetime on the prairie. Its rattles are notably short and small, and it has a distinctive pattern of nine very large scales on the top of the head (a trait shared only with the rare pygmy rattlesnake), although few people are likely to think about counting head scales when they suddenly encounter a rattlesnake. Its black eye-stripe extends well back on the side of the neck, and the body is typically covered with an attractive pattern of dark-edged diamonds and more rounded markings. Like other pit vipers, it has elliptical pupils and a small pit located behind its nostrils and below and in front of each eye; these pits serve as infrared heat detectors that allow it to track warm-blooded animals. The species' English name is from the Chippewa language, meaning "great river mouth," and may relate to its often moist habitats.

MASSASAUGA RATTLESNAKES WILL OFTEN BASK IN THE SUN, SOMETIMES IN THE MIDDLE OF THE ROAD. THEY MAY REMAIN MOTIONLESS IF APPROACHED OR MAY ASSUME A DEFENSIVE POSTURE.

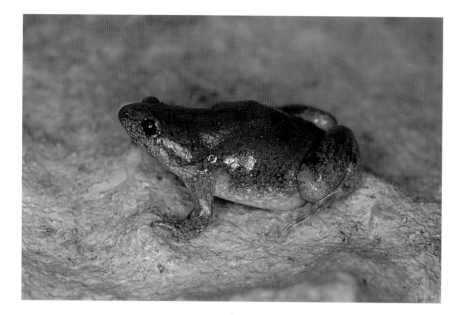

MOST PEOPLE HAVE NEVER SEEN THE SECRETIVE **GREAT PLAINS NARROW-MOUTH TOAD.** THEY ARE ONLY AN INCH LONG, NOCTURNAL, AND SPEND MOST OF THEIR LIVES UNDERGROUND. THEY ARE EASIEST TO FIND AT NIGHT, AFTER SUMMER RAINS, WHEN MALES CHORUS AT TEMPORARY POOLS.

THE **WESTERN SLENDER GLASS LIZARD** HAS NO LEGS BUT UNLIKE SNAKES, IT DOES HAVE EYELIDS AND EAR OPENINGS. IF A GLASS LIZARD IS CAPTURED IT WILL TWIST AND THRASH ABOUT, AND THE TAIL, NEARLY TWO-THIRDS OF ITS TOTAL LENGTH, MAY BREAK OFF. A SHORTER TAIL WILL EVENTUALLY REGENERATE IN ITS PLACE.

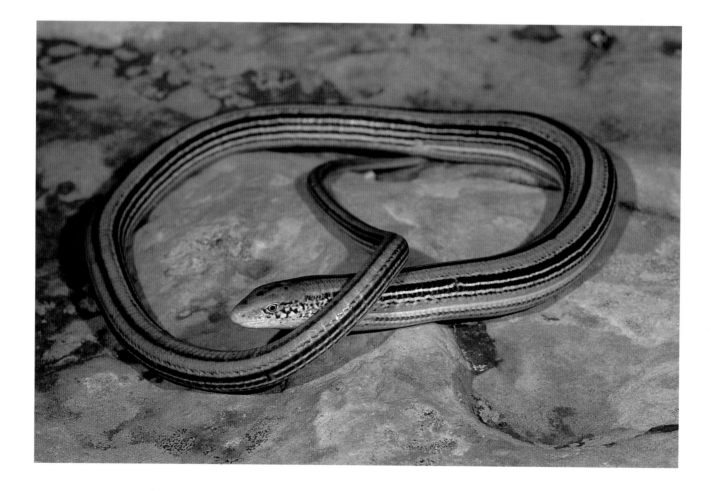

The slender glass lizard is also often called the slender glass snake, since it lacks external legs; but it has external ear openings as well as flexible eyelids, features that are lacking in true snakes. It is called a glass lizard because, like the skinks, it has an easily detached tail; grabbing one almost anywhere will usually result in the rear part of the animal detaching and wriggling about like an earthworm while the anterior part of it escapes as rapidly as possible. This is a surprisingly large lizard; the adults may reach lengths of three feet and even more in old males, although rarely. Both sexes are strongly striped from head to tail, the tail making up more than half of the total body length.

The tallgrass prairies have many of the same lizards and snakes that occur in the mixed-grass prairies and even in the shortgrass plains. The collared lizard is one of the most attractive of these and occurs in all these habitats, north from Mexico to Kansas, especially where a rocky substrate is present to provide hiding places. It is also the most distinctively colorful of all the Great Plains' lizards, the adults having one or two vertical black shoulder bands on an orange background and their upperparts sprinkled with orange crossbanding and pale yellow spots on a darker background. Adult males are larger than females and have a yellow-to-orange throat and bluish belly markings, especially when breeding. The animals reach almost fifteen inches as adults and are nimble runners, sometimes getting up on their hind legs and sprinting in a bipedal manner. They are often associated with rocky and canyon-rich areas, such as Oklahoma's Black Mesa region, but they also occur widely throughout the southern plains. The animals seem to favor rather arid habitats, especially where rocky outcrops are present.

LARGE, FAST, AND PUGNACIOUS, THE **EASTERN COLLARED LIZARD** CAN RUN ON ITS HIND LEGS WHILE HOLDING ITS FRONT FEET OFF THE GROUND. MALES, LIKE THIS ONE, USE THEIR BRIGHT COLORS TO DISPLAY TO OTHER LIZARDS OF BOTH SEXES. THEY ARE COMMONLY FOUND WHERE LARGE ROCKS CAN PROVIDE SHELTER.

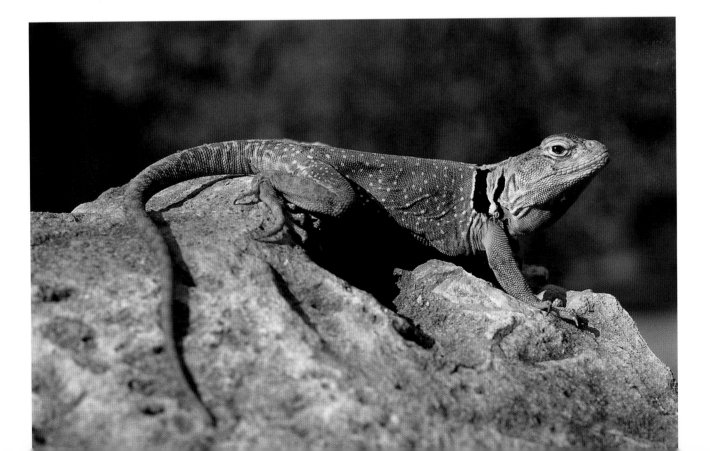

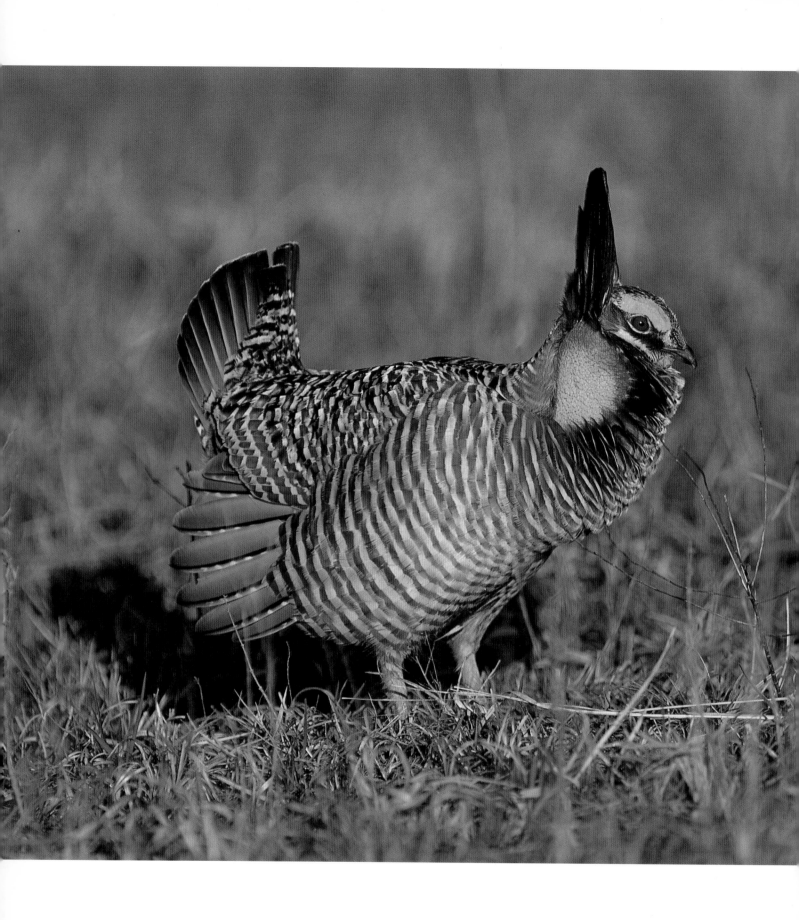

Field Notes

For the ninth time in a two-week period in mid-April the alarm went off at 4:00 A.M. It took me a moment to clear my head and stumble out of bed. Once outside, I looked up at stars. The day looked promising, but it also had looked promising on previous mornings. They had begun with stars but changed to overcast skies, or thunderstorms, or clouds that strangely positioned themselves in front of the sun.

This was the last morning I was escorting friends from the Great Plains Nature Photographers to a prairie-chicken blind in the Flint Hills of Kansas. I knew the birds would be on the lek, and I knew they would put on their usual spirited courtship display. What I didn't know was whether we would be rewarded with no wind and a few minutes of golden light when the sun first breaks the horizon. This light illuminates the bird's orange and red throat pouches, and their golden eyebrows glow with vivid color. I'd spent countless hours waiting on the perfect light, highlighting the perfectly positioned bird.

By 5:45 A.M. we were bouncing across a hilltop on The Nature Conservancy's Flint Hills Tallgrass Prairie Preserve near Cassoday, Kansas. Without using flashlights we found our way into the blind and quietly waited. In the darkness, we could hear the dozen chickens cooing and cackling and could barely make out their shapes through the observation hole. Eventually, that elusive sunrise caught two birds whooping, dancing, and booming directly in front of the blind, only twenty feet away. They were captured on film as shutters whirred.

As one bird pivoted and ran off to boom with another, the remaining bird flew directly at us and landed on top of our wooden blind. As if to celebrate the beautiful morning, he cackled and danced. It sounded as if we were in a drum. I glanced at my grinning friends. It was the perfect morning photographers dream of. Finally, the weather and the birds had cooperated.

THE "BOOMING" CALLS OF DISPLAYING MALE **GREATER PRAIRIE-CHICKENS** ARE HEARD ONLY ON THE GREAT PLAINS. EACH SPRING THE MALES GATHER AT DAWN ON BREEDING GROUNDS CALLED LEKS TO DISPLAY. NEARBY FEMALES WATCH THE SHOW AND CHOOSE THEIR MATES ACCORDINGLY.

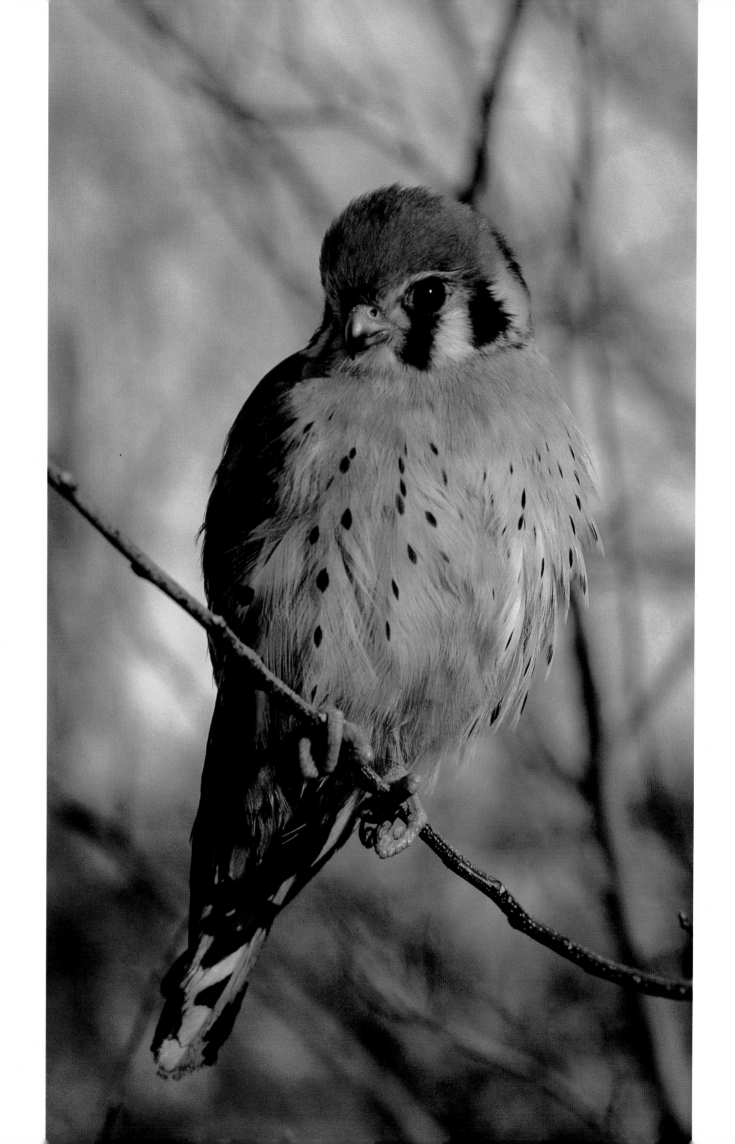

MIXED-GRASS PRAIRIE

Across eastern South Dakota and from roughly the southern edge of the Nebraska Sandhills south through nearly all of Kansas and locally beyond into western Oklahoma and Texas, the surface of the land has been liberally sprinkled with unimaginable quantities of almost microscopic-sized particles. They had their origins in the silts deposited by meltwater streams that bordered the glaciers. These tiny materials were carried south and east for hundreds of miles from the margins of retreating glaciers during powerful windstorms of the long interglacial periods and also during the dry winters of the glacial periods themselves. The clouds of dust were eventually dropped from the sky and settled on lowlands and uplands, sometimes gradually building up into hills one hundred feet or more in depth. Because of the relative uniformity of their particle sizes, the soils that developed from these deposits had little real internal structure and instead were notably "loose." The related German term "loess" has been widely adopted by geologists to describe this distinctive type of substrate. It is not only easily tilled but also very easily eroded. Because of this, much of the Great Plains' topsoils derived from loess have found their way down the Missouri and Mississippi Rivers, eventually to be redeposited as part of the Mississippi's delta.

Birds

I suppose everybody has a special plant or animal they truly associate with spring. This is especially true for those people living in the northern parts of the Great Plains, where waiting for spring's arrival must simply be endured through the endless dreary months of winter, just as a woman must wait for the eventual arrival of her child. During my boyhood in North Dakota, my ultimate symbol of spring was the marbled godwit. Godwits didn't then (and still don't) nest in the table-flat lands of the intensively cultivated clay soils of glacial Lake Agassiz where I lived, but they did seek out remnant bits of native prairie scattered along the gravelly shorelines oriented north to south just a few miles east and west of the Red River. In late April or early May, just after the last of the snow geese had passed on northward to places then unknown to me, the godwits finally arrived. They seemed

THE **AMERICAN KESTREL** IS THE SMALLEST OF NORTH AMERICAN FALCONS. ONCE REFERRED TO AS THE SPARROW HAWK, IT FEEDS ON SMALL BIRDS AND RODENTS, BUT ITS PRIMARY DIET IS INSECTS. THE MALE KESTREL, SHOWN HERE, IS SMALLER AND MORE COLORFUL THAN THE FEMALE.

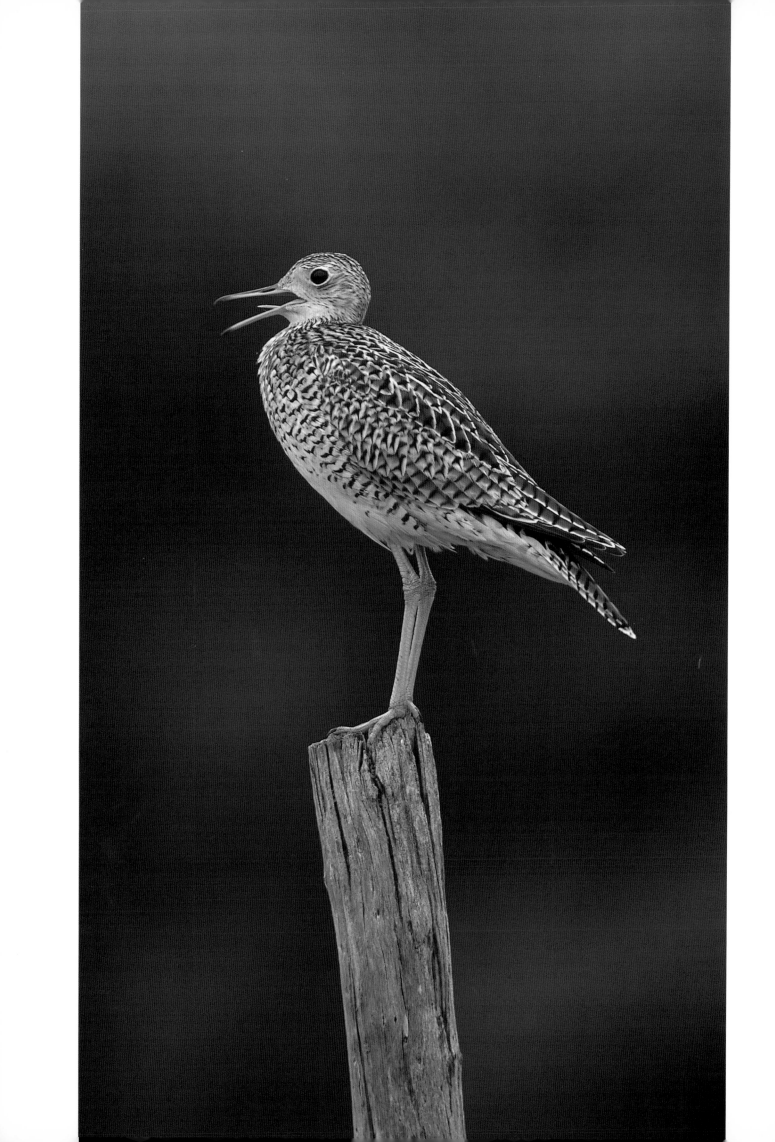

to me to have all the grandeur of the infinitely more abundant snow geese, their relative rarity making their arrival even more special. I knew that the fields they chose to nest in were ones in which I could later find such wonderful prairie plants as pasqueflowers and, still later, blazing stars.

Wherever one finds marbled godwits, there are also likely to be upland sandpipers. Both are "indicator species" of native prairies, and both require large expanses of grassland to breed. In the case of upland sandpipers, areas of at least 150 acres might be needed to attract any, and even on sites as large as 500 acres their populations are likely to be only about half of their maximum densities. In very good mixed-grass habitats they may associate in loose colonies. They rarely occur in grasses more than twenty inches high or in very short grasses. They do occur in tallgrass prairies that are subjected to moderate grazing, and especially in eastern parts of their range they may nest in the mowed fields of airports.

The sharp-tailed grouse historically took over in the Great Plains wherever the greater prairie-chicken gave up for lack of winter grains. The sharp-tail is a bird that once ranged widely, from the open muskeg country of interior Alaska and northwestern Canada south-

THE WOLF-WHISTLE CALL OF THE **UPLAND SANDPIPER** CAN BE HEARD IN PRAIRIES THROUGHOUT THE GREAT PLAINS. ALTHOUGH TECHNICALLY A SHOREBIRD, IT IS RARELY FOUND NEAR WATER. THIS LONG-DISTANCE MIGRANT WINTERS IN THE GRASSLANDS OF ARGENTINA AND SOUTHERN BRAZIL.

DISPLAYING **SHARP-TAILED GROUSE** STAMP THEIR FEET SO RAPIDLY THEY APPEAR TO DANCE ACROSS THE PRAIRIE LIKE WINDUP TOYS. THE MALES SUDDENLY STOP, LIKE THE BIRD SEEN HERE, AND REMAIN IMMOBILE FOR UP TO A MINUTE BEFORE CONTINUING THEIR DANCE.

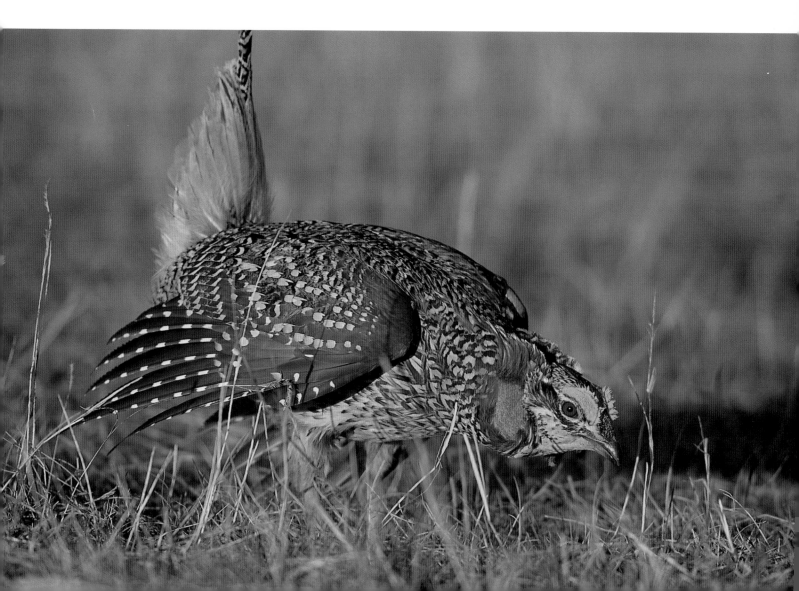

ward to California and Kansas and east to the central Great Lakes. The Kansas population is now gone, as are most of the now-scattered populations ("Columbian sharp-tails") of the American West. But sharp-tails still persist in the mixed-grass prairies of the Dakotas and Nebraska, only grudgingly retreating before the intensive agriculture that robs them of important winter cover and food plants. In the shrubby prairie draws they find rose hips, willow buds, and the seeds and fruits of a variety of plants that remain above snow line. During very heavy snows and times of intense cold they often tunnel into snowbanks, where the temperature may be much warmer and there is no windchill.

Western meadowlarks are also hardy birds, sometimes overwintering as far north as Nebraska and South Dakota. It has been estimated that the western meadowlark is the fourth-most abundant nesting bird in North Dakota, is second only to the mourning dove in South Dakota, and is fourth-most abundant in Nebraska. Farther south, where it is progressively replaced by the eastern meadowlark, it has a much lower numerical rank as to relative abundance. Yet it is a dearly beloved bird wherever it occurs. In North Dakota the western meadowlark is the earliest of the breeding songbirds to return in late winter, showing up in loose flocks that must scratch hard for food along the edges of melting snow. Not long after its arrival, the males become territorial and begin their wonderful fluty songs, optimistically promising that spring will not be too far off.

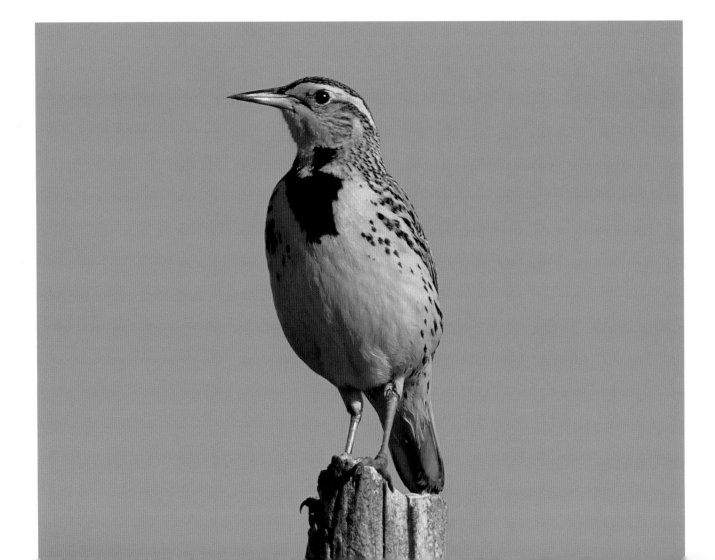

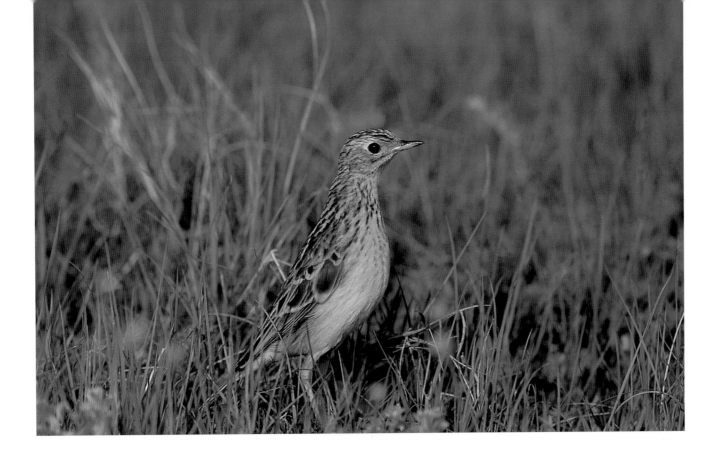

THE **SPRAGUE'S PIPIT** IS ONE OF THE MOST CHALLENGING SUBJECTS FOR A BIRD PHOTOGRAPHER. ITS TERRITORIAL SONG IS PERFORMED HIGH IN THE SKY AT THE LIMIT OF NORMAL VISION. ON THE GROUND THE BIRD IS SHY AND SLINKS THROUGH THE GRASS IN A MOUSELIKE FASHION.

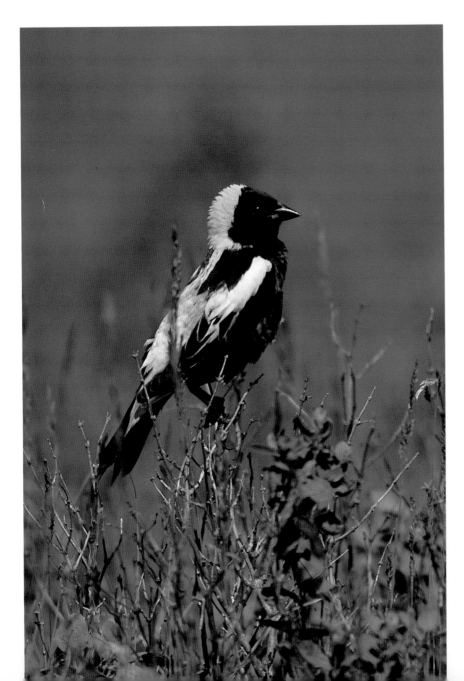

THE MALE **BOBOLINK** IS THE ONLY NORTH AMERICAN SONGBIRD THAT IS BLACK ON THE BELLY AND WHITE ON THE BACK. DURING FALL MIGRATION IT FEEDS ON RICE IN THE SOUTHERN STATES BEFORE IT HEADS ACROSS THE CARIBBEAN TO ARGENTINA.

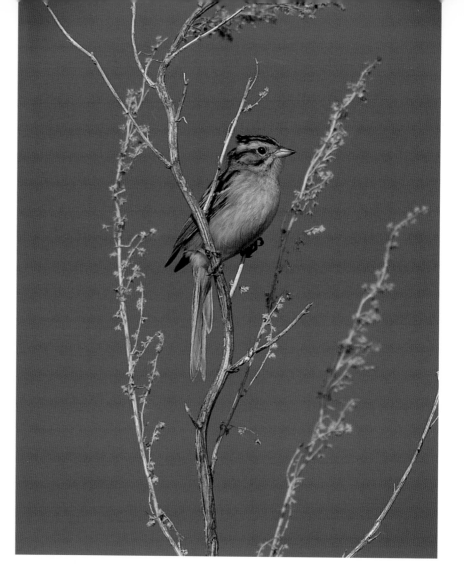

THE APPROPRIATELY NAMED **CLAY-COLORED SPARROW** BREEDS IN THE NORTHERN PRAIRIES IN OPEN BRUSHY AREAS. ITS SONG CONSISTS OF AN INSECTLIKE BUZZ.

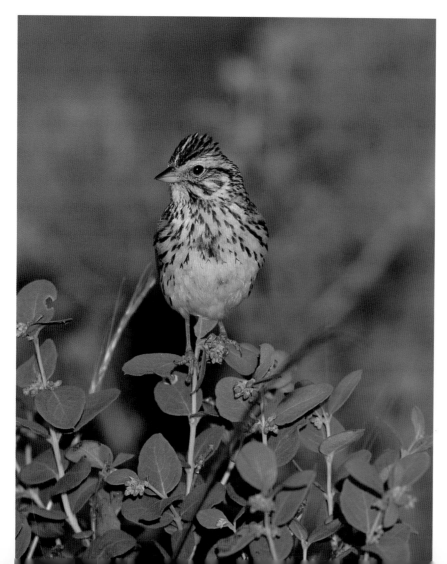

THE **SAVANNAH SPARROW** IS FREQUENTLY SEEN CHASING OTHERS OF ITS KIND OR SINGING PROUDLY FROM AN EXPOSED PERCH ON ITS BREEDING TERRITORY. THIS IS ONE OF THE MOST ABUNDANT SPARROWS ON THE NORTHERN PRAIRIES.

Two of the many native sparrows sometimes nesting in mixed-grass prairies are the clay-colored and Savannah sparrows. In truth, both have broader ecological and geographic ranges than just mixed-grass prairies. The Savannah sparrow is a species that is broadly tolerant but prefers to nest in areas having intermediate vegetation density, grass and forb cover, canopy height, and litter density but with little or no woody cover present. Its breeding range extends from Alaska to Maine, where it occupies diverse herbaceous habitats, including tall-grass prairies. The clay-colored sparrow is more restricted in its range and ecological needs, preferring more brushy areas, with scattered trees or even thickets present.

Few if any of the mixed-grass sparrows are more attractive than the chestnut-collared longspur. It is one of the few redeeming features of living through a North Dakota winter that nowhere else south of the Canadian prairies is there a better chance of seeing both the chestnut-collared longspur and the Baird's sparrow on the same spring day and perhaps even in the same prairie. The two have slightly different visual appeal. The male chestnut-collared longspur is easily the Beau Brummell of prairie sparrows; its chestnut nape and white-edged ebony crown, breast, and belly markings are a stunning sight. Its song is long and musical, with up to ten distinct phrases, including some

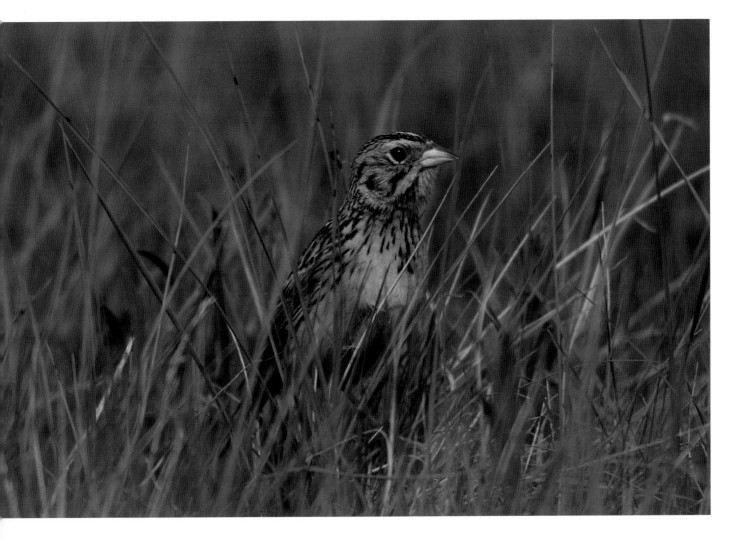

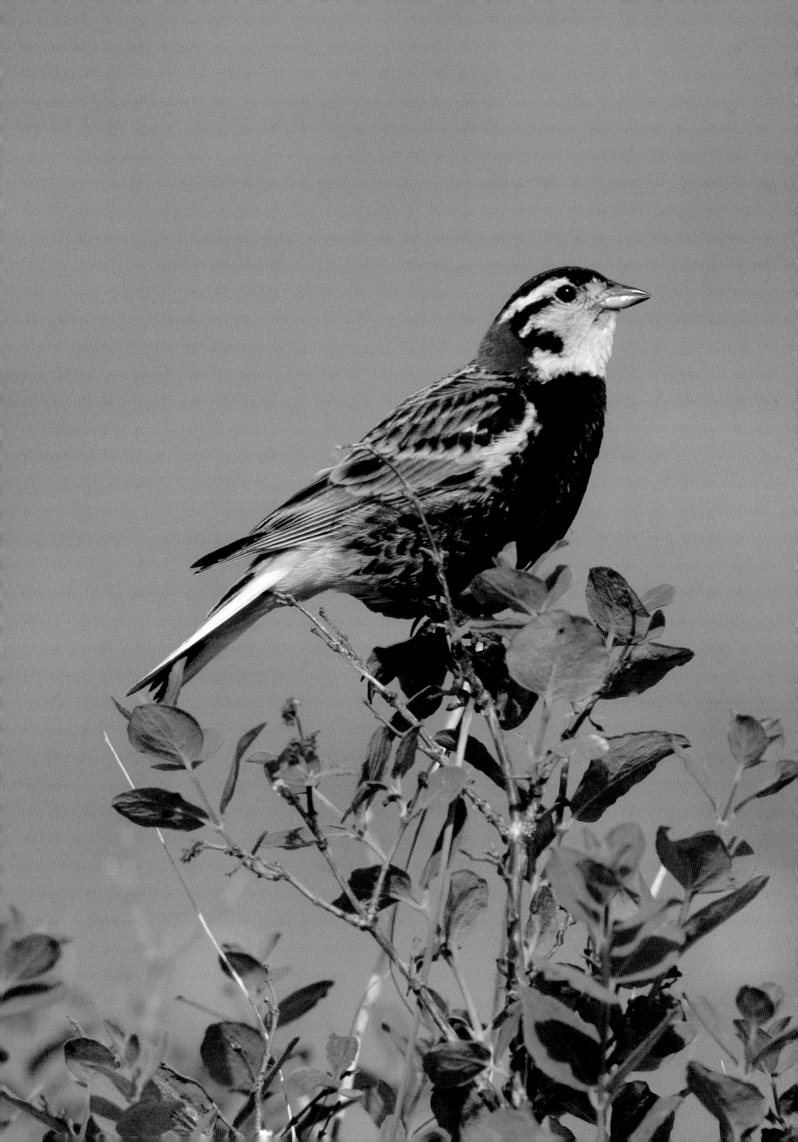

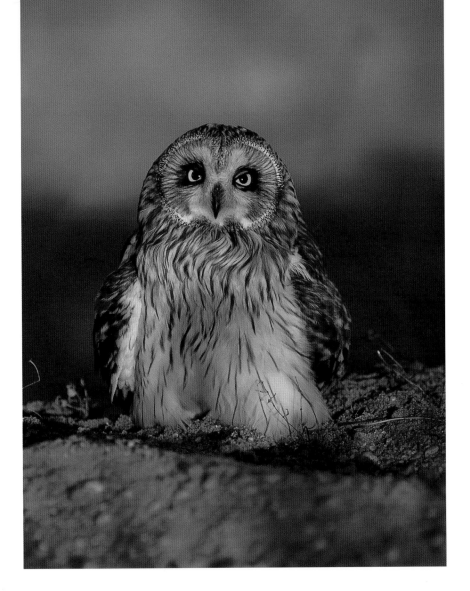

THE STRIKINGLY PATTERNED MALE **CHESTNUT-COLLARED LONGSPUR** SINGS IN FLIGHT. WITH TAIL FEATHERS SPREAD, HE FLOATS BACK TO A PERCH AND CONTINUES TO SING AND WATCH FOR COMPETING MALES.

repeated notes. It may last almost three seconds and is often performed at the apex of a towering display flight that may reach a height of fifty feet, although rarely. Like the similar McCown's longspur of the shortgrass steppes, it then drifts slowly back to earth on outstretched wings, often while still singing loudly. Males will also sing from whatever perches that might be available within their territories, which are often large glacially transported boulders, called glacial erratics.

Other than the tiny burrowing owl of the shortgrass prairies, probably the only prairie owl likely to be seen during daytime hours is the short-eared owl. On late afternoons, when the sun is starting to cast long shadows across the prairies, one sometimes suddenly sees a completely silent bird moving low over the meadows, resembling a giant moth as much as a bird, and intently going about its business of looking and listening for prairie voles or any other small rodents that make the mistake of moving even so much as a blade of grass while in its presence. It has very large eyes, similarly large facial disks, and enormous external ears (well hidden below the feathered facial disks) that are attuned to the slightest sounds. It is one of the owls that probably can capture prey by either sight or hearing, depending on the amount of available light.

Mammals

Among Great Plains ground squirrels, the Richardson's ground squirrel shares its range in some areas with thirteen-lined and Franklin's, but it is more clearly a mixed-grass prairie species than either. All these ground squirrels undergo a very long hibernation and are visible above ground for only a few months, from the time of spring melt until about July or August, depending on both age and sex. Their many predators include the larger owls; ferruginous, red-tailed, and Swainson's hawks; prairie falcons; badgers; weasels; coyotes; and diverse snakes, to mention only the primary ones. As a result, probably few ground squirrels live longer than a year.

THE SHRILL ALARM CALL OF THE **RICHARDSON'S GROUND SQUIRREL** IS COMMONLY HEARD IN PARKS, PICNIC AREAS, CAMPGROUNDS, FARMS, AND ROADSIDES THROUGHOUT THE NORTHERN GREAT PLAINS.

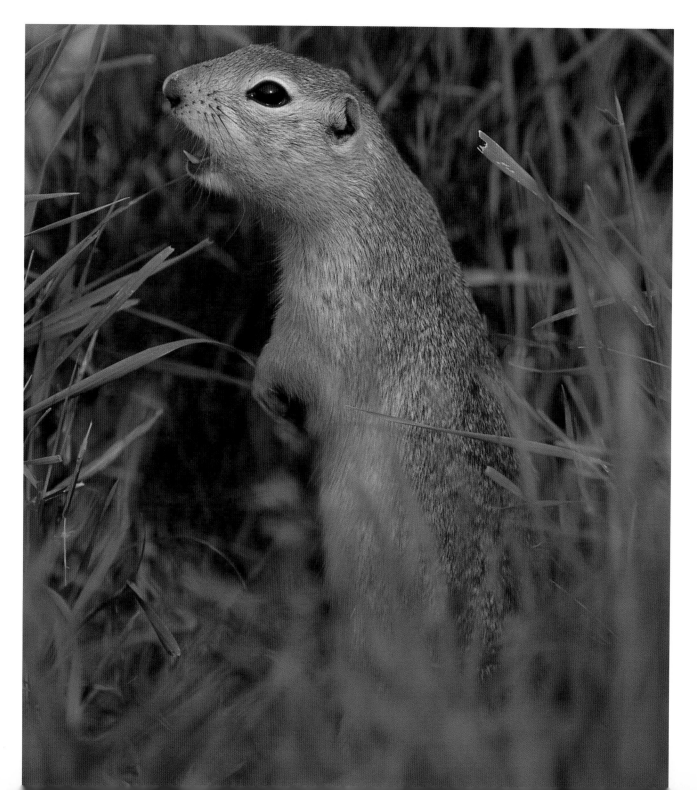

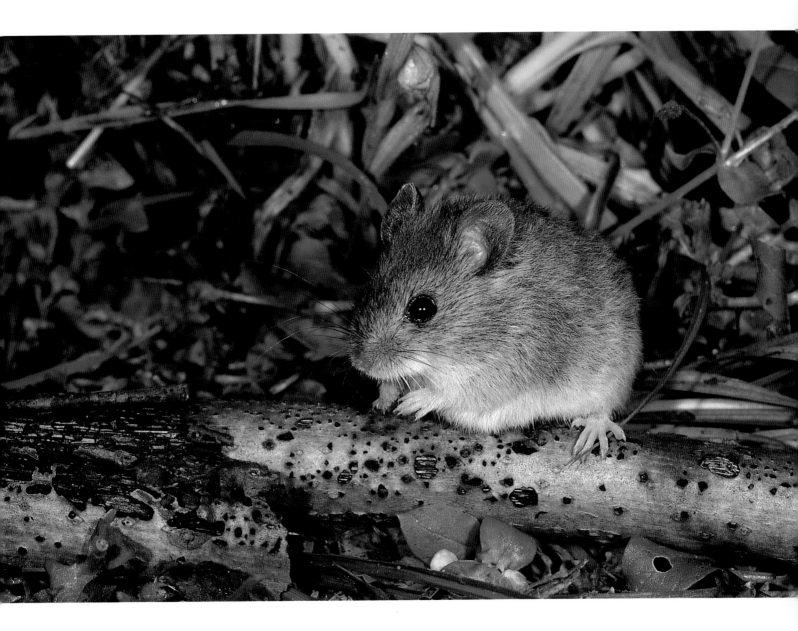

Harvest mice are among the several small, nondescript mice that commonly occur in mixed-grass prairies, but they are distinctive in at least two ways. First, their upper incisors are distinctively grooved along their anterior surface, a curious feature that decisively separates all harvest mice from other very similar grassland mice. Another feature that makes harvest mice appealing is that they construct globular above-ground nests, somewhat like those of marsh or sedge wrens, usually quite close to the ground or even on it. The nest may be about three inches in diameter and, like a wren's, has a small round opening located well below the midpoint, often at the bottom. The inside of the nest is also somewhat birdlike but is lined with plant down rather than with feathers. In rocky ground these mice may also nest underneath rocks. However, upland grasslands seem to be their preferred habitats.

Jackrabbits and prairies seem to belong together. In the northern parts of the Great Plains it is the white-tailed jackrabbit that is more common. Farther south, the smaller but longer-eared black-tailed species takes over. In Nebraska both still occur fairly commonly, although neither species is as abundant as was once the case. Jackrabbits seem to be persecuted wherever they occur. I remember villagewide jackrabbit hunts being organized in North Dakota when I was a child. Now both jackrabbit species are relatively rare. Their large size makes them a tempting rifle target in the shorter grasses where they often are found, and they do not seem to be much more wary than cottontails, in spite of their large eyes and even larger ears. By being active mainly at night they avoid being noticed by humans and such daytime predators as golden eagles. However, coyotes are a danger to jackrabbits at any time of day or night.

WITH EARS ERECT AND SHARP EYES, THIS **WHITE-TAILED JACKRABBIT** STANDS ON ITS HIND LEGS TO GET A BETTER VIEW OF POTENTIAL DANGER. THESE JACKRABBITS LIVE IN THE NORTHERN GREAT PLAINS, AND DURING WINTER THEIR HAIR GROWS THICK AND WHITE.

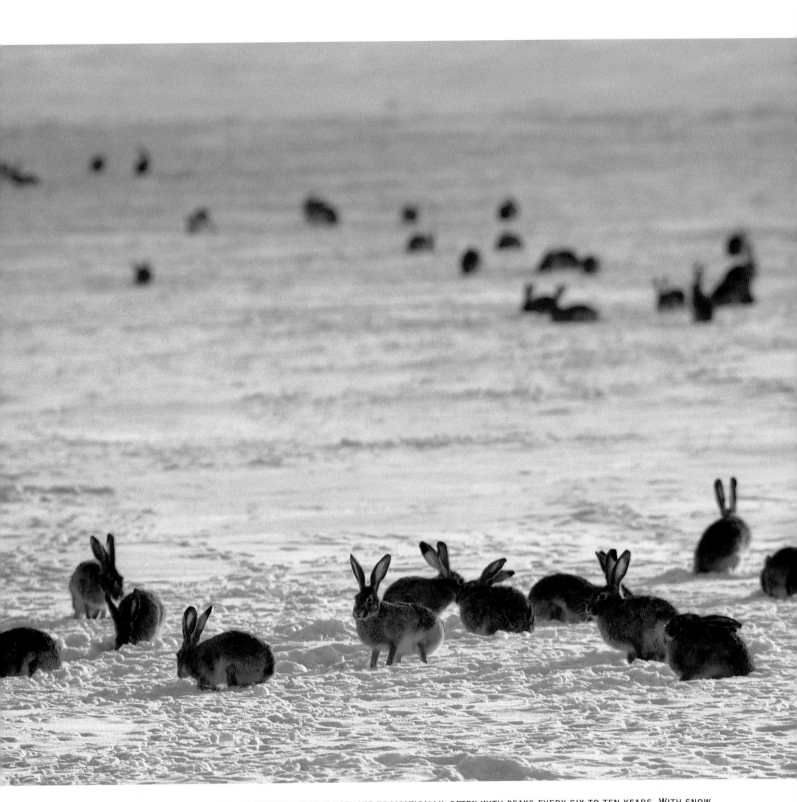

Populations of **BLACK-TAILED JACKRABBITS** fluctuate dramatically, often with peaks every six to ten years. With snow covering already limited food supplies, these jackrabbits gather near a hay supply out of sight in the foreground. Concentrations like this can do serious damage to crops.

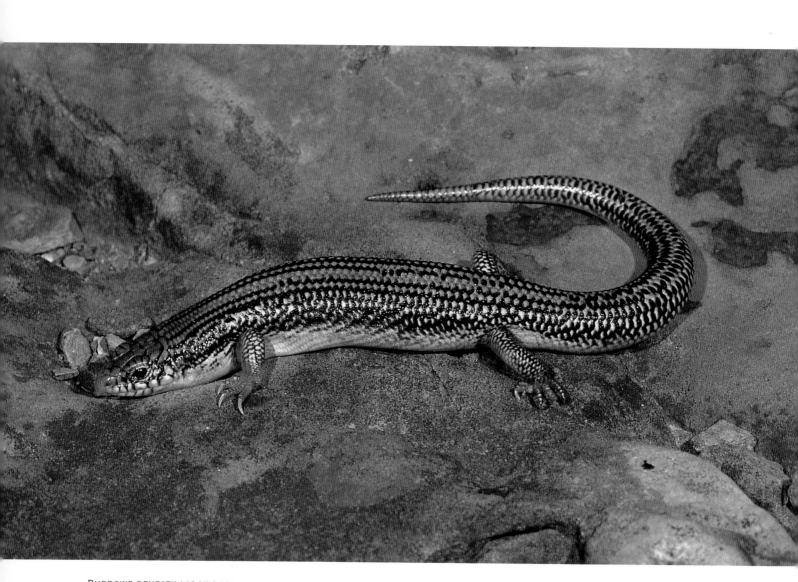

Burrows beneath large rocks in the open prairies provide perfect shelters for
Great Plains skinks, which feed on insects and spiders. They are not easily
captured but if grabbed will inflict a surprisingly strong and aggressive bite.

Like other skinks, **Northern Prairie skinks** have shiny, smooth, flat
scales on their bodies. They prefer to hide under rocks on prairie hillsides.
Large ones may reach seven inches in length.

Reptiles

Mixed-grass prairies have their share of small reptiles, including several lizards and a few snakes. Skinks are small, agile lizards, and like snakes, they use their tongues to detect airborne odors and probably can detect and identify members of their own and other species through olfactory signals. Yet skinks are also shiny and brilliantly colored, frequently with linear stripes that probably serve as species-recognition signals. The Great Plains skink has only a slightly striped appearance and is fairly large, but the smaller prairie skink is strongly striped all the way to its tail. Skinks are active during warmer daylight hours, catching insects and scurrying to safety at the first sign of danger. They have rather short legs but long tails, and their tails are easily detached from their bodies when grasped, leaving the predator with only a writhing tail to eat while the rest of the animal escapes to safety. The blood vessels in the tail stump shut down immediately and healing begins soon thereafter. The brilliant blue color of the tails of many juvenile skinks may actually serve as a distracting target for predators; it is better to lose one's tail than one's life.

During the breeding season male skinks establish small territories and perform various visual displays, plus apparent scent-marking with cloacal rubbing of the substrate. Fights among males may occur, and courtship involves such activities as head-bobbing, chin-rubbing, and other contact behavior. Skinks are egg-layers, producing a clutch of up to twenty eggs that are deposited in a single place and tended by the female until they hatch, about forty to fifty days later.

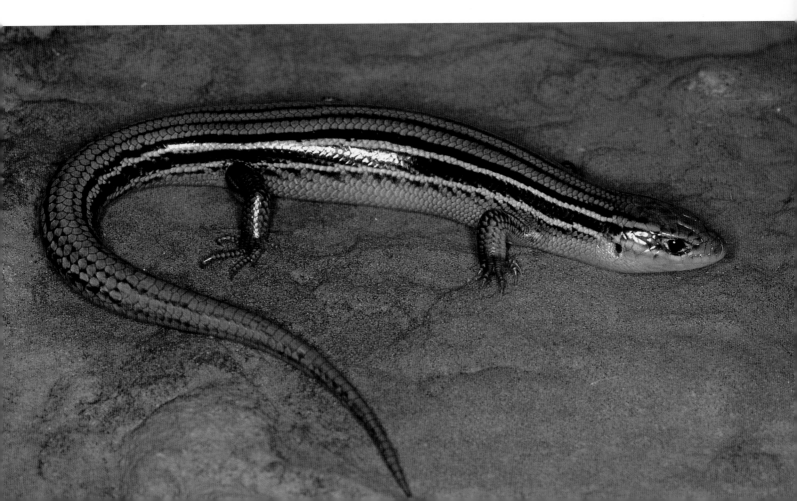

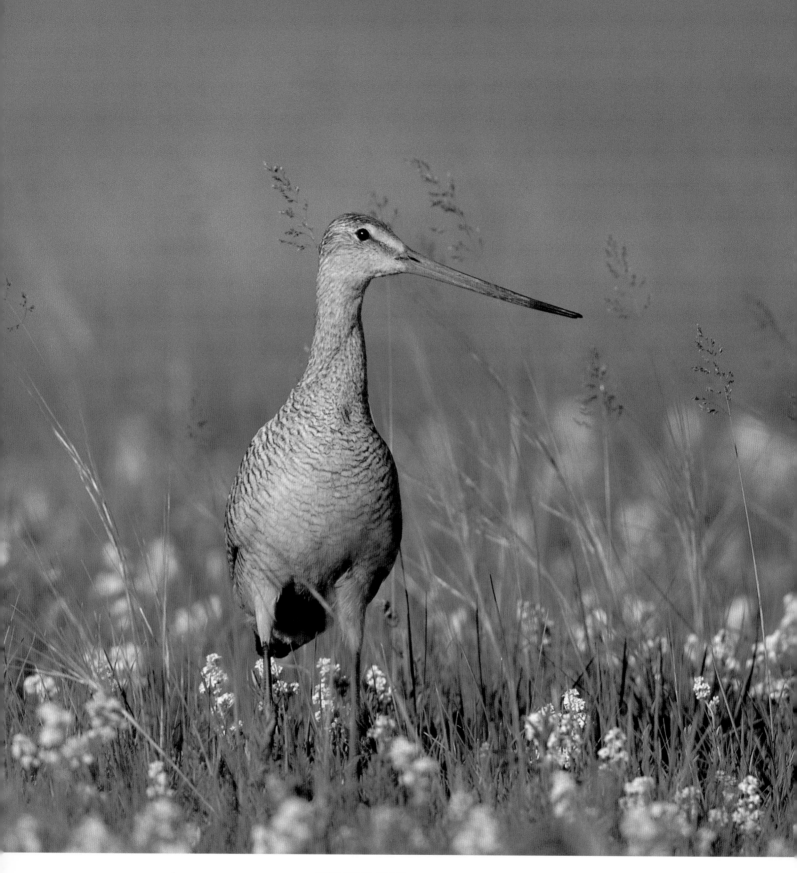

Some birds are shy and secretive in their efforts to hide their young, but the **MARBLED GODWIT** is bold. It screams for attention to distract intruders, whether a hunting coyote or a photographer.

Field Notes

Although most prairie species are shy and elusive, marbled godwits can be bold and noisy. When they behave like this, they sometimes venture close enough for easy photos. It was mid-June and I was driving slowly on a narrow road in the rolling hills of North Dakota's Lostwood National Wildlife Refuge. A pair of marbled godwits spotted the van and flew across the prairie, circling above and scolding constantly. As I stopped the van and mounted the camera on the tripod, the birds drifted off and settled down over a hilltop a quarter mile away. I started walking toward a distant pothole in the direction where they first appeared. This got their attention, and they immediately flew toward me, screaming their displeasure. When I turned to face the godwits, they would fly off. If I didn't look in their direction, they would fly back and land about one hundred feet away. If I remained uninterested, they would run toward me, calling and trying to get my attention. I lay on the ground, and the birds came even closer. When they were within camera range, I would spin and shoot a few frames before they flew up and started the process over again.

They tried to get me to follow them away from the pothole, although the water was still two hundred yards away. Scanning the shoreline with binoculars, I spotted movement and saw their half-grown young running off through the grass. This explained their bold behavior and why they would approach a potential predator so closely.

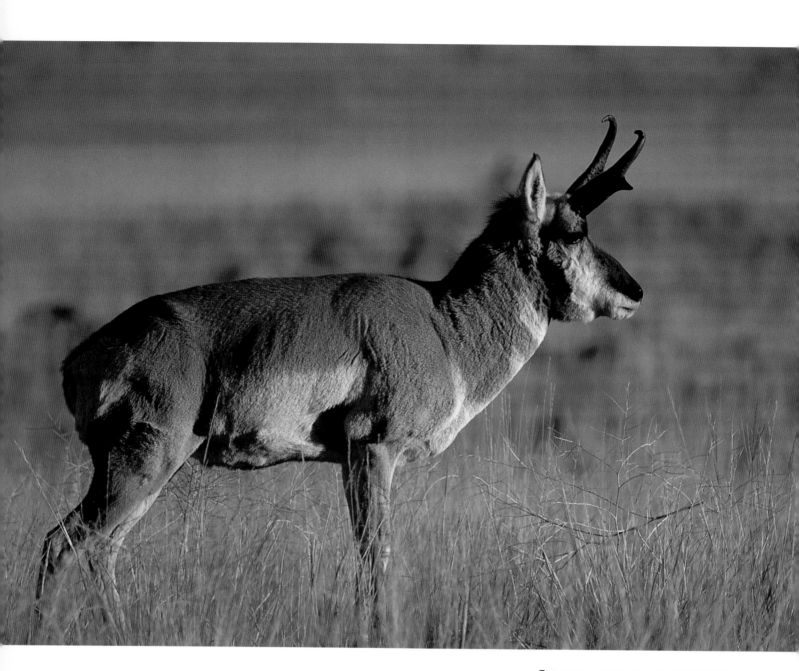

THE VISUAL ACUITY OF A **PRONGHORN'S**
EYES HAS BEEN COMPARED TO THAT OF
A HUMAN USING EIGHT-POWER BINOCU-
LARS. IT IS THE FASTEST LAND MAMMAL
ON THE CONTINENT. DURING THE FALL RUT
THE MALE'S NECK GROWS THICK AND
MUSCULAR.

SHORTGRASS PRAIRIE

During early June 2001 I drove to the Rocky Mountains and decided to take a detour into the Pawnee National Grassland. Unlike previous years, that spring had been unusually wet, and it was clear even before I entered the limits of the preserve that a remarkable transformation had occurred since my last visit a few years ago, when the area seemed to be a desert rather than a prairie. In some places the landscape resembled a great flower garden. White daisy fleabanes and evening primroses, purple milk vetches, and scarlet mallows peppered the green stands of grama grasses and buffalo grass, and even the yellow flowers of prickly-pear cactus created a festive scene. Pronghorns watched warily when I slowed to a stop, and Swainson's hawks sought out the rare windmills as perching sites. In a particularly beautiful location, I stopped to photograph some flowers. While I was focusing on one such blossom, a movement caught the edge of my vision, and I looked up to see the black and white chest and throat pattern of a male McCown's longspur standing about twenty yards away on a small rock. I remained still while it eyed me with as much suspicion as I watched it with unbounded pleasure. I had searched almost in vain for longspurs on the previous trip and had finally been rewarded with a single rather unimpressive female that was feeding among a flock of horned larks along a roadside edge. The vision of that handsome male, in contrast, remains indelible in my memory. One swallow may not make a spring for perennial skeptics, but a single McCown's longspur may personally commemorate a shortgrass summer.

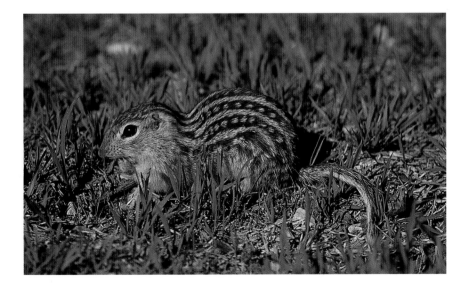

THIS GROUND SQUIRREL GETS ITS NAME FROM THE THIRTEEN ROWS OF ALTERNATING STRIPES AND SPOTS ACROSS ITS BACK. LIKE MOST GROUND SQUIRRELS, THE **THIRTEEN-LINED GROUND SQUIRREL** WILL STAND ON ITS HIND LEGS TO GET A BETTER VIEW.

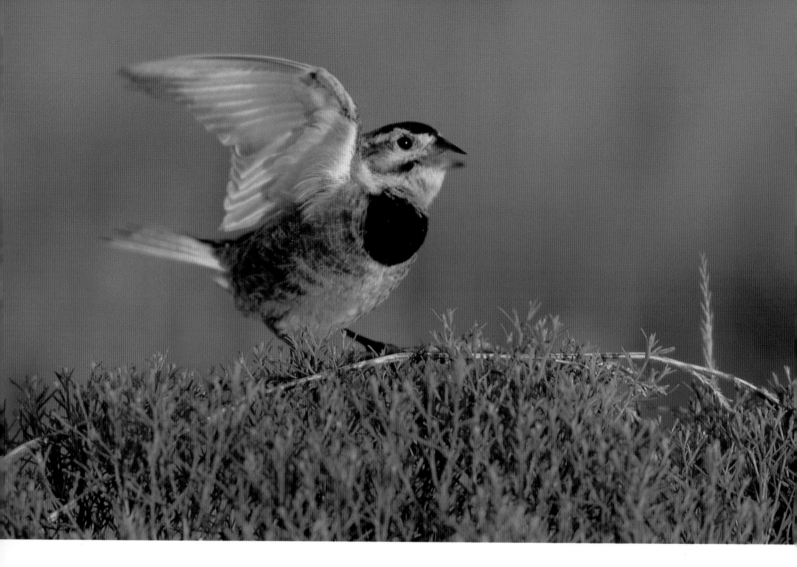

Birds

Next to the sight of a golden eagle, the appearance of a ferruginous hawk will convince any bird watchers that they are indeed at home in the high plains. Although distinctly smaller than a golden eagle, the ferruginous hawk is actually the largest of the North American buteos, and they share many of the eagle's traits. It is an open-country species that is most often seen in shortgrass or sage-scrub habitats, typically wheeling high above ground, its pale pinkish tail and whitish upper-wing window panels often clearly visible as the bird banks in a lazy turn. These hawks exude a sense of majesty that exactly fits their scientific name *Buteo regalis*, although a prairie dog cowering several hundred feet below in the shadow of a ferruginous hawk would probably not be thinking in such grandiose terms.

The prairie falcon might almost be thought of as a peregrine in grassland camouflage. It is essentially the same size as a peregrine, and its plumage pattern is a slightly faded and brown-toned version of the peregrine's. It always takes my breath away to see a prairie falcon suddenly emerge from nowhere, throw a prairie dog or ground squirrel colony

McCown's longspurs are birds of the dry high plains. Territorial males spend a great deal of time chasing other longspurs and singing in aerial and ground displays. In this photo, a male in full song flashes his white underwing to a rival male flying overhead.

The eyesight of hawks is estimated to be several times as keen as that of humans. The ferruginous hawk is the largest hawk on the prairie and preys on a variety of mammals, including jackrabbits, prairie dogs, and ground squirrels.

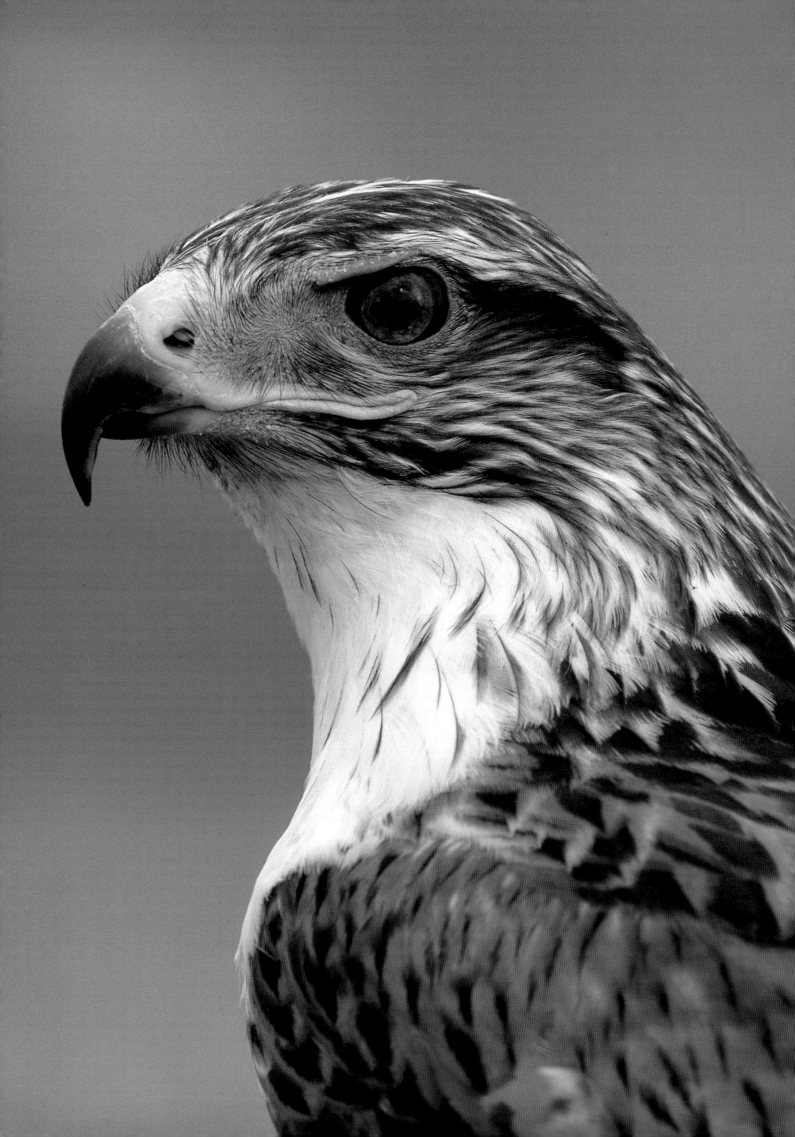

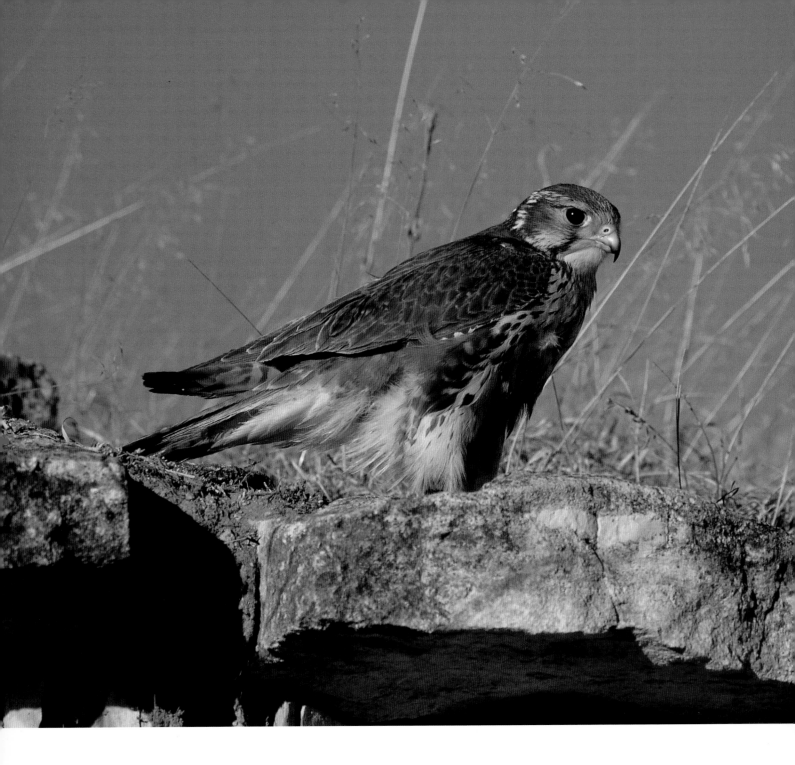

into utter panic, and just as quickly disappear, apparently having decided that a better chance for a meal lies somewhere over the horizon. In such situations, lifetime memories for human observers may be forged in a matter of a few seconds, and for unlucky rodents lifetimes may be ended just as quickly.

Mountain plovers might well have been named prairie plovers, for except during migrations to and from their California wintering areas the birds are rarely within sight of high mountains. Like prairie falcons and ferruginous hawks, they have a somewhat bleached look about them, making them remarkably hard if not impossible to detect when they are crouching in shortgrass prairie. For mountain plovers, the shorter the better seems to be the watchword in terms of grass prefer-

PRAIRIE FALCONS HUNT THE OPEN COUNTRY OF GRASSLANDS, FARMLANDS, AND BADLANDS FOR SMALL MAMMALS AND PRAIRIE BIRDS. NESTS ARE LOCATED ON SHEER CLIFFS USUALLY FIFTY TO THREE HUNDRED FEET HIGH. THE EGGS ARE LAID ON A ROCKY LEDGE IN A SHALLOW SCRAPE OF LOOSE GRAVEL.

ences; the close-cropped soils of prairie-dog colonies were probably once their prime habitat, and now they have to rely on the overgrazed pastures of marginally productive sheep or cattle ranches to find nesting sites. They are now most likely to occur where there is a substantial area of bare, relatively level ground, where the vegetation has been recently burned, where kangaroo rats or prairie dogs still occur, and where horned larks are also to be found. Not many such areas still exist in the Great Plains states, and the birds are now most likely to be found along the very western edges of the shortgrass prairie.

The two most wonderful songbirds of the shortgrass plains are the lark bunting and McCown's longspur, at least during the spring and early summer months. During fall and winter both species hardly merit

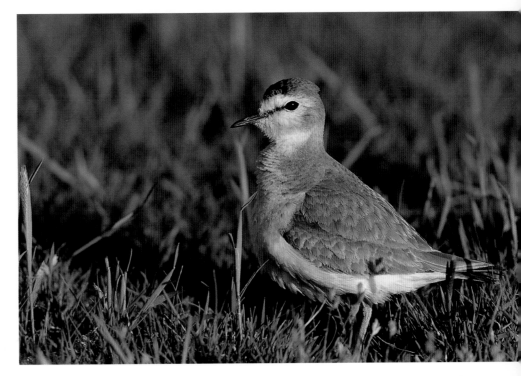

THE SECRETIVE **MOUNTAIN PLOVER** HAS BEEN CALLED THE PRAIRIE GHOST. THIS SHOREBIRD INHABITS SOME OF THE BAREST AREAS IN THE SHORTGRASS PRAIRIE. HABITAT LOSSES HAVE CAUSED ITS POPULATION TO DROP DRAMATICALLY.

more than a passing glance from anyone other than the most hard-core birders, but during a high plains spring the spirited song flights by territorial males of both species can bring joy to even the most jaded spirits. Imagine driving along a dusty trail in open range country, with no trees in sight, and looking for anything that moves. Suddenly a small, mostly black bird about the size of a large sparrow erupts from the grass like a toy rocket and ascends nearly vertically while singing with all the volume it can muster. It stalls out about twenty feet in the air and rapidly descends, leaving the observer to wonder if the entire event had simply been an apparition. By the second or third time, it becomes clear that this is a sparrow with real pizzazz, a lark bunting.

Perhaps no sooner has one adjusted to this strange experience than

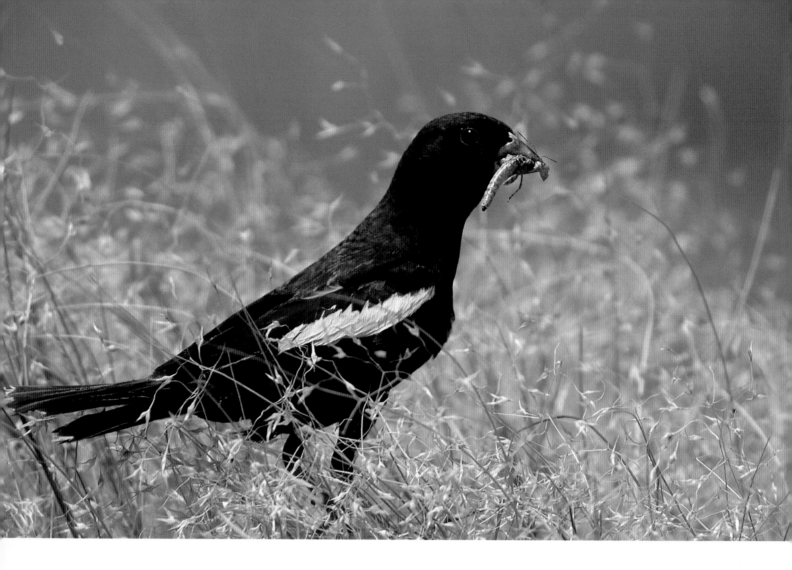

another similar-sized but quite different bird does the same thing. Its undersides are mostly white instead of black, and it has a white edging on its black tail and white underwings, rather than white wing patches on black wings. It ascends higher in the sky, to about seventy feet, and its prolonged song is both musical and warbling, unlike the somewhat staccato and less melodic output of the lark bunting. Both species gradually float back down to earth after they finish their songs, resembling giant moths from some child's picture book.

A COLONY OF DISPLAYING **LARK BUNTINGS** CAN BE MESMERIZING. EXHIBITING THEIR STRIKING PLUMAGE, THE MALES RISE TO HEIGHTS OF NEARLY THIRTY FEET WHILE SINGING, THEN FLOAT SLOWLY BACK TO THE GROUND. THEY FEED ON INSECTS AND SEEDS.

FOR A SPARROW, THE ADULT **LARK SPARROW** HAS RATHER DISTINCTIVE MARKINGS. ITS CONTRASTINGLY COLORED FACE AND CENTRAL BREAST SPOT MAKE IT EASY TO IDENTIFY. WHEN FLUSHED IT OFTEN FLIES TO A FENCE OR LOW BRANCH.

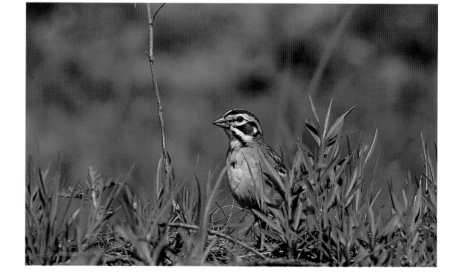

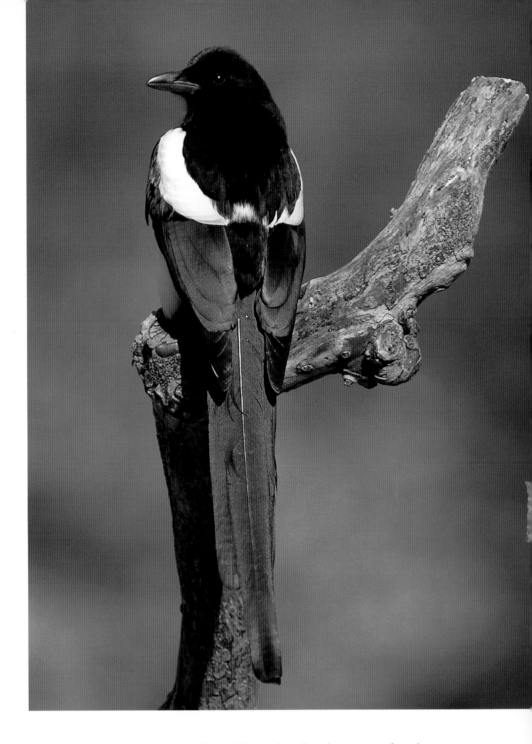

The lark sparrow is one of those sparrows that is just simply perfect. It has a bright, distinctive facial pattern of chestnut, white, and black that is never forgotten once it is seen, a black stickpin parking on an otherwise buffy breast, and white corners on the tips of its tail that flash open in flight, allowing for easy field identification when the bird takes off. Add to these features its somewhat larklike song, a long, musical string of clear notes interrupted near the end by a few buzzy and discordant ones, like a trumpeter who nearly got to the end of his solo before making a mistake. This feature only adds to the bird's charm, making it one of the most memorable of all grassland sparrows.

Not even an ecological Scrooge could easily resist the sudden appearance of a burrowing owl. Standing solemnly beside a prairie dog hole or perched on a nearby fence post, the presence of a miniature owl standing erect and in plain view during the middle of the day somehow seems to be such an unlikely event that it requires a sudden stop and a prolonged look. Burrowing owls have undergone the same frightening decline in numbers as has occurred with other members of the prairie dog community. In western Nebraska their numbers have plummeted in close parallel with those of prairie dogs, and each year they become more difficult

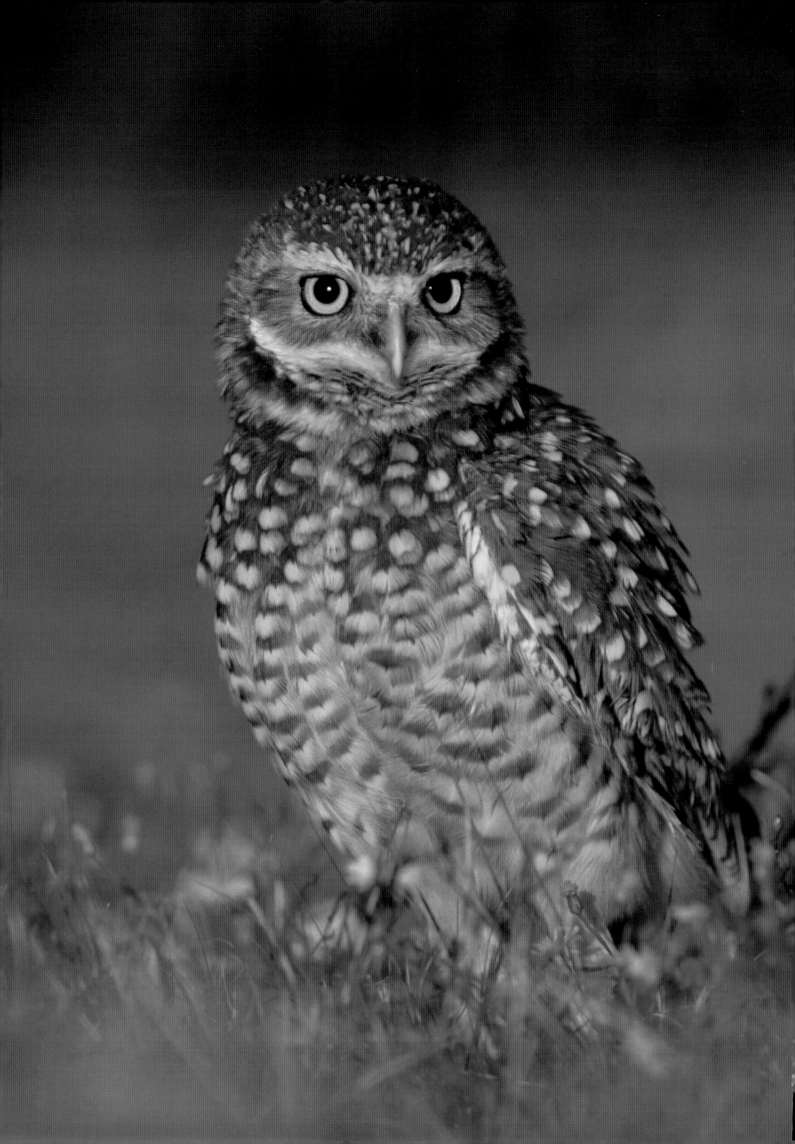

to locate. The familiar "howdy owl" of the shortgrass prairie is now in increasing danger of having to say a final goodbye over the entire western Great Plains.

Mammals

If ever a single keystone animal species were to be identified with the prairie ecosystems of North America, the black-tailed prairie dog would probably most easily qualify. Keystone species are those animals that tend to hold an ecosystem together and whose presence or absence has the greatest effect on the well-being of the other species. In various ways it can be argued that predators such as the black-footed ferret, swift fox, coyote, ferruginous hawk, golden eagle, and prairie rattlesnake all largely or partly depended historically on the black-tailed prairie dog as prey. The ecological effects of prairie dogs on surrounding vegetation are exploited by the mountain plover, horned lark, various ground squirrels, and the grasshopper mouse. Their abandoned burrows are used by burrowing owls, horned lizards, spadefoot toads, tiger salamanders, spiders, and a variety of other invertebrates. Few if any other North American animals can claim so many coattail associates. However, coattail associations are dangerous. Recent surveys suggest there may now be only about four hundred square miles of active prairie dog colonies left between North Dakota and Oklahoma, with about half the total in Kansas, a quarter in South Dakota, and the rest roughly equally divided among North Dakota, Nebraska, and Oklahoma.

Having lived on the plains for seventy years, I have never seen one of its most charismatic and most endemic members, the black-footed ferret. I assumed it to be long vanished from North Dakota by the time I was old enough to know about such rare wildlife. There Teddy Roosevelt had helped solidify its infamous reputation by describing a case in which a ferret was supposedly seen fatally clutching the throat of a pronghorn fawn and "sucking its blood with hideous greediness." Roosevelt believed the ferret preyed on all manner of birds, snakes, and mammals but correctly judged that it was the archenemy of prairie dogs, by being able to follow them into their burrows. It is now well known that about 90 percent of a ferret's food comes from prairie dogs alone, making its ecological tolerance extremely narrow and one that is highly dependent on a large and stable prairie dog population.

Like the prairie dog and black-footed ferret, the story of the bison is a sad one indeed. Given an early estimate of some 50 to 60 million bison on the plains and prairies of central North America prior to European settlement, the situation for bison during most of the ninteenth century

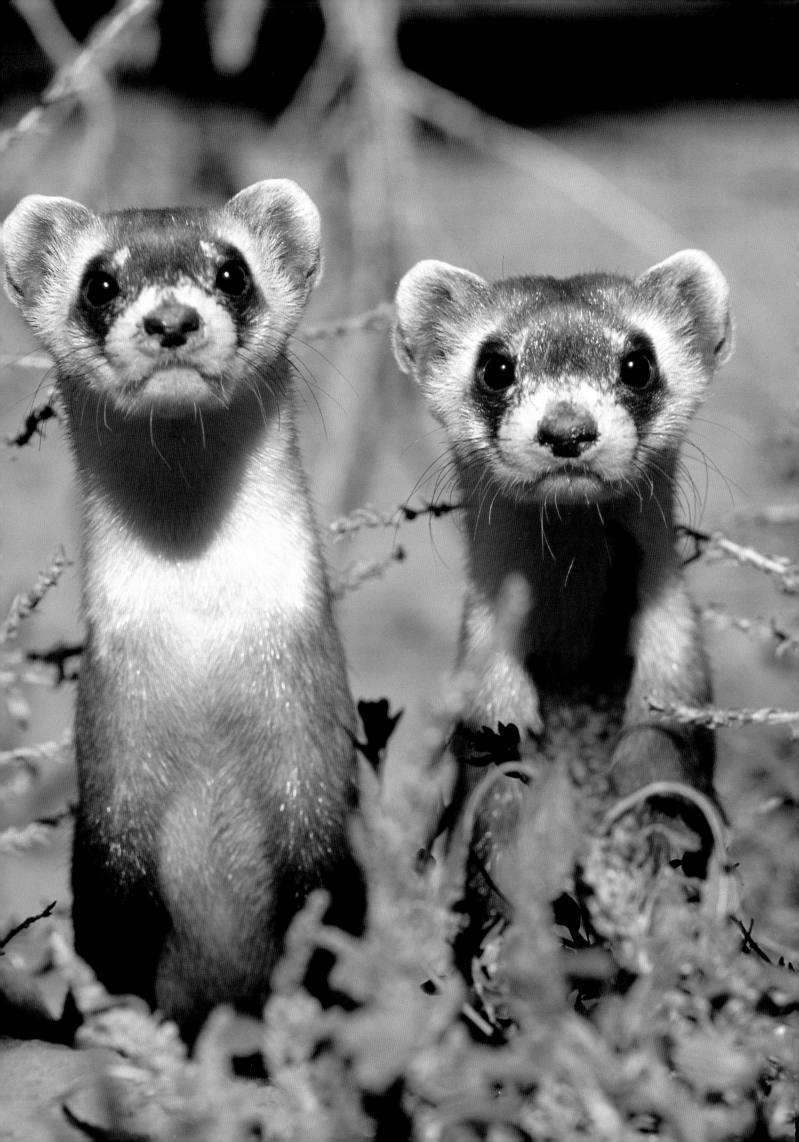

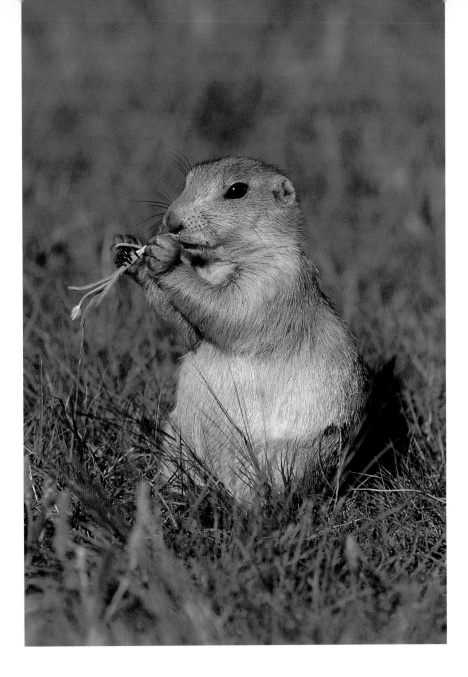

FIVE BILLION **BLACK-TAILED PRAIRIE DOGS** ONCE INHABITED APPROXIMATELY 250 MILLION ACRES OF THE GREAT PLAINS, BUT NOW THE SPECIES TEETERS ON EXTIRPATION IN MOST STATES. PRAIRIE DOG TOWNS PROVIDE HABITAT OR FOOD FOR MORE THAN ONE HUNDRED SPECIES OF ANIMALS, INCLUDING BLACK-FOOTED FERRETS, BADGERS, FERRUGINOUS HAWKS, AND BURROWING OWLS.

PREVIOUSLY FEARED TO BE EXTINCT, A SMALL POPULATION OF **BLACK-FOOTED FERRETS** WAS DISCOVERED IN WYOMING IN 1981. AS A RESULT OF CAPTIVE BREEDING, THEY ARE BEING REINTRODUCED INTO LARGE PRAIRIE DOG TOWNS IN SEVERAL STATES. HOWEVER, THE DECLINE OF PRAIRIE DOGS PLACES THE FUTURE OF FERRETS IN JEOPARDY.

was one of unparalleled genocidal destruction. Until the end of the Civil War in 1865 the rate of slaughter was perhaps still controllable, but after the war there was a ready availability of improved rifles and ammunition for the general public. The completion of the transcontinental railroad in 1869 effectively split the surviving herds in two and interrupted traditional north-south migration routes. The railroad also offered easy transport for bison hunters heading west and ready access to city markets for bison meat and hides being shipped back east. Although as late as 1871 a herd of 4 million animals still could be found in Kansas, it took only about a decade more to complete their eradication. The last few individuals surviving in the northern herd between Nebraska and North Dakota were gone by the late 1880s. Only a few hundred captive animals then survived south of Canada, some of which were owned and managed by Native Americans. Nearly all the plains bison existing today have been derived from these and from some Canadian animals.

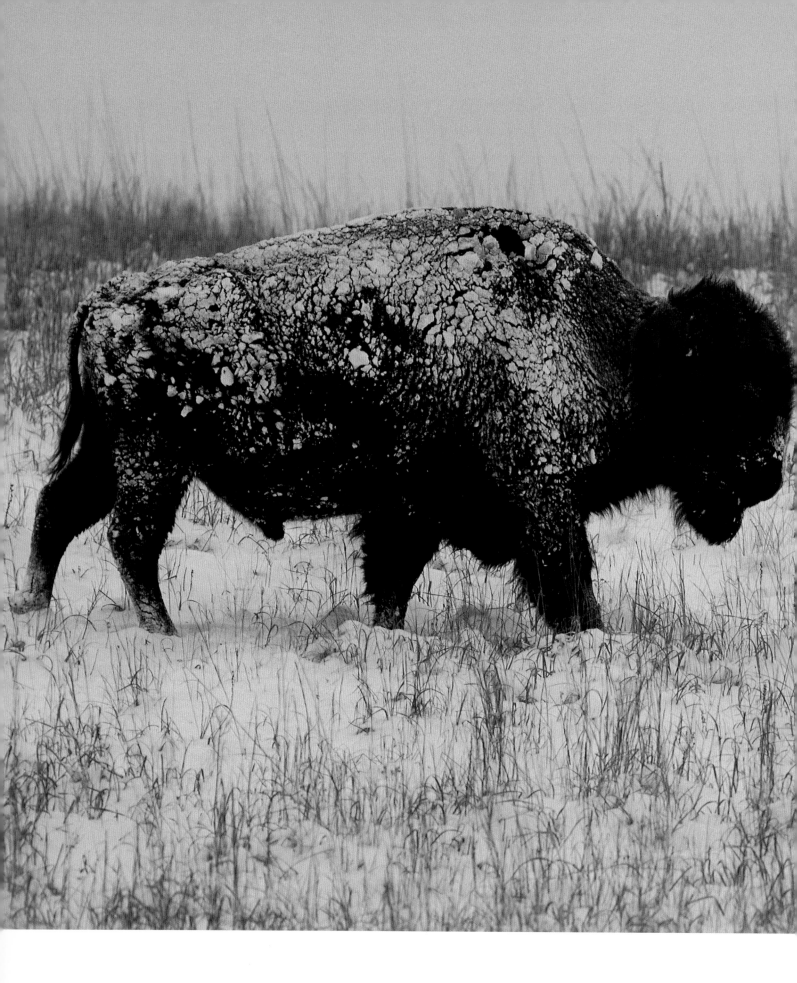

A LARGE **BISON** BULL MAY WEIGH ONE
TON. IN DEEP SNOW, A BISON WILL SWING
ITS MASSIVE, WOOLLY HEAD TO SWEEP
THROUGH SNOW UP TO THREE FEET DEEP
TO REACH THE GRASS BELOW.

Pronghorns are often called antelopes, but they share only distant affinities with the true antelopes of the Old World. They are exclusively a New World group, with only a single surviving species. Yet like some small African antelopes such as gazelles, pronghorns are born to run. It is as a result of outrunning prairie wolves or their evolutionary predecessors for uncounted millennia that every bone and muscle in a pronghorn's body has been shaped. Along with its long, slender legs, the pronghorn has also been endowed through natural selection with enormous eyes for excellent eyesight, large ears, and a fairly keen sense of smell. Their eyes are substantially larger than a human's, and the animals are reputed to detect people moving at a distance of two or more miles, but they tend not to pay attention to completely still objects. They are able to run at a speed of up to forty-five miles per hour for prolonged periods and for short periods may reach fifty miles per hour or perhaps even slightly more.

Compared with a coyote, the swift fox is minuscule. An adult may weigh from three to six pounds, compared with about six to eight for a red fox and thirty to forty for a coyote. One can imagine that it originally hung out around the kills of prairie wolves in the manner of present-day African jackals, hoping to find a few uneaten scraps of skin and sinew. No doubt ground squirrels, prairie dogs, rabbits, lizards, and nesting birds added to its diet as they were available. Probably it is still a complete opportunist in its foods; when grasshoppers are locally abundant even they might be eaten in large quantities. Partly because of their association with prairie dogs, and partly because of the ease with which they may be trapped, swift foxes are now among the rarest of plains mammals. They are very rare from North Dakota south through Nebraska. They are also rather rare but are still legally trapped in Kansas and in Oklahoma are confined to the panhandle. Release programs are under way in South Dakota and elsewhere, from Wyoming and Colorado sources, where populations are still believed to be secure.

Thirteen-lined ground squirrels are certainly one of the most adaptable of the Great Plains ground squirrels; they might just as easily be listed under the tallgrass or mixed-grass prairies. Mowed areas such as golf courses or city parks in the eastern plains states are among its favorite haunts, and such human influences may have allowed this ground squirrel to spread out and move from its shortgrass habitat into what were once tallgrass locations. Like the thirteen-lined, the Franklin's ground squirrel is now largely associated with disturbed habitats, such as railroad rights-of-way, cemeteries, and overgrown fields. It is larger and more robust than the thirteen-lined, but both species hibernate from midsummer through the winter months. Both are largely vegetarians, but thirteen-lined ground squirrels have been increasingly implicated as significant destroyers of eggs and small nestlings of ground-nesting birds during spring and early summer.

Amphibians

The only toad endemic to the Great Plains region is the appropriately named Great Plains toad. Like other American toads, it is large, slow, and seemingly content with a leisurely if not indolent approach to life. Earthworms and large insects are among its favorite prey. It is a fair-sized toad, growing to about four inches long, with many dark-greenish blotches that are outlined by cream or yellow, and its entire upper surface is covered by tiny wartlike growths. A pair of bony crests arise behind each eye, which merge to form a V and continue forward as a knob on the snout. It often is found well away from water, in grassy habitats, but it must return annually to ponds and pools for breeding. This occurs in spring and summer, the availability of surface water permitting. Like other toads, the male's throat is greatly inflated during chorusing, extending forward and reaching in front of the snout. The call is a harsh and pulsating chugging, with individual call sequences lasting thirty to fifty seconds. The eggs are laid and fertilized in water, and the tadpoles also must mature in water. As colder weather returns, the toads retreat underground for the winter.

THESE TOADS LIVE IN UPLAND PRAIRIES AND USUALLY REMAIN UNDERGROUND THROUGHOUT THE DAY. THEY EMERGE TO SEARCH FOR FOOD AT NIGHT. **GREAT PLAINS TOADS** RARELY LIVE AS LONG AS TEN YEARS.

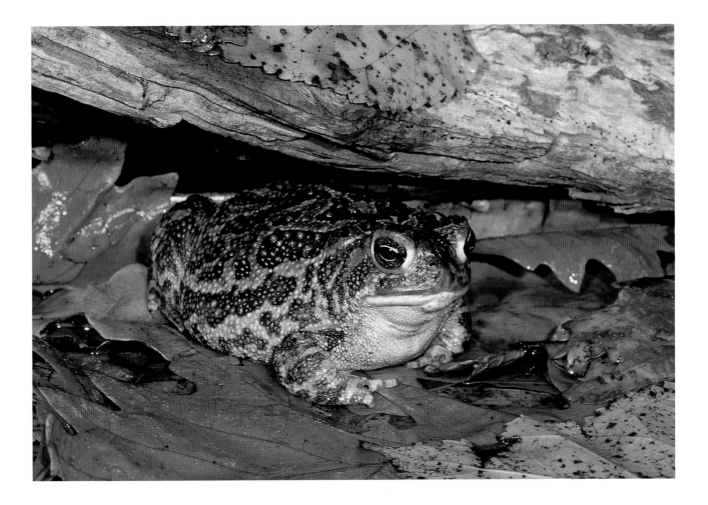

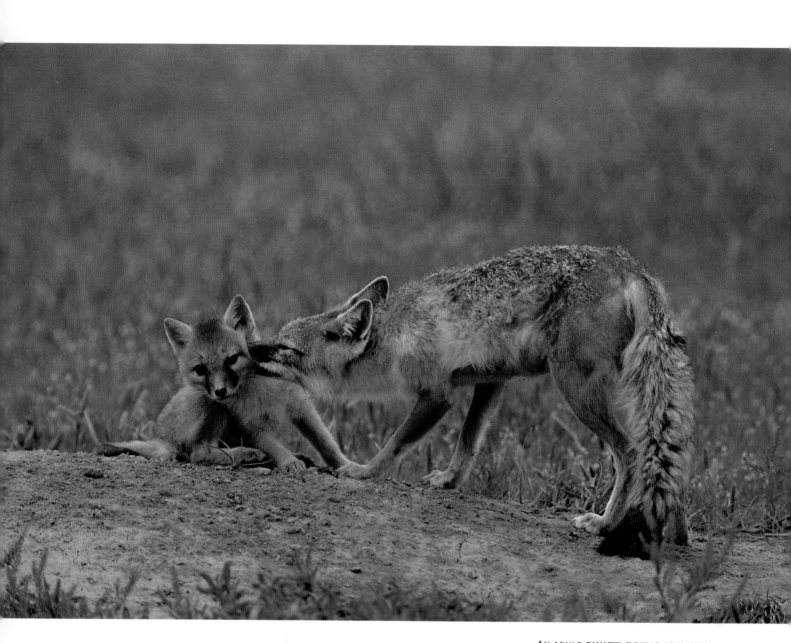

An adult **SWIFT FOX** is about the size of a house cat. Litters of three to six pups are born each spring. At three months, they begin hunting for small mammals, insects, lizards, and small birds.

Field Notes

Early one morning in late May, I followed a Wallace County, Kansas, landowner's pickup across the pasture. Harassment-free living and an abundance of thirteen-lined ground squirrels led to a unique photo opportunity with a family of swift foxes. Two adults and several kits scampered into the den as we approached. As the landowner returned to his fieldwork, I positioned my van and poked my telephoto lens through the camouflaged material hanging over the windows. As I waited I was entertained by the aerial displays of territorial lark buntings. Their singing was joined by horned larks, grasshopper sparrows, and western meadowlarks.

With no additional sighting by noon, I figured I was in for a long wait. I poured a drink, fixed a sandwich, and had taken two bites when a fox stuck her head out of the hole! The adult female, about the size of a long-legged cottontail, ventured out and was soon followed by four kits the size of small kittens.

During the next two hours I photographed the antics of the playful young. The kits seemed fascinated with their newly developed ability to chew. No item remained untouched as they gnawed on sticks, clods, grass, and one another's ears, feet, and tails. The kits were at the bounce-and-pounce stage. They were quite skillful at stalking and streaking in for a pounce on an unsuspecting cow chip.

The mother paid little attention to me but was quite attentive to the kits. She would pin one with her foot periodically and groom its ears and neck with her front incisors. While the foxes played, the clouds rolled in, and at 2:15 P.M. light rain sent them scurrying into the burrow. I returned to my now-dry sandwich. The rain stopped around 4:15 P.M., and they ventured out again. Over the next hour I shot another six rolls of film. I left as the sky turned deep purple, signaling the approach of a major storm.

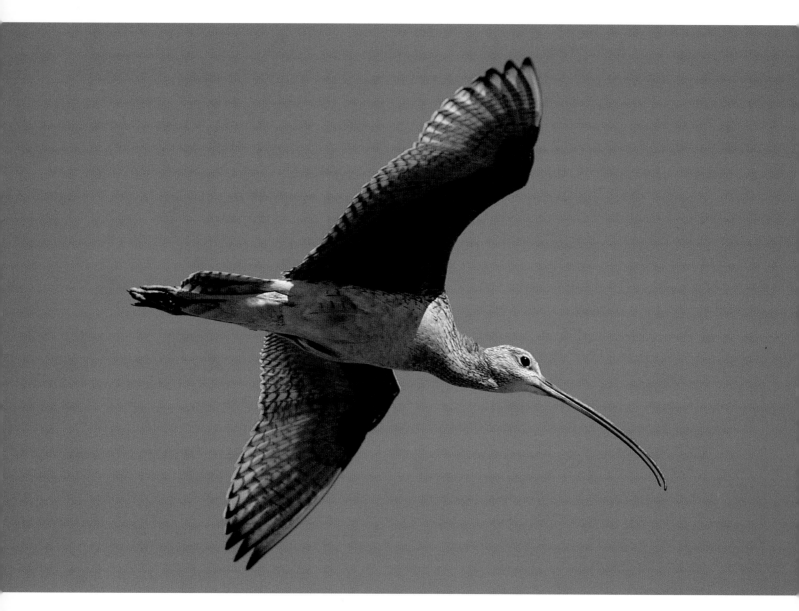

THE **LONG-BILLED CURLEW** IS THE LARGEST SHOREBIRD IN NORTH AMERICA. IN
FLIGHT ITS CINNAMON COLORED WINGPITS ARE CLEARLY VISIBLE. FEMALES' BILLS ARE
LONGER THAN MALES AND MAY REACH NINE INCHES IN LENGTH.

THE **LOGGERHEAD SHRIKE** IS A SONGBIRD THAT BEHAVES LIKE A BIRD OF PREY.
GRASSHOPPERS, BEETLES, RODENTS, AND SMALL BIRDS ARE CAPTURED AND OFTEN IM-
PALED ON THORNS OR BARBED-WIRE FENCES. THIS LARDER MAY BE AN ATTRACTIVE TRAIT
FOR A PROSPECTIVE MATE OR AN IMPORTANT SOURCE OF FOOD DURING HARD TIMES.

SANDHILLS
GRASSLANDS

Imagine a place in the Great Plains where the nights are so dark that almost every star in the visible universe can be seen and the evenings are so quiet that coyotes can be heard yipping from miles away. Visualize a land where the nearest grocery store or filling station may be fifty miles or more distant and where the sight of a billboard is sufficiently rare that one actually notices and reads it. Think of a place where the presence of old, discarded cowboy boots stuck upside down on a fence post may be the only sign of human influence and where a line shown as a road on a state highway map may represent nothing more than two narrow tracks in bare sand that disappear over the far hills without so much as the slightest hint that anything or anyone might exist at the other end. It is not a land for the fainthearted, for those in a hurry to be somewhere else, or for those unwilling to feel totally alone and self-reliant. It is a land, however, of gracefully bending horizons, of waving grass and shifting late afternoon shadows, of stunning sunsets, and of inner peace. It is called the Nebraska Sandhills.

Birds

The breeding birds of the Sandhills are so different from those of the adjacent dry prairies that upon entering this region, visitors may feel as if they have begun a new chapter in their ornithological memories. Suddenly, horned larks begin to flush from the roadsides, their white-edged black tails providing the only easy fieldmarks as to their identity. Loggerhead shrikes periodically decorate the telephone wires that parallel the main roads and occasionally branch off across the dunes toward some invisible ranch. Western meadowlarks sing persistently from yuccas, and western kingbirds flutter out from the low trees along creeks and wetlands. Sharp-tailed grouse scuttle off rapidly through the grasses, and grasshopper and vesper sparrows perch inconspicuously on low barbed-wire fences or tufts of little bluestem. Best of all, the whistles and screams of upland sandpipers and long-billed curlews proclaim that, yes, you really are back in the Sandhills, and all's right with the world.

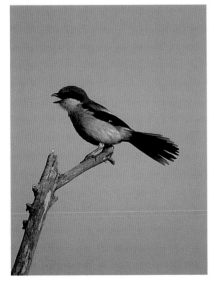

It is hard to imagine a more perfect symbol of the Sandhills than the long-billed curlew. At least in Nebraska it is unique as a breeding species to the Sandhills. Its plumage blends well with its dead-grass

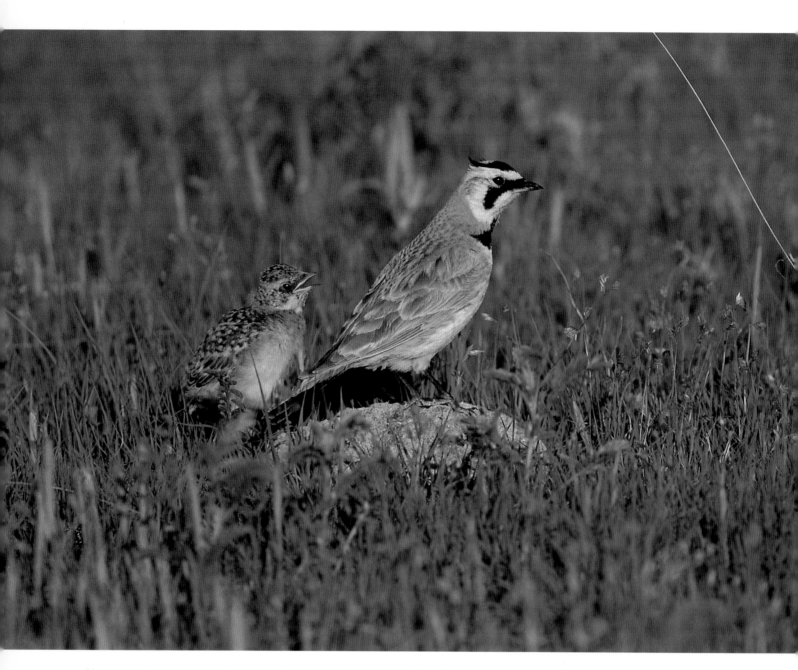

HORNED LARK NESTS ARE LOCATED IN A DEPRESSION ON BARE GROUND. THEY
CONSIST OF A SHALLOW CUP OF FINE GRASSES LINED WITH FEATHERS, HAIR, OR DOWNY
PLANT MATERIAL. AFTER THE CHICKS LEAVE THE NEST, THEY HOP ALONG BEHIND THE
ADULT, BEGGING FOR FOOD.

background and is nearly the same creamy buff-brown color of the local sand. It often stands conspicuously on dune tops or circles about in the sky, proclaiming ownership of a wide territorial domain, calling to mind the independent-minded Sandhills ranchers. No wonder the ranchers themselves most often choose it as their favorite bird, and the one they consider most symbolic of their region.

Over most of the plains states the horned lark is a widespread and fairly common breeder; in North Dakota it has even been judged to be the state's most common breeding bird, but in South Dakota it only ranks among the top fifteen species as to overall frequency of breeding occurrence. In Nebraska it is much less common in the east than in the west. Overall, it does not join the list of the state's top twenty breeding species, but any bird survey in the Sandhills will almost certainly show it to be that region's most common breeding bird. Yet most casual tourists are unlikely to notice the birds as they drive down Sandhills roads; their plumage so perfectly matches the color of sand that the birds are essentially impossible to see before they fly, and then they offer only a few seconds of viewing time before landing and again disappearing.

Loggerhead shrikes are the smallest of the Sandhills avian predators and were presumably named for their relatively large heads, which are associated with massive beaks and powerful jaw muscles, used in subduing and killing small prey. The genus *Lanius* is Latin for butcher, and butcher-bird is a fairly common vernacular name for the birds, too. Shrikes may impale their recently killed prey on a tree thorn or on the barb of a barbed-wire fence and leave it there temporarily until it is eaten. This curious trait is shared by no other group of birds and would seem to be of limited survival value except in situations where the prey is only periodically superabundant. Shrikes are easily the most raptorial of all North American songbirds, and wherever they occur around the world they are noted for their killing abilities. Their prey not only includes such expected targets as large grasshoppers and crickets but also extends to include very small rodents and small songbirds, especially nestlings.

Mammals

Grasshopper mice are certainly among the most attractive of our native mice; in addition to having a beautiful cinnamon pelage morph, they also have a gray version, thus being the only Great Plains mouse occurring in two quite distinct color types. They are also unusual among Great Plains mice in having a quite short tail and a distinctly stocky body, powerful jaw muscles, and long fingers and claws that are used in grasping their prey, mainly large grasshoppers. Although small mammals may at times also be attacked, invertebrates evidently constitute their primary diet.

If the grasshopper mice and pocket mice of the Sandhills can be considered cute, then the Ord's kangaroo rat goes one step beyond in achieving a maximum of babylike human features within a rodent's morphology. Their eyes are larger, their faces are more rounded, and their foreheads more bulging. Their hands are relatively much smaller than their hind legs, so they are more likely to stand erect in humanoid fashion, especially when holding food or stuffing it into their capacious cheek pouches. The lives and foods of kangaroo rats are similar to those of pocket mice. Because of their larger size and greater food requirements, they have larger home ranges, about three acres. Their density in very favorable habitats such as the Sandhills may reach up to twenty animals per acre. They are almost entirely nocturnal, as suggested by their huge eyes, and can easily hop for distances of as much as five feet, especially when frightened. They can also hop vertically, or even backward, when trying to escape a predator.

THE BODY OF A **BADGER** IS SUITED FOR LIFE UNDERGROUND. ITS LEGS ARE SHORT, ITS CLAWS LONG, AND ITS BODY SHORT AND FLAT. IT IS A FIERCE FIGHTER AND TYPICALLY DIGS UP A MEAL OF PRAIRIE DOG, GOPHER, GROUND SQUIRREL, OR SNAKE EACH DAY. THIS YOUNGSTER EXPLORES A PATCH OF PURPLE POPPY MALLOW.

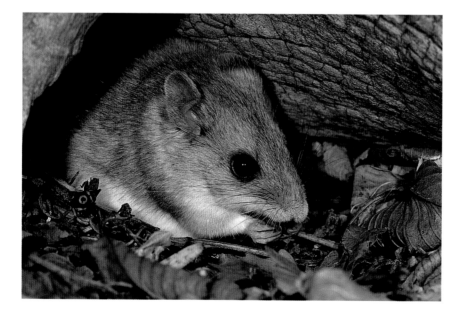

THE **NORTHERN GRASSHOPPER MOUSE** IS AN AMAZING RODENT WITH HUNTING TRAITS MORE INDICATIVE OF LARGE CARNIVORES. GRASSHOPPER MICE COMMUNICATE WITH A HOWLING VOCALIZATION EASILY HEARD BY HUMANS. THEY EAT INSECTS BUT OCCASIONALLY HUNT PREY MUCH LARGER THAN THEMSELVES. THEY KILL WITH A BITE THROUGH THE NECK AT THE BASE OF THE SKULL.

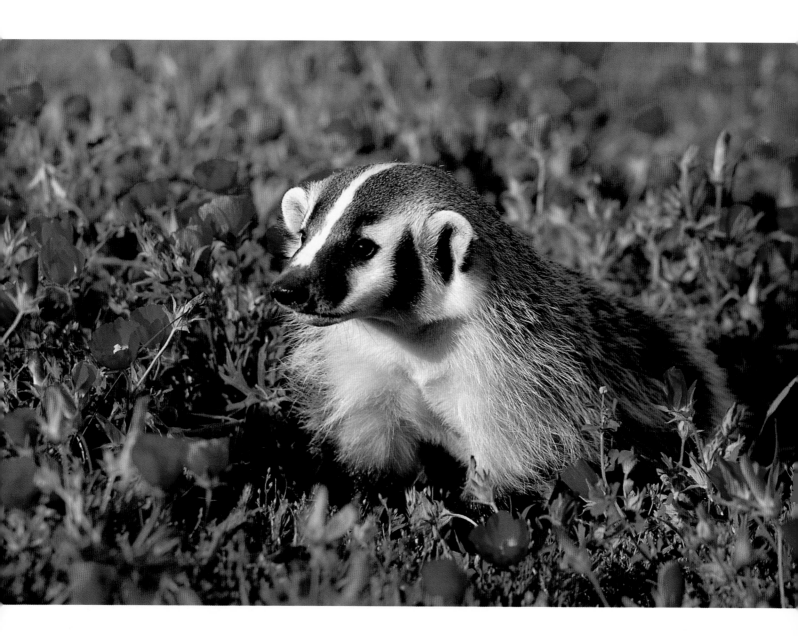

Named for its ability to run by hopping on its hind legs, the **Ord's kangaroo rat** is ideally built for its unique locomotion. With large feet, powerful hind legs, and a whiplike tail for balance it can usually scamper to safety. Other methods of defense include thumping its hind feet and kicking sand into a predator's eyes.

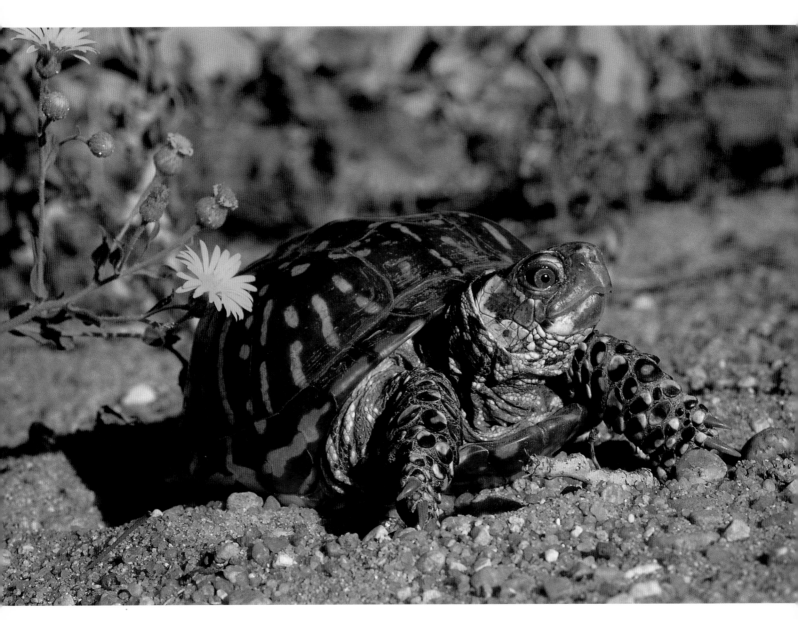

Bright red eyes are a trait of male **ORNATE BOX TURTLES.** Box turtles historically occurred throughout the Great Plains and were found in most prairie habitats. The illegal pet trade has seriously depleted their populations.

The **SIX-LINED RACERUNNER** is fast. It is a lizard of hot, dry, open areas and is frequently encountered along sandy roads. It is most active when temperatures exceed ninety degrees.

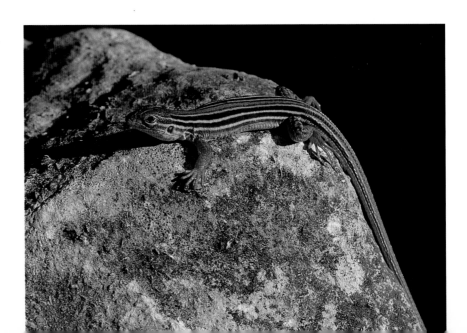

Reptiles and Amphibians

Ornate box turtles are easily the most approachable and perhaps most charming of our Sandhills reptiles. During the months of June and July especially, when males are on the lookout for receptive females, they are often quite literally on the road. Males are easily identified by their bright red, rather than brownish-yellow, eyes, and average slightly smaller than females as adults. Both sexes have an attractive pattern of yellowish spots and vertical streaks coursing down their dorsal shell, or carapace, looking as if they might have fallen asleep under a house painter who was careless about where his paint had dripped.

Although not as common as the box turtle or the ubiquitous bull snake in the Sandhills, the western hognose snake is certainly not rare, and it finds its preferred habitats in sandy areas where it can easily burrow in order to maintain an ideal body temperature. From Kansas south it is joined by the somewhat larger eastern hognose snake, which also favors sandy areas. All hognose snakes have curiously upturned snouts, which aids in their digging ability. Much of their food is obtained this way, during which they might expose hidden toads, the eggs of reptiles, or small snakes and lizards. Only mildly venomous, hog-nosed snakes have two enlarged teeth at the rear of the upper jaw, which help in deflating toads that have become enlarged with swallowed air as a defensive strategy. They also secrete fluids from their adrenal glands that quickly detoxify the powerful poisons produced by toads. Salamanders and frogs are sometimes also eaten, probably especially tiger salamanders.

It always seems strange to find tiger salamanders in the dry

THE SHARPLY UPTURNED SNOUT IS A CHARACTERISTIC OF ALL THREE SPECIES OF HOGNOSE SNAKES, INCLUDING THIS **WESTERN HOGNOSE SNAKE.** THEIR FAVORITE FOODS ARE TOADS, AND THEIR SNOUT IS AN EXCELLENT TOOL FOR UPROOTING BURIED PREY.

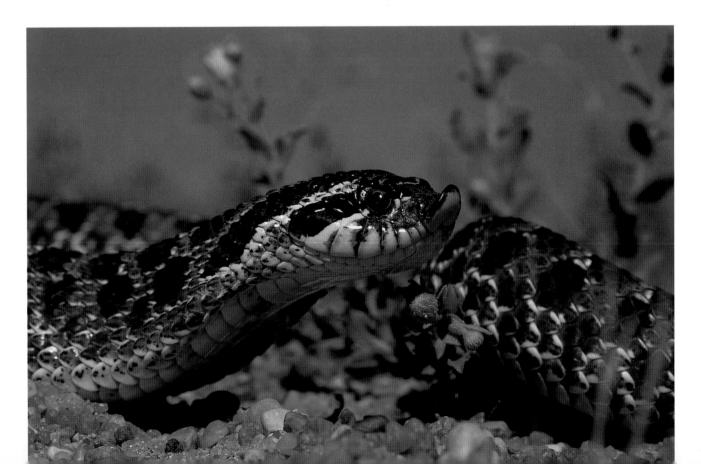

Nebraska Sandhills, but they are actually quite common there; and they extend into the even more arid shortgrass plains, where they occupy prairie-dog burrows. The Sandhills wetlands provide fine habitat for them and may help put them out of easy reach of many predators that are common on more solid substrates. The plains spadefoot toad also likes sandy soil, and with the aid of its hard spurs on its hind feet it is an effective digger. Both species winter below the ground surface and emerge with warmer weather and spring rains. Male spadefoots then gather around pools and call loudly, usually in grouped choruses. Their eggs are laid in irregular elongated clusters that often are attached to aquatic vegetation. On the other hand, tiger salamanders court in water, with mutual body-rubbing a significant part of their breeding activity. Single eggs or small clusters are laid, the female attaching them to various submerged objects. No parental care is given to the eggs or larvae by either species. Tiger salamanders typically require two years to become sexually mature, remaining as gilled larvae their first year. In some areas, where permanent water areas are available, they may even retain their gills into adulthood.

THE **BARRED TIGER SALAMANDER** GENERALLY SPENDS MOST OF ITS TIME UNDERGROUND AND IS RARELY SEEN. IT IS USUALLY ENCOUNTERED AT NIGHT AFTER HEAVY RAINS FLOOD ITS BURROW.

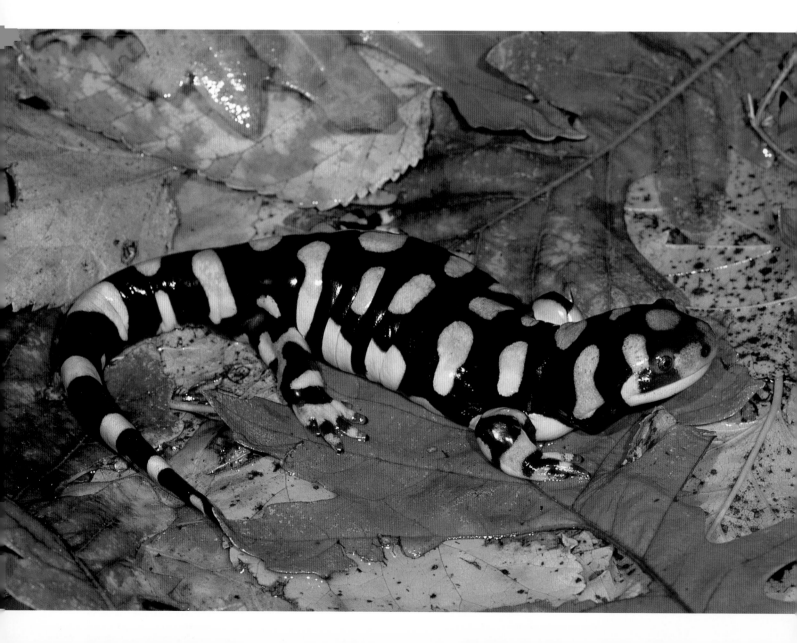

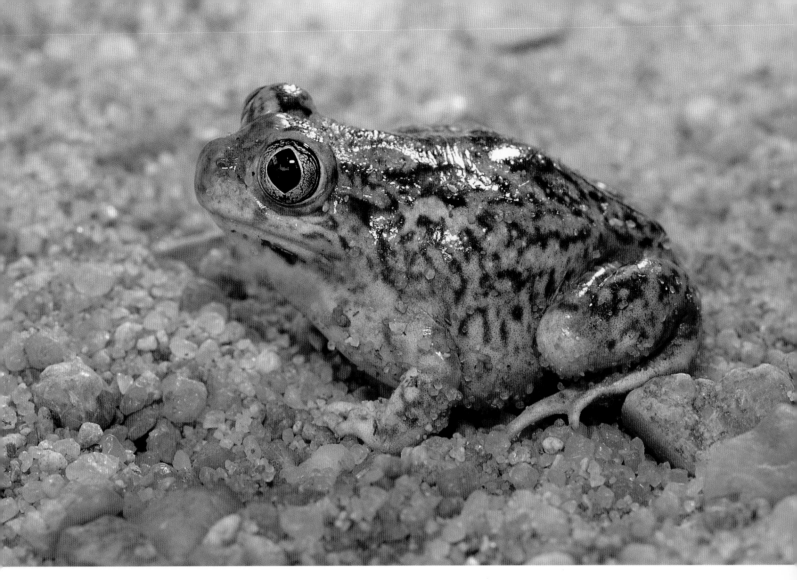

Found in areas of loose soil or sand, the **PLAINS SPADEFOOT** can quickly burrow out of sight using its hind feet, which are equipped with a black spur or spade. Its eyes become vertical slits when exposed to bright light.

The **BULLSNAKE,** also known as the gopher snake, is one of the largest snakes of the Great Plains. It hisses loudly when frightened and sometimes mimics a rattlesnake by wildly shaking its banded tail while making a clicking noise with its mouth.

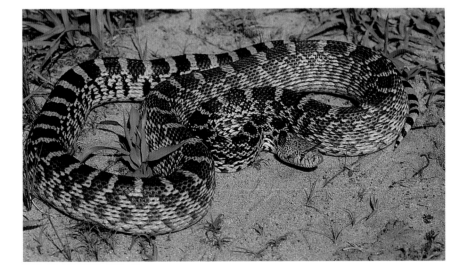

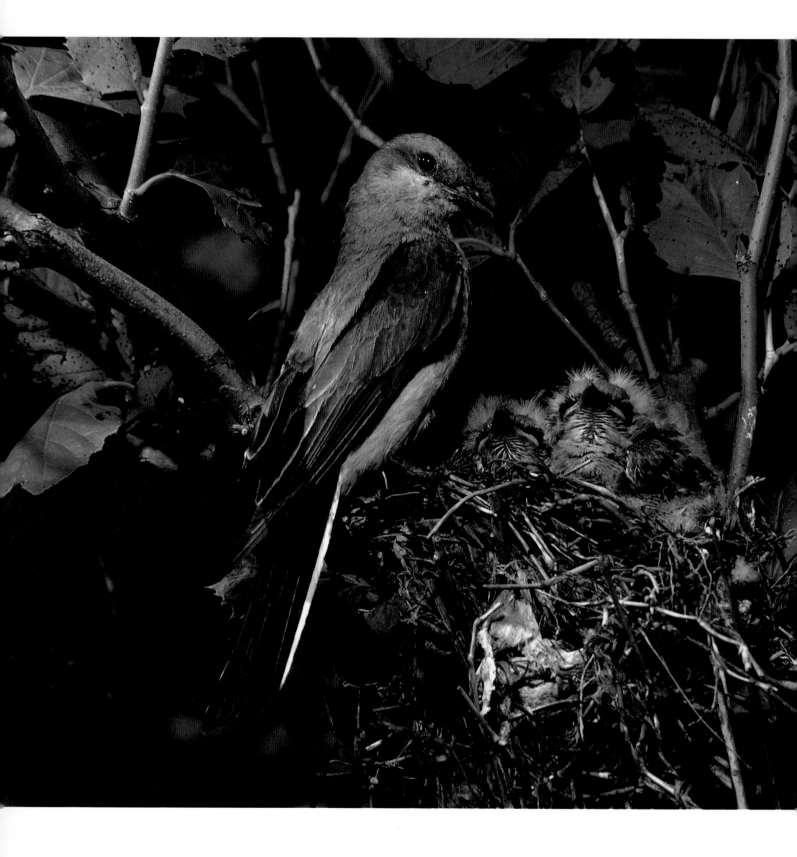

Field Notes

I located the nest of a western kingbird about ten feet up in a sycamore tree. Eight-feet-high scaffolding was erected about fifteen feet from the nest site. An observation blind constructed on the ground was placed on the scaffolding the following afternoon. I returned the next day and climbed into the blind to photograph the birds.

After several visits from the adult kingbirds to feed the growing chicks, a female house sparrow surprisingly appeared at the nest and scrutinized the begging young before disappearing. Moments later she returned with a small, green caterpillar and fed a nestling. Within five minutes she returned again and fed the young while an adult kingbird watched from a perch a few feet away. Between visits from the house sparrow, the parent kingbirds were making two to three visits to the nest with food.

The next day I watched as the kingbirds and the house sparrow fed the young. On one visit, a kingbird arrived with a rather large grasshopper. The house sparrow watched as the kingbird struggled to get one of the young to take it. The sparrow flew to the nest, grabbed the grasshopper from the kingbird, and both birds tumbled out of the tree. A few moments later the kingbird returned to the nest, and the house sparrow immediately attacked the kingbird from behind; then both flew off through the branches. For several more days the kingbird parents and the confused house sparrow supplied food for the growing young. With all this attention, the young kingbirds grew quickly and all successfully fledged.

WESTERN KINGBIRDS ARE COMMON AROUND CITIES, TOWNS, FARMS, AND RANCHES. THEY OFTEN MOB OR ATTACK HAWKS OR CROWS FLYING NEAR THEIR NESTS. THE KINGBIRD'S CROWN IS SELDOM SEEN, BUT CONSISTS OF A SMALL PATCH OF CONCEALED ORANGE-RED FEATHERS ON TOP OF ITS HEAD; THESE ARE EXPOSED DURING THREAT DISPLAYS.

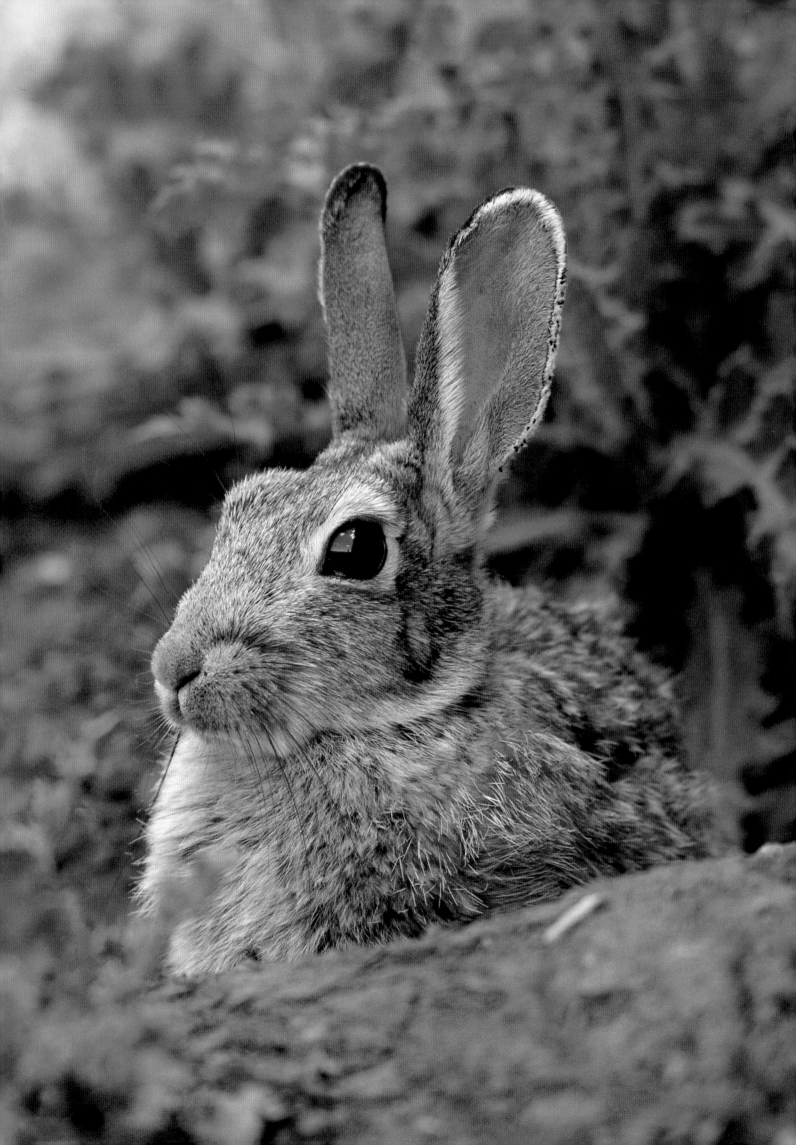

ARID
SHRUBSTEPPES

The sandsage grasslands community type of the southwestern Great Plains occurs locally as far north as extreme southwestern Nebraska. Yet it mainly extends from the sandy edges of the Arkansas and Cimarron valleys of southwestern Kansas and the adjoining region of Colorado south through the rolling plains of western Oklahoma and the northern panhandle of Texas to the Staked Plains arid semidesert grasslands along the border of northwestern Texas and southeastern New Mexico.

Farther north, in extreme western Nebraska, western South Dakota, and southwestern North Dakota, another type of sage-permeated brushland occurs. These are the communities dominated by big sagebrush and some lesser relatives, such as dwarf sage and long-leaved sage. Big sagebrush has one of the largest distributions of the North American shrubs, once covering roughly 150 million acres throughout the arid west. Over much of the region now associated with big sage, eroded canyon and bluff topography is typical. Glaciers never reached these places, and the work of wind and water over countless millennia has sculpted the landscape into eroded badlands of all types. Here bluffs or clifflike promontories above valleys or tablelands provide perches and nest sites for raptors such as ferruginous hawks, golden eagles, and prairie falcons as well as nesting crevices for smaller birds such as rock and canyon wrens, cliff and violet-green swallows, and white-throated swifts. Here too bobcats regularly prowl, and prairie rattlesnakes seek out rodents on warm summer nights. Then also the persistent calls of common poorwills echo through the canyons, as do the occasional notes of great horned owls. It is a time when sitting by a small campfire provides a special sense of contentment.

THE EARS OF THE **DESERT COTTON-TAIL** ARE SLIGHTLY LONGER THAN THE EASTERN COTTONTAIL. THIS MAY BE BENEFICIAL FOR HEAT DISPERSAL. THE COTTONTAIL PICTURED HERE RESTS AT THE ENTRANCE TO A PRAIRIE DOG TUNNEL. IT WILL QUICKLY RETREAT BELOW GROUND IF DISTURBED.

Birds

In early April 2001 a small group of us set out late in the afternoon for a lek about ten miles southwest of Garden City, Kansas, where eighteen to twenty male lesser prairie-chickens had regularly displayed, in order to set up some blinds before nightfall. The next day we arrived early at the lek about 6:00 A.M., almost an hour before sunrise. The males were already present on the display ground, calling in a way that

THE HANDSOME MALE **GREATER SAGE-GROUSE** SPREADS HIS TAIL AND STRUTS
ABOUT WITH LARGE, INFLATED, PENDULOUS THROAT POUCHES. WITH A BOUNCING MOTION
HE RELEASES THE AIR WITH A POP, AND THE POUCHES MOMENTARILY DEFLATE. AS MANY AS
TWENTY TO SEVENTY BIRDS DISPLAY ON THEIR ANCESTRAL LEKS.

I might not have even recognized as coming from prairie chickens if I hadn't already heard recordings of their calls. As darkness gave way to dawn, it was evident that nearly twenty males were present. They paid almost no attention to the blinds, except when camera sounds startled them. Their performance struck me as something resembling the choreographed drama of the greater prairie-chicken, but this was being performed in an entirely distinctive manner and on a very different ecological stage. The birds' movements were surprisingly fast, their aggressive cacklings unusually high-pitched. The repeated threats made by the males at their territorial boundaries were apparently mostly bluffs, and in contrast to greater prairie-chickens' behavior, I never saw an actual fight.

In the same way that the lesser prairie-chicken is a kind of trademark species of the sandsage, the sage grouse is the counterpart species of big sagebrush. Like that of the lesser prairie-chicken, the distribution of sage grouse is correlated exactly with that of a sage species, big sagebrush, and this plant, plus its very near relatives, provides an even higher percentage of the sage grouses' year-round food requirements. The range of the sage grouse once approximated that of big sagebrush, or nearly 150 million acres, but in recent decades the distributions of both have become greatly retracted, and sage grouse now enter the Great Plains states only in extreme southwestern North Dakota and western South Dakota.

THE REDDISH THROAT SACS OF THE MALE **LESSER PRAIRIE-CHICKEN** DISTINGUISH IT FROM THE GREATER PRAIRIE-CHICKEN. THE RANGE OF THIS BIRD HAS SHRUNK DRAMATICALLY IN RECENT YEARS, AND TODAY IT IS FOUND ONLY IN RESTRICTED AREAS OF KANSAS, COLORADO, OKLAHOMA, TEXAS, AND NEW MEXICO.

In their social behavior, greater sage-grouse somewhat resemble lesser prairie-chickens, in that a lek-based breeding system exists in which males directly compete, gladiator-like, in an arena for determining sexual access to females. However, in the greater sage-grouse, lek sizes in healthy populations may average fifty or more males, rather than the ten to twenty birds more typical of lesser prairie-chickens. With the greater competition among males in such large groups, it should not be surprising that serious fights are more frequent and more intense, and the overall effects of sexual selection are more clearly apparent in sage grouse. Not only are the males extremely large, but they also average almost twice the weight of females, as compared with a nearly even adult-weight ratio in lesser prairie-chickens. Furthermore, the genetic payoff for alpha males is greater in sage grouse than in prairie chickens, for a dominant male sage grouse might easily fertilize nearly all the females in a lek of fifty or more males during a single spring. He is thereby passing on his own specific genes to much of the local population in the next generation, assuring that genes for large male size, virility, and social dominance will continue to be perpetuated. Male sage grouse may sometimes be attacked by golden eagles while displaying on the lek, but even a female golden eagle would have a hard time carrying one off.

The first nest of a golden eagle that I ever climbed to was on a mountain ledge overlooking a vast area of wetland tundra in the Kuskokwim River delta of western Alaska, only a mile or so from the edge of the Bering Sea. It was mid-June, and two well-grown young were in the nest. The floor of the nest was littered with the remains of willow ptarmigans and snowshoe hares. From the nest one could see nothing but flat tundra to the very horizon toward the east and south, the greatest waterfowl breeding area in all of North America. Golden eagles have enormous home ranges, up to one hundred square miles, within which no jackrabbit can ever feel secure. Like buteo hawks, the birds may circle silently on their broad wings for hours on end, their keen eyes evidently able to detect prey from heights of one thousand feet or more, then plunge down in a dive almost as impressively steep as that of a peregrine falcon and with equally deadly results. Their two-inch-long rear talons can penetrate to the vital organs of even quite large mammals, and a large female eagle weighing ten pounds or more will not hesitate to take on a six-pound mammal such as a large jackrabbit.

All the members of the nightjar family have powerful abilities to stir the imagination with their nocturnal songs and their abilities to remain essentially invisible in broad daylight, and the common poorwill is no exception. I heard them singing in rocky canyons during all the

THE **GOLDEN EAGLE** IS THE MOST WIDESPREAD EAGLE IN THE WORLD AND IS FOUND IN OPEN HABITAT THROUGHOUT THE WESTERN GREAT PLAINS. IT SEARCHES THE OPEN PRAIRIES FOR JACKRABBITS, PRAIRIE DOGS, AND GROUND SQUIRRELS.

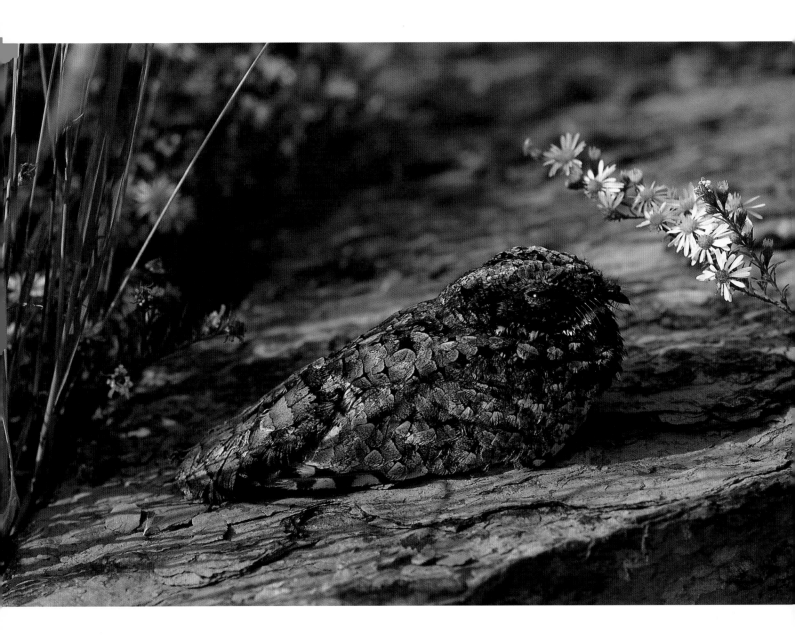

THE **COMMMON POORWILL** CAN BE
HEARD ON CALM NIGHTS MAKING ITS
"POOR WILL" CALL IN THE ARID HABITATS
WHERE IT LIVES. WHILE IT SITS ON
COUNTRY ROADS, ITS EYES SHINE PINK
FROM REFLECTED HEADLIGHTS. IT IS THE
ONLY NORTH AMERICAN BIRD KNOWN TO
HIBERNATE.

seventeen summers that I taught at our field station in western Nebraska, but I never actually observed a live bird there, save for a few that momentarily appeared as they fluttered up mothlike in the glare of my car's headlights when I drove up dusty roads during ink-dark nights.

It is now known that at least some common poorwills hibernate in rock crevices during the colder months, a trait otherwise virtually unknown among North American birds. The first individual found in this remarkable condition was determined to use the same resting niche every winter for four successive winters. Very few such torpid birds have ever been found in the wild, but captive birds can be induced to enter a state of torpidity. In one case it was determined that a ten-gram fat deposit would support a torpid poorwill for one hundred days.

In essentially the same habitats that common poorwills and golden eagles prefer, rock wrens are likely to be found. I remember finding the nest of a rock wren at the foot of Courthouse Rock, a large and historic monolith located adjacent to Jail Rock and near the North Platte River of western Nebraska. The nest was placed in a seemingly natural crevice amid fallen rocks, its entrance marked by a distinctive pavement of small pebbles located around the opening in the rocks. Although reminiscent of the bits of dried cow dung that often mark the entrance of a burrowing owl's nest burrow, these pebble accumulations are of less certain function. Perhaps they help make the entrance somewhat smaller and harder for rodents or other animals to enter, or possibly they provide a landmark in helping the adults locate the nest among the rubble. It is unlikely that they simply accumulate as the inner nest chamber is cleared of debris, since some materials are clearly brought in; and in one remarkable case mentioned in Bent's life histories, over sixteen hundred items were present, including almost five hundred small stones of quite uniform size.

Cassin's sparrow is one of those essentially southwestern grassland species that periodically and unpredictably invades the central plains states, nesting with some regularity as far north as southern and western Nebraska. But its primary habitat is the mesquite grassland region of western Texas. In dense mesquite cover the birds are more likely to occur in edge areas, using dense cover as refuges but foraging in more open grasslands. The Cassin's is a large, rather pale sparrow, somewhat like the vesper sparrow in its attraction to dry sites; and also like the vesper sparrow, its outer tail feathers are mostly white, providing a useful fieldmark in flight.

Although few residents of the Great Plains might claim familiarity with a Cassin's sparrow, probably all would recognize a greater roadrunner at first sight. It is difficult to separate the actual living road-

ROCK WRENS ARE COMMONLY HEARD
SINGING IN ROCKY HABITATS OF QUARRIES, CLIFFS, AND CANYONS. SOME MALES
SING MORE THAN ONE HUNDRED DIFFERENT SONG TYPES.

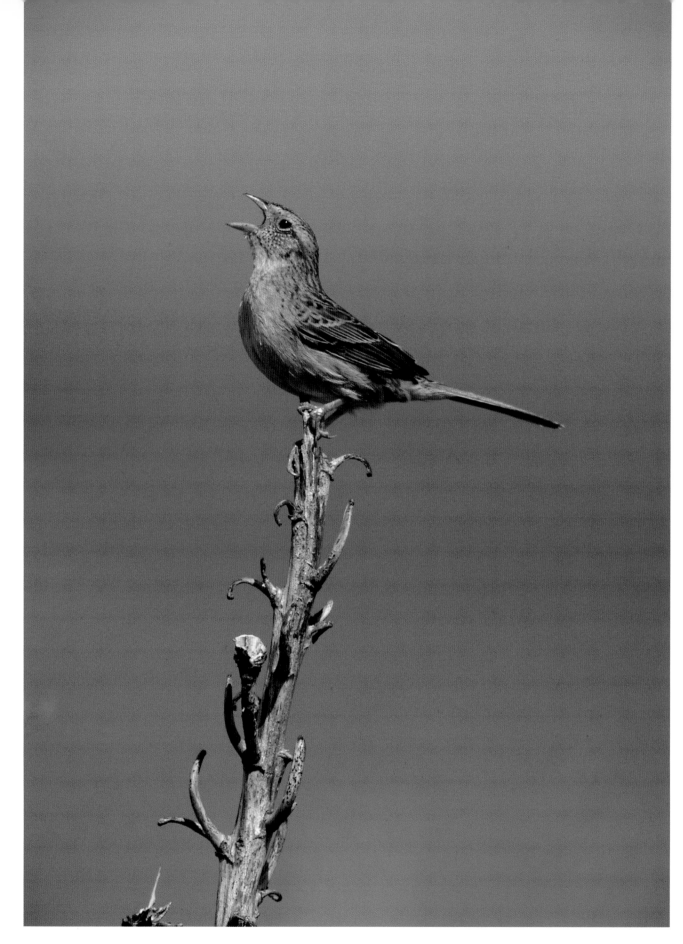

CASSIN'S SPARROWS OCCUR IN LOOSE COLONIES ON THEIR BREEDING GROUNDS. TERRITORIES ARE ADVERTISED BY AERIAL DISPLAYS AND SINGING FROM EXPOSED PERCHES LIKE THIS DRIED YUCCA STALK. THE FLIGHT SONG CONSISTS OF A DESCENDING, LIQUID TRILL GIVEN AS THE BIRD SETS HIS WINGS AND DRIFTS SLOWLY BACK TO A PERCH.

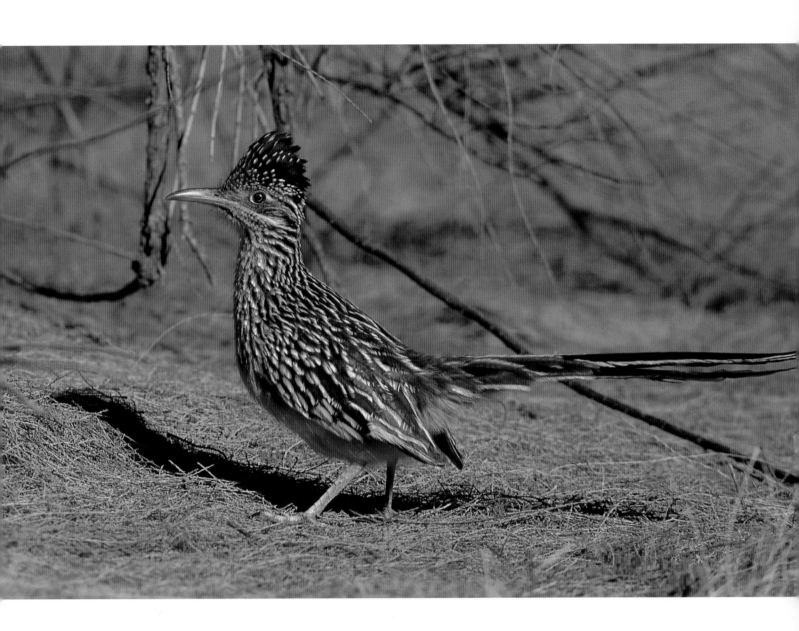

runner from its cartoon equivalent, for Americans raised on television during the past several decades can tell you all about the lifelong enmity between roadrunners and coyotes, even if they might be unable to identify a living representative of either. Yet greater roadrunners are at least as fascinating as the cartoon version, although the birds rarely if ever run full speed down the middle of roads. They are, however, great runners, an especially useful trait for chasing and catching small lizards or snakes. Attempts to measure the species' top running speed have resulted in estimates of about fifteen miles per hour for distances of about three hundred yards. The famous Oklahoma ornithologist George Sutton once judged that for short periods the birds can reach eighteen miles per hour, or about the average maximum top running speed of an adult human. Professor Sutton also once watched two captive roadrunners fighting over a cotton rat they had collectively managed to kill after a prolonged struggle. In true Solomonic fashion, Sutton finally cut the rat in two and let each have half.

THE **GREATER ROADRUNNER** IS A MEMBER OF THE CUCKOO FAMILY AND IS FOUND IN THE SOUTHERN PORTIONS OF THE PLAINS. IT IS KNOWN FOR ITS PREFERENCE FOR RUNNING RATHER THAN FLYING. IT USES ITS LONG TAIL FOR BALANCE AS IT RUNS DOWN LIZARDS, INSECTS, RODENTS, YOUNG BIRDS, AND SNAKES.

Mammals

Pocket mice lack the slim body shape of the white-footed and harvest mice or the stocky build of grasshopper mice. Instead, they have all the charm of a Walt Disney creation. Their bulging eyes, large head, long tail, and tiny forelegs make them appear more like a creature from a cartoon than a real animal. Like kangaroo rats, their favorite habitats are sandy, dry ones, where they can easily dig and where seeds can be collected and kept for long periods without danger of becoming wet and moldy. They make nightly excursions out of their burrows to find small seeds, which they stuff into their fur-lined cheek pockets as rapidly as possible, and then they hightail it back to their burrows to deposit their treasures in seed caches. Like kangaroo rats, their hind legs are relatively long, so their common mode of locomotion is by hopping, at least when they are in a hurry. The long, tasseled tail probably provides a useful counterbalance for such locomotion. By day, the naturalist will find only a few tiny footprints to mark their passing.

HISPID POCKET MICE ARE SOLITARY AND LIVE IN A VARIETY OF HABITATS ASSOCIATED WITH GRASSES. THESE MICE DO NOT DRINK WATER BUT ACQUIRE THEIR MOISTURE FROM SEEDS, GREEN VEGETATION, AND INSECTS THEY CONSUME. THEY USE THEIR FUR-LINED CHEEK POUCHES TO TRANSPORT SEEDS TO UNDERGROUND FOOD CHAMBERS.

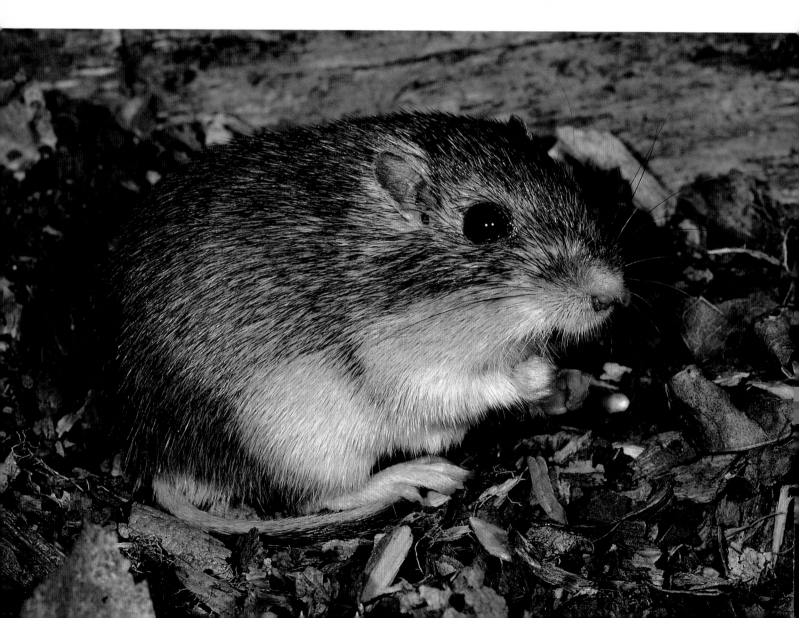

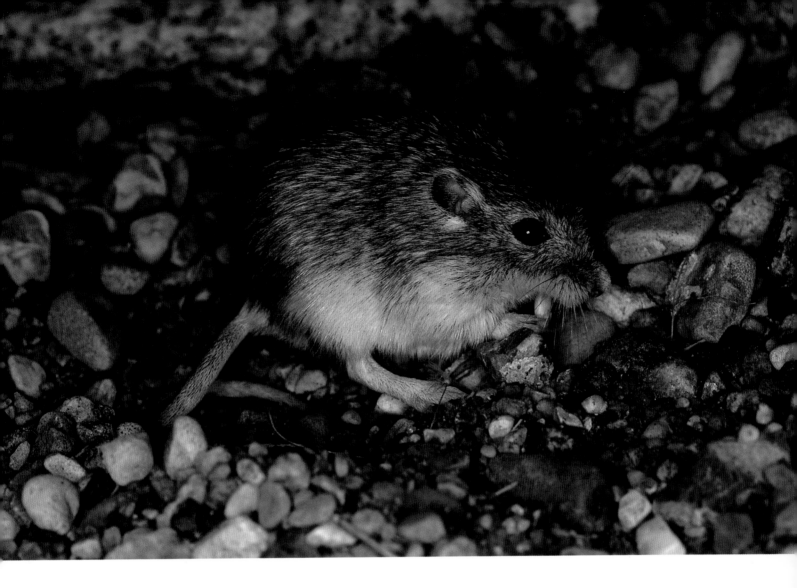

The hispid pocket mouse is one of several species of pocket mice that are common in many parts of the Great Plains, especially in sandy substrates, where burrowing is easy. Like other desert- and grassland-adapted mice, pocket mice are the mammalian counterparts of the grassland sparrows. Also like the grassland sparrows, pocket mice are often almost identical in appearance and size, with only minor differences in their ecologies to help reduce competition among them. Most weigh only about half an ounce, and all have long tails, large heads, small ears, and fur-lined external cheek pouches that can hold a substantial number of seeds. The pelage color of all species closely matches their environmental backgrounds, sometimes making identification especially difficult.

The olive-backed species is part of a group of pocket mice called "silky-haired," which also includes the plains pocket mouse and silky pocket mouse, and these three very similar species have overlapping ranges in the central and southern Great Plains. The olive-backed and silky are most likely to be found in arid prairies, scrub deserts, or even scrubby woodlands where the soil is loose and sandy. The plains

LITTLE IS KNOWN OF THE NATURAL HISTORY OF THE **OLIVE-BACKED POCKET MOUSE** SINCE MAMMALOGISTS SELDOM ENCOUNTER IT. LIKE OTHER POCKET MICE IT REQUIRES SANDY SOILS IN WHICH TO SAND BATHE. THIS DUSTING BEHAVIOR REMOVES EXCESS OILS FROM ITS FUR.

pocket mouse ranges from mixed-grass habitats to grainfields and weedy areas. The hispid ranges from mixed-grass prairies to more arid shortgrass habitats, especially where a substantial amount of bare ground may be present.

The hispid pocket mouse is named for the rather bristly appearance of its longer black outer hairs that contrast with an otherwise more generally yellowish pelage. Hispid pocket mice are the largest of the several species of Great Plains pocket mice, ranging up to nearly two ounces as adults, or as much as four times heavier than the smallest species, the silky. Over most of the year the animals live exclusively on seeds, but in spring insects may constitute up to 15 percent of the total food intake. The seeds are selectively chosen and stored, so that over the long winter months the animals rarely if ever need to venture out. Then their burrows are kept plugged with earth most of the time, keeping out at least some potential predators. They may also become dormant in hot, dry weather, although they are not believed to require free-standing water at any time.

The silky is the smallest of the Great Plains pocket mice and at least in some favored areas may attain densities of up to 150 per acre but more often are fewer than 25 per acre. Home ranges may vary from about 0.1 to 0.25 acre and are flexible, depending on resources.

Reptiles

When clambering about rock faces in search of rock wren nests or other rock-inhabiting wildlife, it is always good to be very careful not to put your hands in places that cannot be clearly seen. There are few sounds more disconcerting than the sudden buzz of a rattlesnake coming from some nearby but uncertain location. It is a sound that must be equally frightening to many other species, as rattlesnake mimics include not only some nonvenomous snakes that shake their tails vigorously in defense but also burrowing owls, which, when trapped in a burrow, will utter similar notes. And some insects or their pupae produce surprisingly similar rattling sounds when they are disturbed.

The diamondback is the largest of the Great Plains rattlesnakes, reaching maximum lengths of nearly ninety inches, compared to about seventy inches in the timber rattlesnake, forty-five inches in the prairie rattlesnake, and thirty-five inches in the massasauga. In central and eastern Oklahoma it occurs in some of the same locations as the timber rattlesnake, but it extends farther west and is more likely to occur in rocky or mountainous habitats, such as the Wichita Mountains and Gypsum Hills. Instead of the black tail of the timber rattler

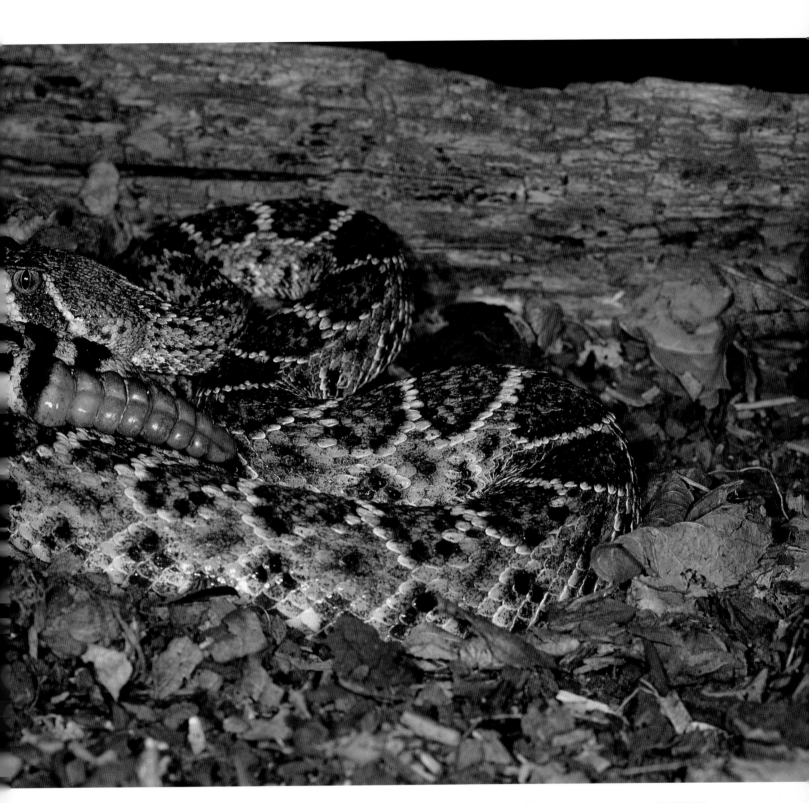

THE **WESTERN DIAMONDBACK RATTLESNAKE** DOES NOT OCCUR NORTH OF OKLAHOMA. THESE SNAKES CAN REACH LENGTHS OF OVER SEVEN FEET. THE DIAMONDBACK IS RESPONSIBLE FOR MORE FATAL SNAKEBITES THAN ANY OTHER NORTH AMERICAN VENOMOUS SNAKE.

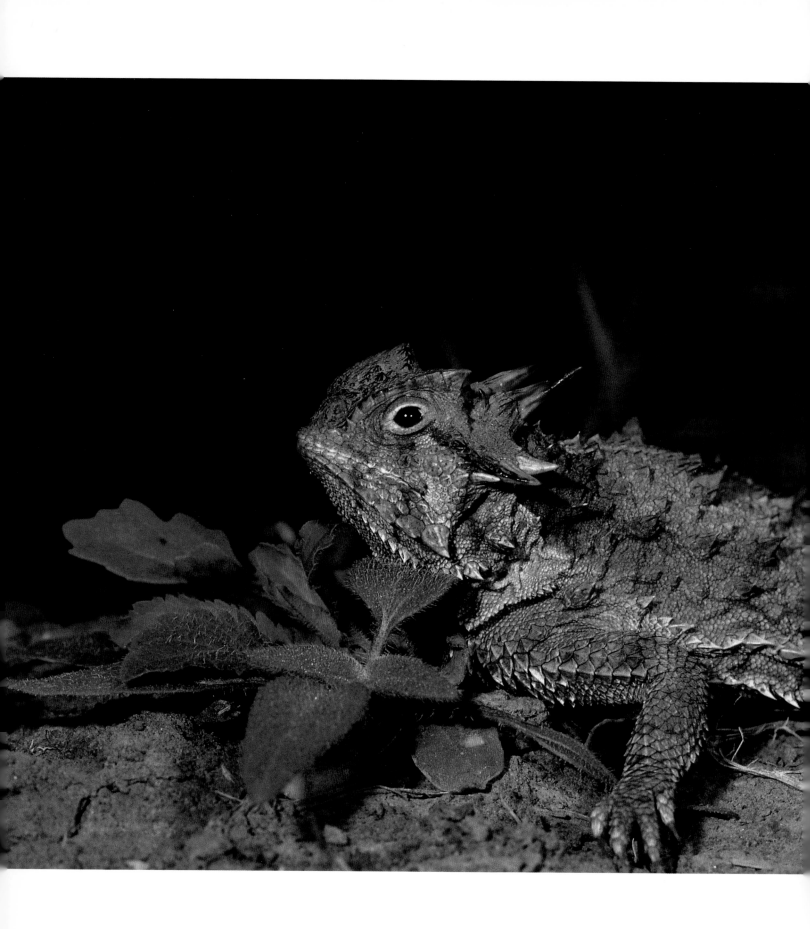

or the banded gray and brown tail of the prairie rattlesnake, the diamondback's tail is pale gray to whitish, with black rings.

Like roadrunners, horned lizards are the stuff of legends. Stories of the animals shooting blood out of their eyes are at least part of the animal's strange folklore, and in this instance it is actually the truth and not a myth. When disturbed, the lizard's head develops a higher temperature than the rest of its body, and the slightest pressure will cause blood vessels around the eyes to burst, producing a small stream of blood that may at times be squirted forward. It is thought that this behavior might serve as a distraction or a defense, but it has also been observed that such behavior has not prevented a coyote from consuming the animal after first licking away the blood. However, its generally spiny integument may have some protective function and certainly adds to its grotesque appearance. Regrettably, this animal's strange appearance also makes it a visually appealing pet, but horned lizards are very difficult to keep alive in captivity, and such attempts should be discouraged.

THE **TEXAS HORNED LIZARD** HAS A SPECIAL APPEAL TO MANY PEOPLE. IT ALSO POSSESSES SOME BIZARRE TRAITS. DURING TIMES OF STRESS, BLOOD VESSELS IN THE CORNERS OF ITS EYES MAY RUPTURE, AND THE LIZARD CAN SQUIRT BLOOD SEVERAL FEET.

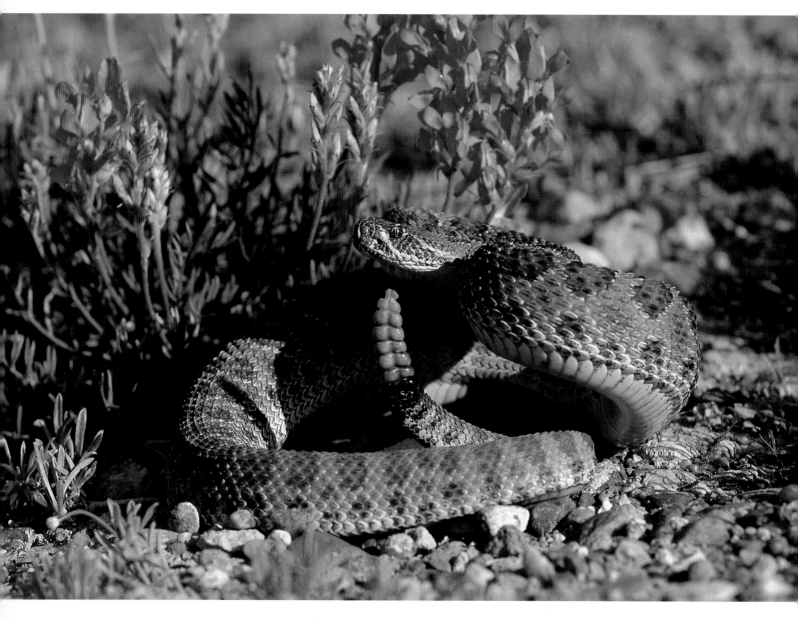

THE **PRAIRIE RATTLESNAKE** IS ALSO KNOWN AS THE WESTERN RATTLESNAKE. IT IS FOUND IN OPEN PRAIRIES AND ROCKY CANYONS THROUGHOUT MUCH OF THE ARID, WESTERN GREAT PLAINS. A NEW RATTLE IS ADDED EACH TIME THE SNAKE SHEDS ITS SKIN. TWO TO FOUR RATTLES ARE USUALLY ADDED EACH YEAR.

Field Notes

I'd stopped to photograph a ferruginous hawk perched on a limestone fence post at the Cimarron National Grasslands in southwest Kansas. I managed one frame before the hawk flew off. Movement caught my eye as I spotted a snake a short distance off the road. As I approached, the snake coiled and the rattling sound made identification easy. The prairie rattlesnake, also known as the western rattlesnake, can have an attitude. Most snakes would rather flee than fight, but the pugnacious rattlesnake is confident in taking a stand against the largest of threats, including photographers. For most reptile photographs I prefer to use a close-up lens. For rattlesnakes, however, the telephoto lens seemed to make more sense as I gave him due respect.

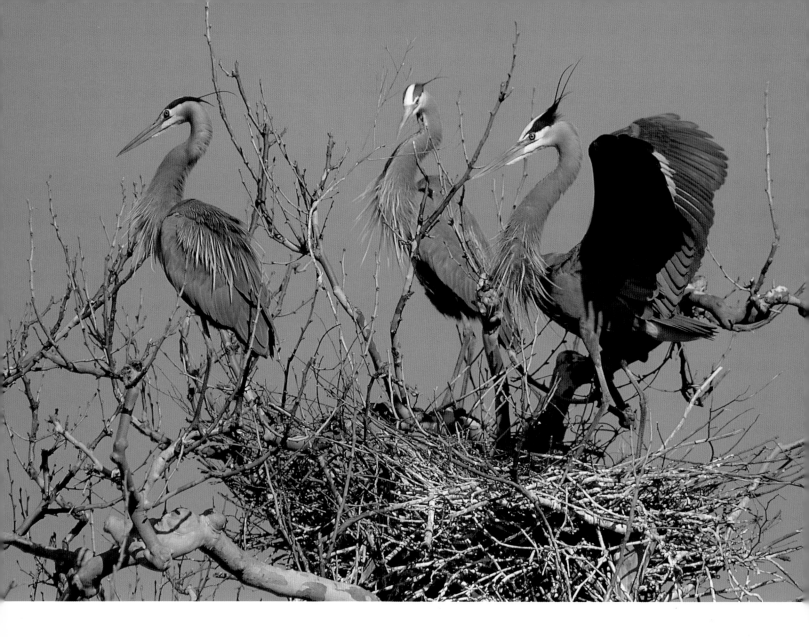

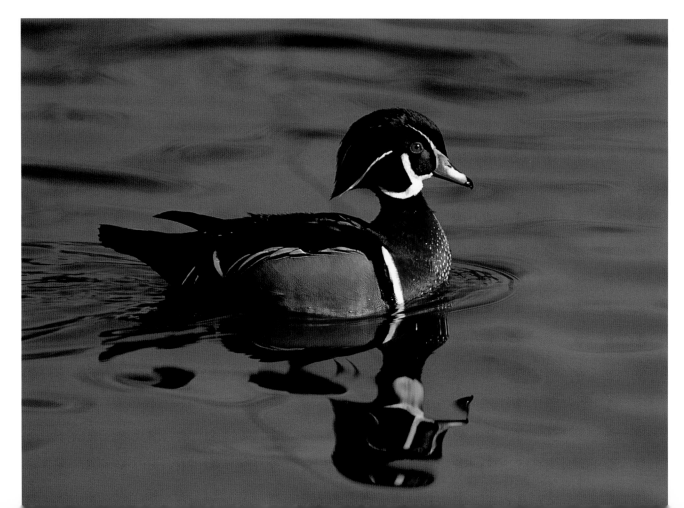

RIVERINE AND UPLAND FORESTS

COLONIES OF NESTING **GREAT BLUE HERONS** OFTEN INCLUDE TEN TO FIFTY NESTS LOCATED IN LARGE COTTONWOOD OR SYCAMORE TREES. BREEDING BIRDS ARRIVE EARLY IN THE SPRING. SOME BIRDS ATTEMPT TO STEAL STICKS FROM ADJACENT NESTS. MATED PAIRS DEFEND THEIR NEST FROM INTRUDERS WITH JABS FROM THEIR LONG, SHARP BILLS.

PUSHED TO THE BRINK OF EXTINCTION IN THE EARLY 1900S, THE **WOOD DUCK** IS NOW ONE OF OUR MOST ABUNDANT DUCKS. IT NESTS IN TREE CAVITIES AS HIGH AS FIFTY FEET ALONG WOODED RIVERS, STREAMS, PONDS, AND LAKES.

The riverine forests of the Great Plains might be thought of as narrow, amoeba-like arms extending from upland forests that form eastern and western boundaries to the plains' grasslands. In the southeast, botanically diverse deciduous forests dominated mostly by oaks and hickories from geologically ancient regions, such as the Ozark Plateau and Ouachita Mountains, snake westward along the Arkansas and Canadian Rivers and northwestward along the Missouri, Kansas, Republican, and Platte Rivers. The cold-adapted hardwood maple-basswood forests of central Minnesota likewise follow the Minnesota and Red Rivers systems northwestward into the eastern Dakotas. From the west, montane coniferous forests dominated by ponderosa pines stretch out locally into the high plains from the Rocky Mountain piedmont, finding eastern expansion corridors along the upper reaches of the Missouri, Niobrara, Platte, Arkansas, Cimarron, and Canadian Rivers. And the Black Hills rise majestically in western South Dakota above the shortgrass plains in solitary splendor, producing an island of ponderosa pines and other conifers that in most ways biologically resemble the pine-dominated forests of the Bighorn and Laramie Mountains a few hundred miles to the west. In only a few places do the eastern hardwood forests extend westward far enough to meet their western coniferous counterparts to any great degree. Along the Niobrara and Platte Rivers this does indeed occur, with fascinating ecological results, such as tree hybridization, bird hybridization, and strangely juxtaposed species.

Birds

Among the Great Plains woodpeckers, the northern flicker is the one that seems best adapted to the Great Plains. It is as much a forest-edge species as a woods dweller. One of its favorite foods is ants, which it often obtains by flying out into grasslands near woods and probing for them in the ground. As a result, it is the most common breeding woodpecker in Nebraska and Kansas, slightly edging out the red-headed woodpecker in both places. The same is most likely true in both Dakotas, where possible or proven breeding by flickers has been found in all their counties. Because of its preeminent numerical position in the Great Plains, the nesting holes that northern flickers drill

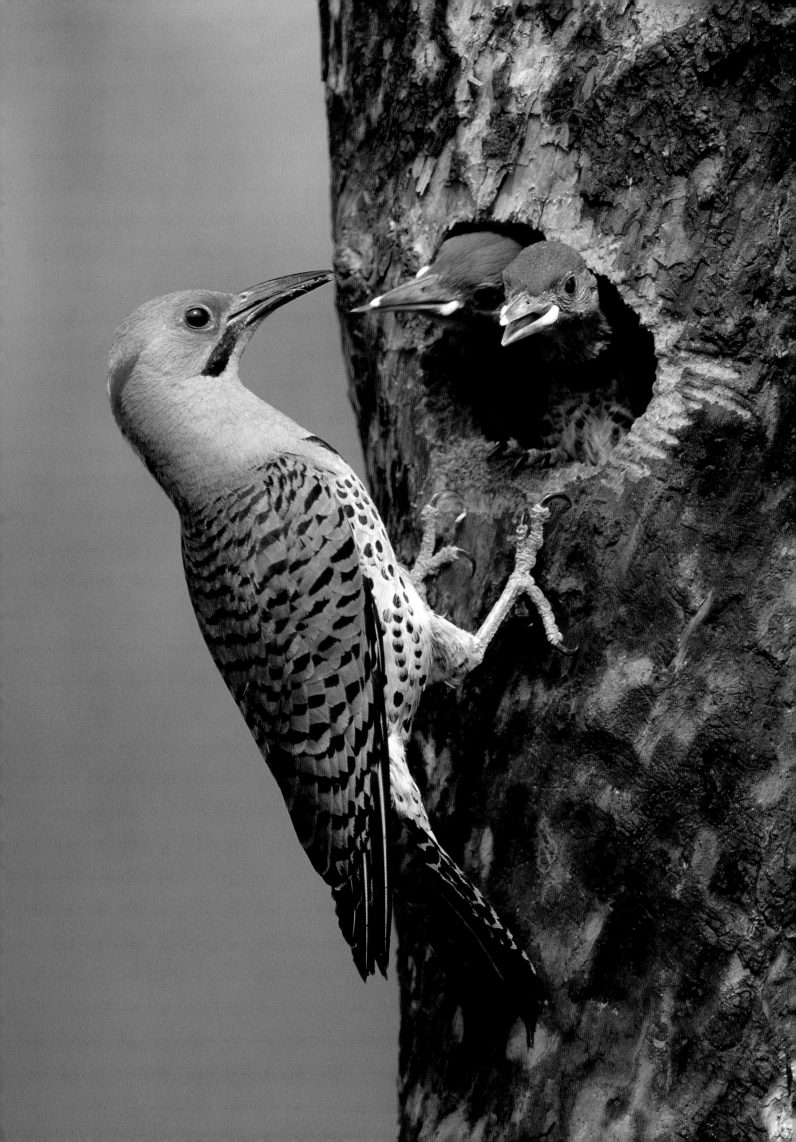

in trees become extremely important as breeding sites for all those species of cavity-nesting birds that must depend on woodpeckers for providing their own lodgings. Species such as eastern bluebirds, tree swallows, chickadees, titmice, nuthatches, wrens, and screech owls are all to varying degrees nest-site commensals of woodpeckers.

Probably most residents of the larger towns and cities of the plains states would scoff if one suggested to them that they might well have a pair of owls nesting in their backyard. Yet such is often the case, for screech owls are small, inconspicuous, and relatively silent birds. They do not screech in the usual sense, but under extreme duress, as when defending a brood, they will utter rasping notes. The usual call of the eastern screech owl is a soft, quivering, and ghostly wail that might be easily overlooked among the many sounds of a city. Even if one hears and recognizes the call, finding the bird that made it is nearly impossible. The typical plumage color of Great Plains screech owls is a mottled dark gray and buff that almost perfectly matches tree bark. When alarmed, a screech owl will assume a slim, erect posture, lean against a vertical trunk or branch, and nearly close its bright yellow eyes, thus hiding them from view. It thereby merges with its background in a near-magical way, remaining immobile until the danger has passed.

Compared with the screech owl, which weighs about seven or eight

THE **NORTHERN FLICKER** IS THE ONLY PLAINS WOODPECKER COMMONLY SEEN ON THE GROUND, WHERE IT FEEDS ON ANTS AND OTHER INSECTS. THE YELLOW-SHAFTED RACE OF THIS FLICKER IS NAMED FOR THE COLOR OF THE FEATHER SHAFTS ON THE WINGS AND TAIL. THE BLACK MUSTACHE IDENTIFIES THIS BIRD AS A MALE.

THE **DOWNY WOODPECKER** IS THE SMALLEST AND MOST ABUNDANT AND WIDESPREAD WOODPECKER IN THE GREAT PLAINS. IT IS EASILY ATTRACTED TO BIRD FEEDERS. THE MALE HAS A SMALL RED PATCH ON THE BACK OF ITS HEAD, UNLIKE THIS FEMALE.

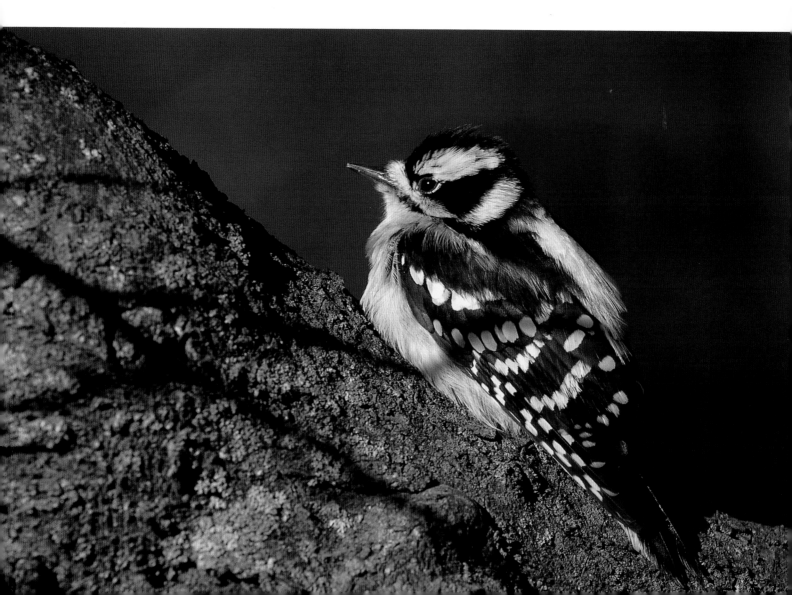

ounces, the great horned owl is a giant, averaging about three pounds in males and four pounds in females. Because of its great strength and power, it is not nearly so shy about revealing its presence to humans and other animals, for few other predators would willingly take on one of these impressive birds. A great horned owl would not hesitate to attack a large rattlesnake, a jackrabbit, or even a small cat, should it get the chance. Each of its toes and stiletto-sharp talons can produce a viselike grip representing nearly thirty pounds of pressure, a grip from which few animals can escape alive. Great horned owls are common everywhere in the Great Plains. They easily represent the largest number of owl breeding records for Nebraska and Kansas, and there are "possible" to "confirmed" breeding records for nearly every county in the Dakotas.

The red-tailed hawk is the daytime replacement raptor for the great horned owl. It is also the so-called "chicken hawk" known to many farmers and ranchers, a generic vernacular name for the large, broad-winged, and wide-tailed hawks that are the signature daytime aerial predators of the Great Plains. Few chickens are ever killed by red-tailed hawks; they are often accused of attacking the chickens that are actually taken by the more secretive great horned owls. Red-tailed hawks instead primarily hunt small mammals; they are the larger hawks

EASTERN SCREECH OWLS ARE ONLY EIGHT TO NINE INCHES IN LENGTH, AND THEIR PLUMAGE MAY BE RED, BROWN, OR GRAY. THEIR CALL IS NOT A SCREECH BUT A MOURNFUL, DESCENDING WHINNY. THEY NEST AND ROOST IN TREE CAVITIES.

LARGE STICK NESTS OF **RED-TAILED HAWKS** ARE COMMONLY SEEN IN TALL TREES ALONG ROADSIDES. THIS FEMALE IS OFFERING A SMALL PIECE OF MEAT TO HER YOUNG. IT IS THE MOST ABUNDANT BUTEO HAWK THROUGHOUT MUCH OF NORTH AMERICA.

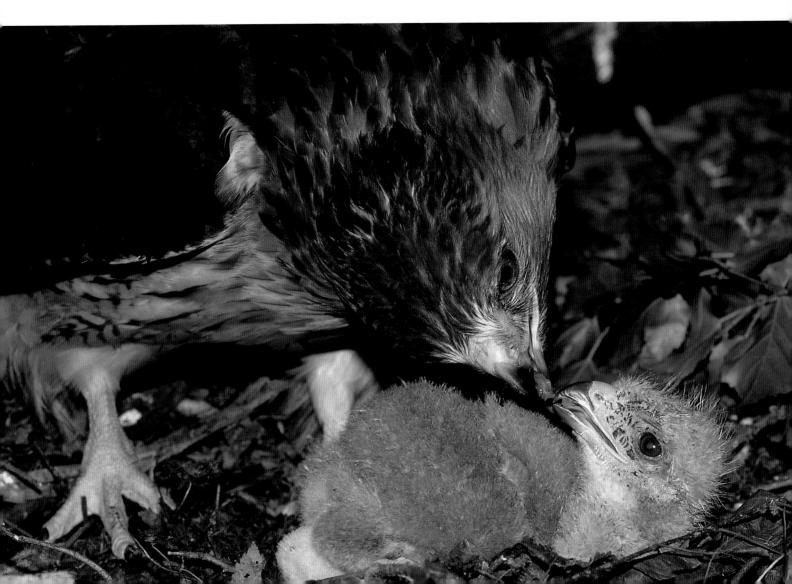

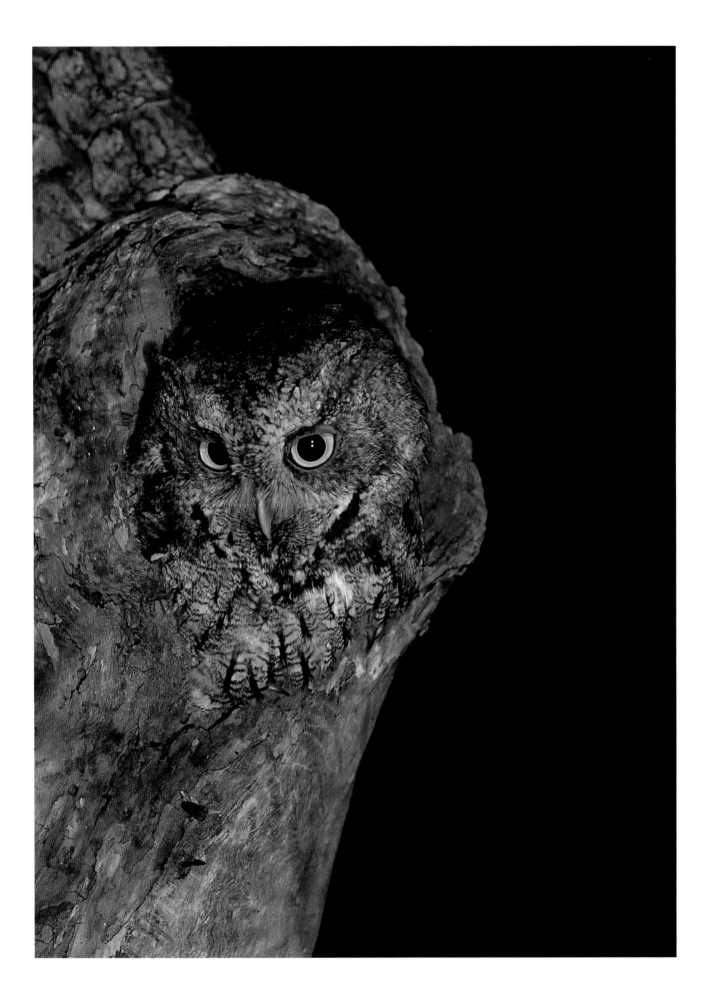

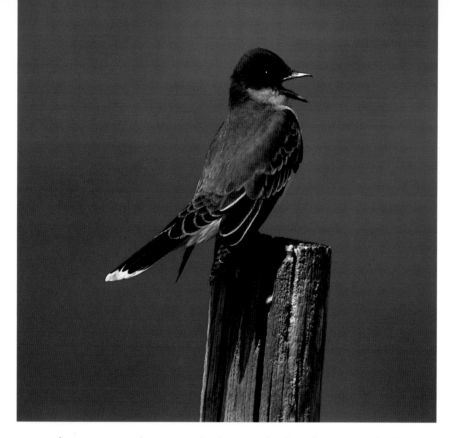

most often seen perching on telephone poles beside country highways, looking for mice lurking in the mowed ditches. They are a good deal more wary than Swainson's hawks, which are also common pole-sitters, and can be rather easily separated from them at takeoff. If the rusty-red upper tail color of adults is not apparent, then the mostly white underwing color, including the longer wing feathers, should help distinguish redtails. Swainson's hawks have a grayish upper tail, and the long primary and secondary feathers have a rather uniformly dark underside color. Sometimes very dark, even almost black, plumage variants of both species occur, making field identification much more difficult.

Cuckoos are a bit like screech owls, in that many Great Plains residents have heard them frequently, but few would claim to have seen one. They expect a cuckoo to sound like a European cuckoo clock, but it produces the rather wooden-sounding and repetitive notes that emanate from the edges of woods on cloudy summer days or toward evening. Such sounds are often thought to be made by rain crows, rather mythical Great Plains creatures perhaps akin to thunderbirds. These residents would be surprised to learn that the rain crow is nothing more (or less) than a yellow-billed cuckoo. The generally rarer and more northerly black-billed cuckoo has a more cuckoolike call, and both species feed almost entirely on hairy or spiny caterpillars that are avoided by nearly every other bird. Nests of both cuckoos are rather flimsy affairs, and their nests and bluish green eggs are almost indistinguishable from one another's. Perhaps this is why yellow-billed cuckoos sometimes lay eggs in the nest of black-billed and vice versa. However, nest parasitism of other species by either of our native cuckoos is relatively rare.

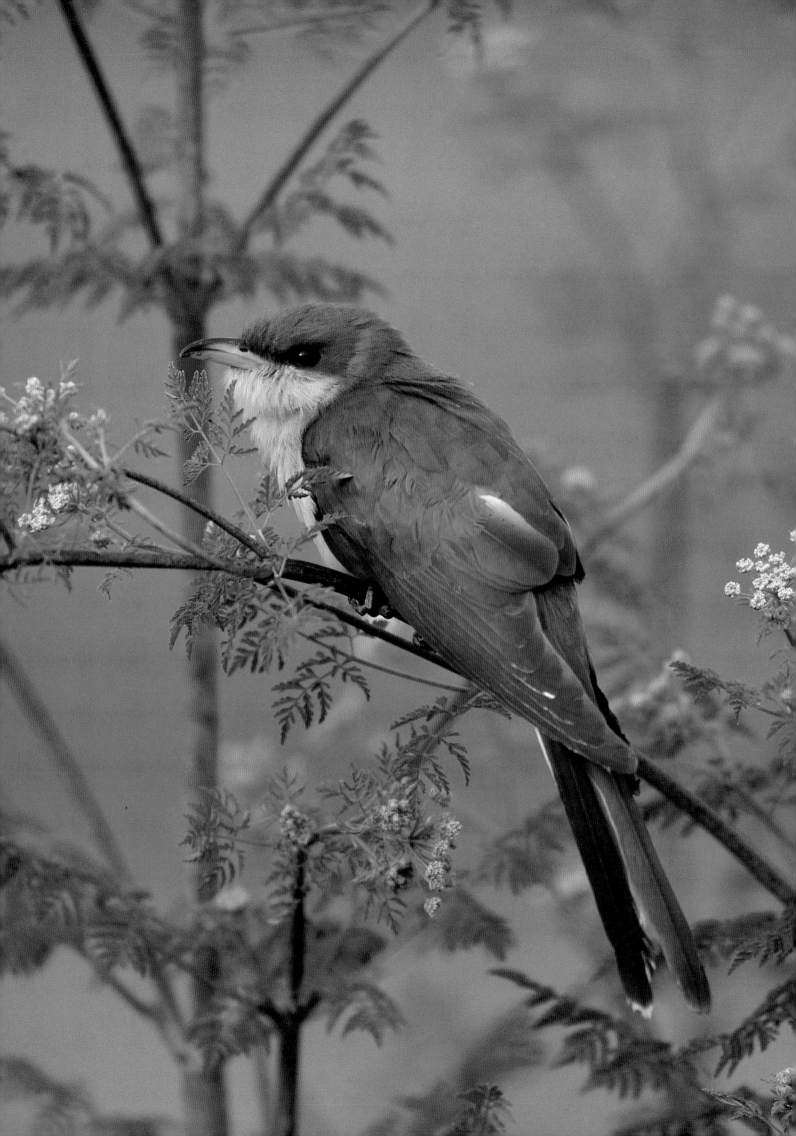

THE STRIKING PLUMAGE OF THE MALE **EASTERN BLUEBIRD** MAKES IT ONE OF AMERICA'S FAVORITE BIRDS. THIS SPECIES IS FOUND IN OPEN WOODLANDS ADJACENT TO FIELDS AND PASTURES. ERECTING TRAILS OF NESTING BOXES IN APPROPRIATE HABITATS HAS HELPED REVIVE BLUEBIRD POPULATIONS.

THE VIBRANT BLUE COLOR OF THE MALE **INDIGO BUNTING** IS SELDOM NOTICED. ONLY IN GOOD CONDITIONS, WHEN THE SHORTER WAVELENGTHS OF BLUE LIGHT ARE REFRACTED BY THE STRUCTURE OF THE FEATHERS, IS THE IRIDESCENT COLOR APPARENT.

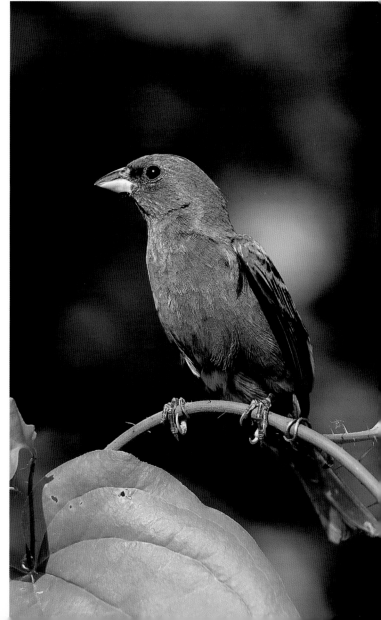

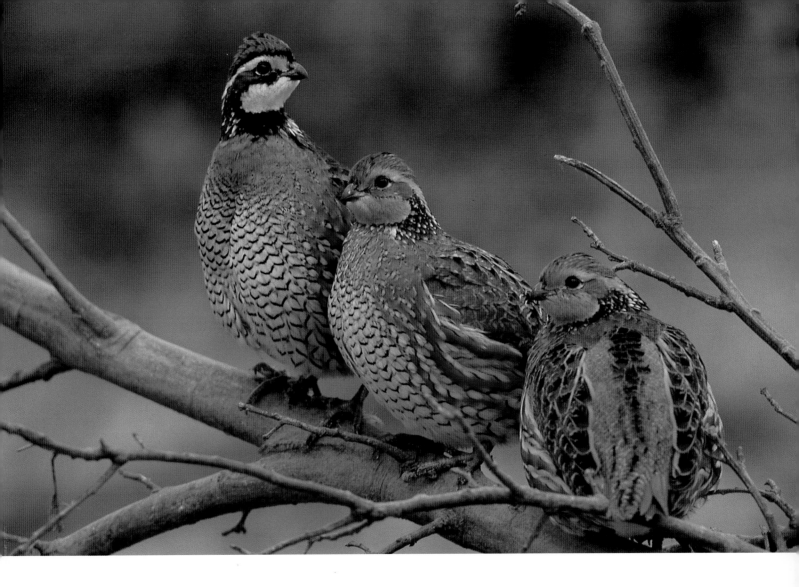

Compared with cuckoos, indigo buntings are highly conspicuous, and males are intensely blue in direct sunlight. In such a situation one can only imagine that they would attract every predator within sight of them as they sit on the tips of a tree branch in full sunshine, singing exuberantly. The brilliant blues of these birds are as much a result of light scattering of the shorter blue rays of light (the same basis for our perception of blue skies) as they are of true iridescence, which depends on refraction of light waves by internal feather structure, as is produced by a prism. In either case, a relatively directed source of light is needed to produce the full visual effect.

Another distinctly blue bird of the woodland edges is the eastern bluebird. At one time eastern bluebirds were one of the most common breeding birds along the western edges of the hardwood forests that gradually graded into tallgrass prairies. However, two major factors led to their near demise. By the 1930s European starlings, which had been introduced into New England in the late 1800s, had spread west far enough to reach the plains states, first being reported in Nebraska and Oklahoma in winter or spring 1929–1930. By the end of that

A SINGLE MALE, IDENTIFIED BY HIS WHITE THROAT, IS SITTING WITH A PAIR OF BUFF-THROATED FEMALE **NORTHERN BOBWHITES.** FOR MOST OF THE YEAR BOBWHITES ARE FOUND IN COVEYS USUALLY NUMBERING TEN OR MORE BIRDS.

decade they had crossed all of Nebraska and continued their march west to the Pacific coast. They proved to be strong competitors with eastern bluebirds for available nesting cavities and probably initiated the bluebird's long decline. The appearance of persistent organic pesticides such as DDT in the mid-1940s only accelerated their decline, and by the time I reached Nebraska in the early 1960s, bluebirds were already rare. Now, helped by the erection of bluebird boxes and the elimination of most pesticides, the birds are again quite common.

THIS FEMALE **BELTED KINGFISHER** HAS RETURNED TO HER NEST CAVITY WITH A FISH FOR HER YOUNG. THE NEST BURROW IS DUG IN A STEEP, ERODED BANK OF A RIVER OR STREAM. THE BURROW IS USUALLY THREE TO FOUR INCHES IN DIAMETER AND FOUR TO TEN FEET LONG.

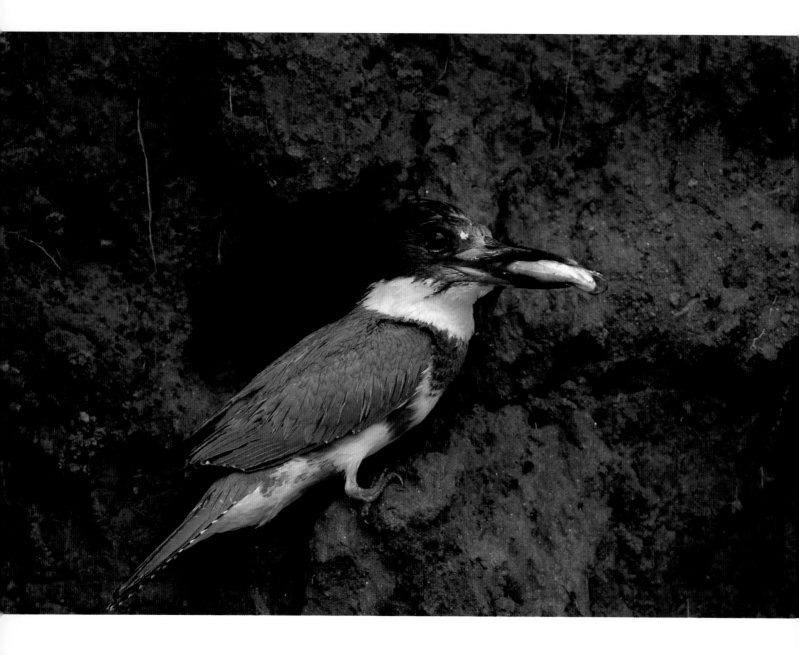

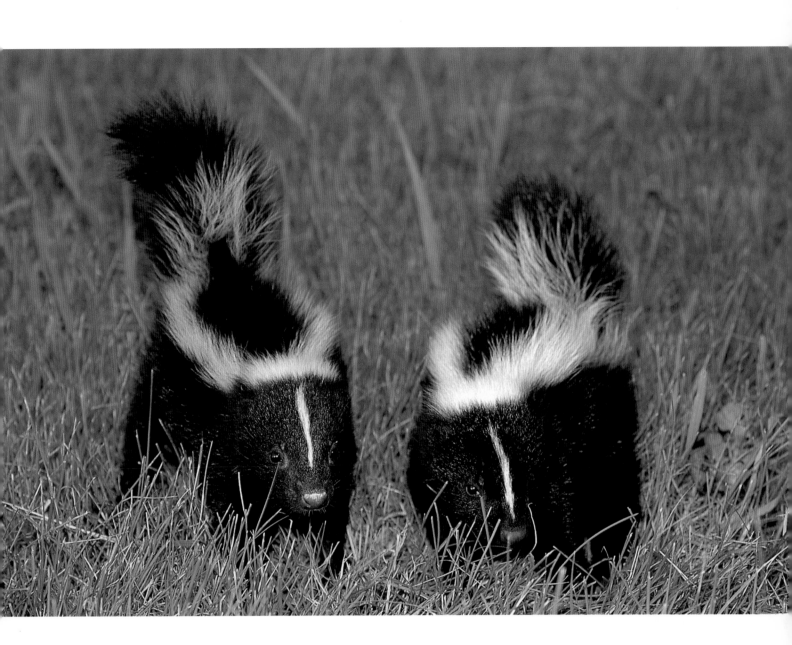

Mammals

The striped skunk is fairly familiar to anyone who spends much time in the field or drives down country roads, where the stench of a road-killed skunk is sometimes hard to avoid. Probably there would be far fewer skunks killed by autos if these animals had not evolved their own usually effective defense mechanism long before the iron age. This remarkably uniform and powerful strategy has allowed all skunks to lose whatever fear they might otherwise have had relative to large moving objects. The distinctive black-and-white pelage pattern of skunks helps serve as an effective remainder to any foxes, coyotes, and other mammals that have had unfortunate prior encounters with a skunk, but it does not seem to work against great horned owls, very hungry bobcats, or Volkswagens.

EVEN AT BIRTH, YOUNG **STRIPED SKUNKS** ARE CAPABLE OF PRODUCING THEIR UNIQUE VERSION OF CHEMICAL WARFARE. THIS PAIR OF YOUNGSTERS WANDERED INTO A NEBRASKA CAMPGROUND WITH ALL THE CONFIDENCE OF VETERAN ADULTS.

Like the Great Plains species of spotted and striped skunks, there are two very similar species of mice with white feet and deer-brown upperparts that are widely distributed in the Great Plains woods and nearby grasslands, the deer mouse and the white-footed mouse. Their large ears and bulging eyes provide evidence of their nocturnality, and in their diets they are about as generalized as any small mammal. As a result they are usually abundant, the populations often ranging up to sixteen animals per acre. Both are the most common of all native mice in North America and are very similar to one another.

Their genus (*Peromyscus*) includes at least fifteen species north of Mexico, with the deer mouse and white-footed mouse having the broadest ranges. The white-footed mouse is more likely to occur in wooded areas, especially the hardwood and mixed forests of the eastern states, but follows the riverine gallery forests westward all the way to the Rocky Mountains. Both species are largely nocturnal,

WITH CAMOUFLAGED FUR AND SECRETIVE, NOCTURNAL HABITS, THE **BOBCAT** IS SELDOM SEEN. ITS HUNTING REFLEXES ARE QUICK AND AGILE, AND IT IS CAPABLE OF TAKING PREY RANGING IN SIZE FROM MICE TO DEER. IT ALSO EATS BIRDS, REPTILES, AMPHIBIANS, FISH, AND INSECTS.

THE **DEER MOUSE** IS FOUND FROM COAST TO COAST AND FROM CENTRAL CANADA TO SOUTHERN MEXICO. IT IS THE MOST WIDESPREAD OF ALL NORTH AMERICAN RODENTS AND PROBABLY THE MOST ABUNDANT.

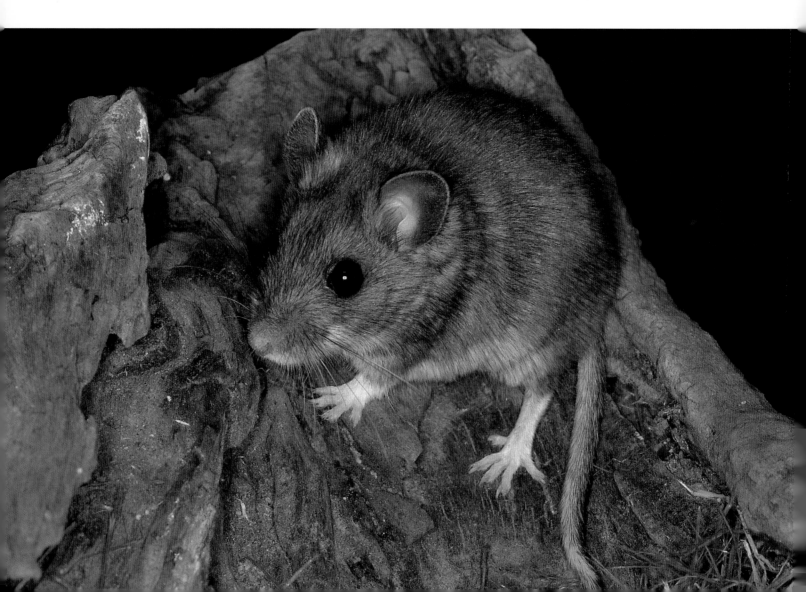

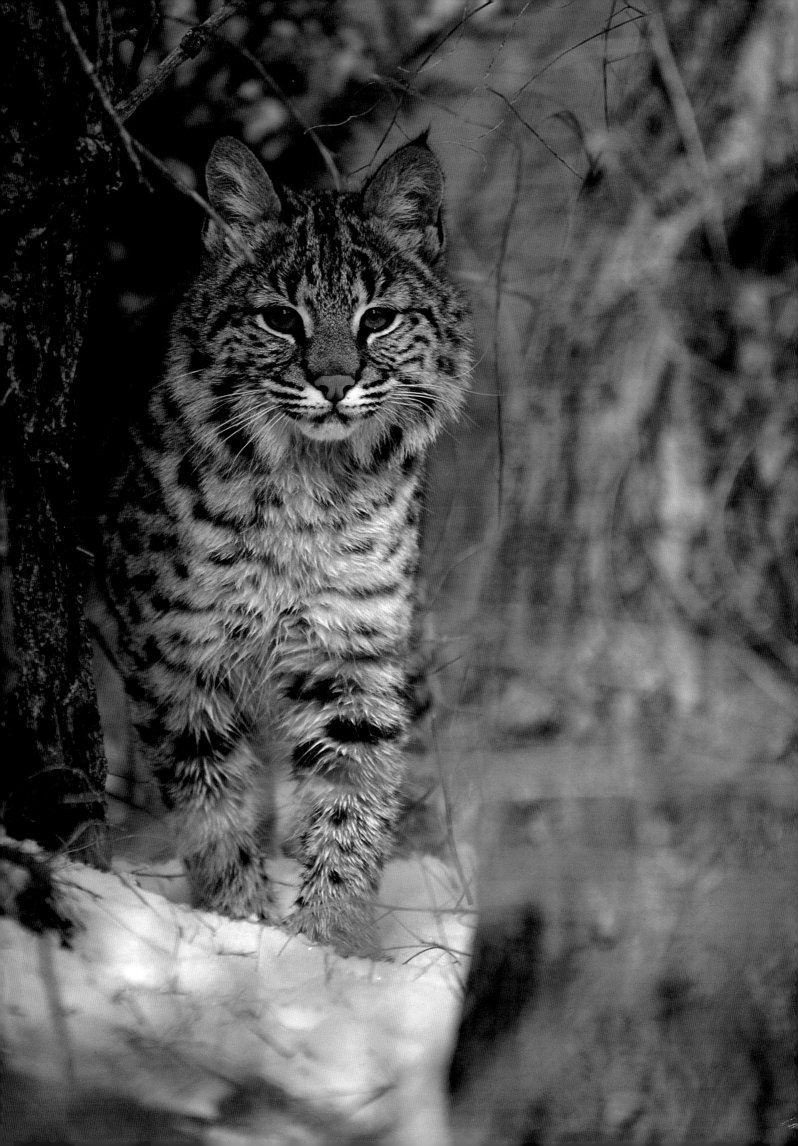

communicating by scent signals and vocalizations that are partly ultrasonic, above the range of human hearing. However, they do utter squeaking, chittering, and shrill buzzing sounds that may be heard by humans from as far away as fifty feet. They will also stamp their feet rapidly when excited. During daytime the animals may doze, and in the coldest parts of their range they may become torpid when food is scarce, adopting a state of semihibernation. During torpor their rate of breathing may drop to about sixty breaths per minute and their body temperature to about sixty degrees Fahrenheit.

Just as we associate ruddy ducks and western grebes with prairie wetlands, we are inclined to think of beavers only in association with the northern and western American forests, where their pelts provided a major impetus for the early exploration and exploitation of North America's rich resources. Yet they have also traveled out into the Great Plains grasslands along our river systems far from any real forests. I have seen creeks so narrow one could jump across them that have had the unmistakable signs of beaver work along their edges, in the form of lopped-off saplings and trees and efficient dams constructed of logs and branches. More than any other wild mammals, the beavers are able to modify their environment in a way that benefits them. These changes in the habitat also allow a wide variety of water-dependent animals, including fishes, amphibians, reptiles, birds, other mammals, and invertebrates, to survive and flourish.

THE QUEST FOR **BEAVERS** PLAYED A MAJOR ROLE IN THE EXPLORATION OF WESTERN NORTH AMERICA. FELT HATS, MADE FROM SKINS WITH THE FUR TRIMMED SHORT, WERE A FASHION STATEMENT FOR CENTURIES. WITH POPULATIONS ONCE DECIMATED, BEAVERS NOW OCCUPY MOST FORESTED HABITAT ALONG RIVERS AND STREAMS THROUGHOUT THE GREAT PLAINS.

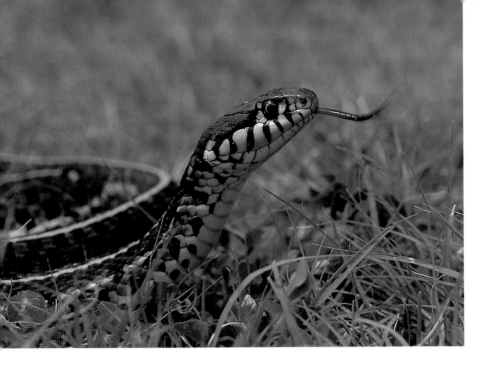

Reptiles

Plains garter snakes are named for their decorative garterlike pattern that runs along their body. The body is mostly gray to tan-colored on the sides, interrupted by a linear series of small back spots and with a middorsal stripe of bright yellow-orange as well as with a pair of lateral stripes that are usually also yellow or greenish yellow. The common or red-sided garter snake is similar but has a bright yellow stripe on each side, above which is an intricate pattern of black spots on a red background. Both species are only medium-sized snakes, growing to a maximum of three feet long; females are slightly larger than males, but males have longer tails. Grassy prairies and the edges of wetlands are the favorite habitat of garter snakes, where they are common and feed on almost anything they can catch and swallow, such as good-sized toads, frogs, and rodents. Frogs are perhaps their most common prey. Garter snakes lack the heat-sensing abilities of the pit vipers and largely rely on olfactory cues, as detected by their sensitive tongues. Being nonvenomous they have only limited powers of self-defense, but when captured they emit foul-smelling material from their anal glands and try to smear it on their captors.

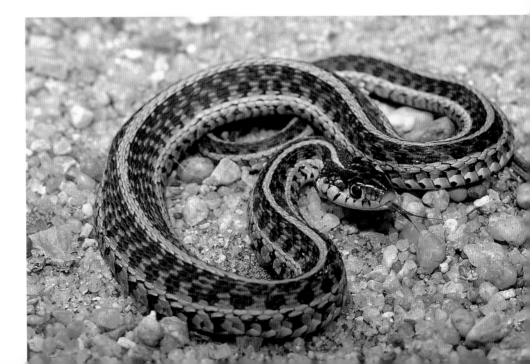

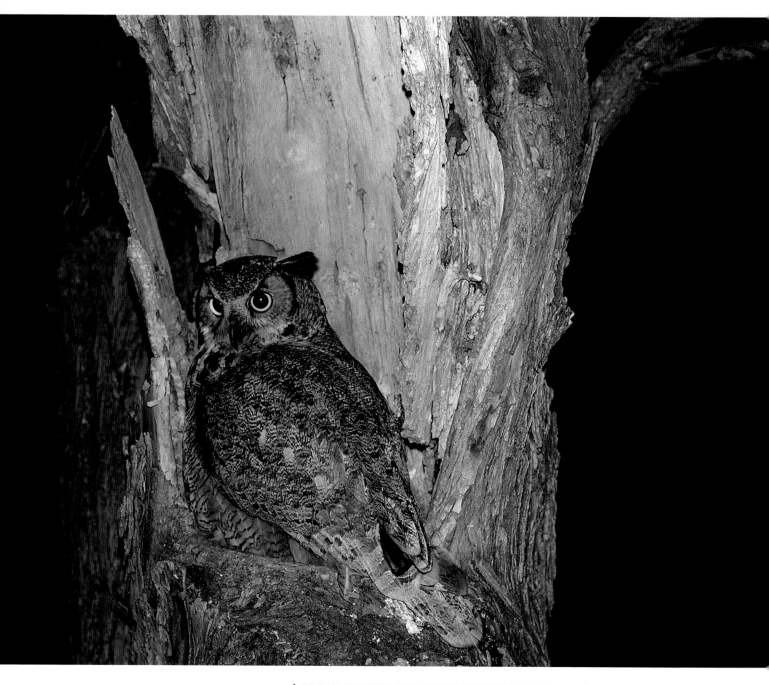

A **GREAT HORNED OWL** PAUSES AT THE EDGE OF ITS NEST. IT IS THE EARLIEST OF ALL BIRDS TO BEGIN NESTING ON THE GREAT PLAINS. IN LATE JANUARY IT CAN BE FOUND INCUBATING EGGS IN THE MIDDLE OF A SNOWSTORM.

Field Notes

I found the owl's nest during the third week of February. An adult was flushed from a depression at the top of a broken-off willow tree about fifteen feet off the ground. Unlike with any other great horned owl's nest I'd found, this tree could be easily climbed and wasn't too high.

As I climbed, the adult swooped close. I remembered all the stories I'd read about owls defending their nests by sinking their talons into human intruders. I turned and waved my hand, and the bird veered away. I took a few photos and then left the bird to incubate in peace.

Each week I returned to check on the nest, and after the second visit the adult would fly to a nearby tree and wait patiently as I quickly snapped a few photos. Incubation lasted four weeks before pipped eggs in mid-March signaled hatching. I visited the nest briefly each of the next several days to photograph the tiny chicks. As the chicks grew, I visited the nest every four days and began to accumulate a nice collection of photographs. But I still had no decent photos of the adult birds.

To remedy this I made a bracket to hold my camera that screwed into a branch about eight feet from the nest. One night about ten o'clock I attached the camera and electronic flash. To trigger the shutter I also attached a homemade fifty-foot electronic cable. The cable ran under the branch, down the tree, and across the ground to a simple blind I'd constructed with branches and burlap. Through a small hole in the burlap I could see the nest silhouetted against the night sky with the help of a full moon. The hours passed as I listened to the quavering calls of screech owls, an eruption of coyote howling, unknown splashes in the creek, and an occasional rustle of the leaves. About the time I'd start to get sleepy a new noise and surge of adrenaline would startle me.

Shortly after 2:30 A.M., I caught the silent flight of an owl out of the corner of my eye. I couldn't locate its silhouette in the trees around me but I knew it was close. A few minutes later it suddenly swooped in, and I could see its dark shape on the edge of the nest. I pushed the cable release and the flash duration was so short I couldn't see what the bird was doing. I figured the bird would fly off but was surprised when it didn't. For the next several minutes I'd snap a photograph every fifteen seconds as the flash recharged. Then the bird was gone as quickly and quietly as it had appeared.

A week later I got the film back and was able to check my results. In the first image the bird's back was to the camera, but I could make out the tail of a rat the adult had caught for the chicks. In the next two images the bird was staring wide-eyed at the camera. The rest of the images, like this photo, show the bird staring at the burlap and branches where I thought I was hidden but apparently wasn't.

PLAINS
WETLANDS

The gifts of glaciers past are sometimes difficult to perceive, even when their evidence is all around us. I grew up in the Red River Valley of eastern North Dakota, a region so flat that, like sailors on the ocean, one could almost imagine the earth's curvature by noticing the way that tall structures such as elevators seemed to recede into the ground when viewed from a distance of several miles. Yet of all the people who lived in Christine, the little town of my childhood, perhaps none realized that the deep, black soil they assiduously cultivated was composed of the clay-rich sediments of a Pleistocene lake bottom and that perhaps twenty thousand years ago the area would have been near the middle of a coldwater lake so vast that its wooded shorelines were likely to have been beyond view. I eventually escaped Christine and increasingly discovered the wonders of prairie wetlands in the potholes country of eastern North Dakota. More than any other single factor, it was the time I spent crouching in cattails and phragmites beds along the edges of just-thawing marshes, with myriads of migrating waterfowl swirling above and all around me, that shaped my entire future.

Birds

Piping plovers and least terns are shorebirds that will nest only on barren sand or gravel near water. At one time both species were widespread along the upper Missouri River as well as along many of its tributary streams, such as the Platte and Arkansas. Their breeding ecology evolved in conjunction with the historic seasonal flow cycles of these rivers. The Great Plains rivers are mostly fed by late-winter and spring snowmelt from the eastern slopes of the Rocky Mountains, plus the spring rains that are the usual precipitation pattern for this region. As a result, the rivers of the plains tended to rise and perhaps flood in midspring, then slowly decline through the summer months. This kind of seasonal fluctuation meant that by May the rivers were usually starting to recede from peak flows, exposing sandy islands and bars. Least terns and piping plovers could then nest on these islands, fairly secure from future flooding and from at least some of the land-based predators that might attack their eggs or chicks. This strategy worked well until technology began to alter river flows, often either entirely

THE **AMERICAN AVOCET** HAS LONG LEGS AND A LONG, RECURVED BILL. SHOREBIRDS OF MANY SPECIES WILL STAND ON ONE LEG WITH THE OTHER TUCKED UP AGAINST ITS BELLY WHILE RESTING. THE BILL'S SHAPE IS UTILIZED WHILE FEEDING BY SWINGING BACK AND FORTH THROUGH THE WATER. IT IS VERY SENSITIVE AND WILL SNAP CLOSED ON AQUATIC INSECTS ON CONTACT.

drying them up through excessive water withdrawals or by modifying annual flow rates to control spring flooding or to facilitate summer barge traffic. Consequently, both species began to experience widespread population declines, and eventually both became candidates for federal threatened species status.

Snowy plovers are essentially slightly faded versions of piping plovers, and their breeding ranges virtually meet in Kansas. The piping plover nests locally south to northeastern Kansas, and the snowy plover breeds north to central Kansas, specifically in Quivera National Wildlife Refuge and Cheyenne Bottoms State Wildlife Area. The Great Salt Plains National Wildlife Refuge of Oklahoma offers even better nesting habitat, as the birds prefer sandy beaches, shorelines, and alkali flats with essentially no standing vegetation. Somehow, the pale plumage of the birds, including thier downy chicks, can blend with the substrate and make them maddeningly hard to find. But this is good for the plovers, which are far too small to defend themselves from even the tiniest predators.

THIS **PIPING PLOVER** IS PREPARING TO INCUBATE ITS FOUR EGGS. NOTICE THE FEATHERS ON ITS BELLY BEGINNING TO PART, EXPOSING ITS BROOD PATCH. THIS BARE AREA OF SKIN ON THE BIRD'S BELLY PROVIDES WARMTH TO THE EGGS. THE PIPING PLOVER IS A NATIONALLY THREATENED SPECIES.

WITH HEAVILY STREAKED PLUMAGE AND BILL POINTING SKYWARD, AN **AMERICAN BITTERN** HAS NEARLY PERFECT CAMOU-FLAGE WHEN STANDING IN TALL CORD-GRASS, BULRUSHES, OR CATTAILS. SO INSTINCTIVE IS THIS BEHAVIOR THAT WHEN CAUGHT IN THE OPEN THIS BITTERN STILL ATTEMPTS TO BLEND INTO TALL VEGETATION THAT ISN'T THERE.

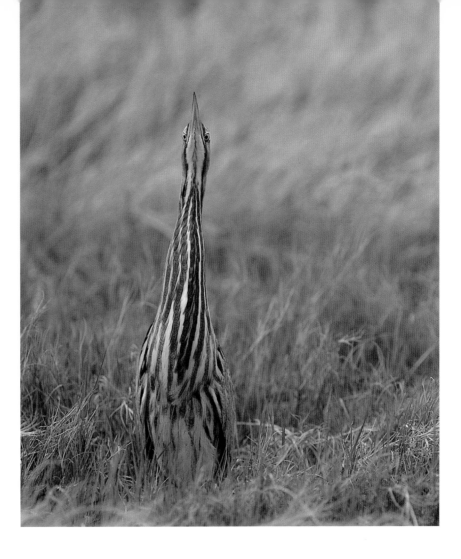

SNOWY PLOVERS HAVE PRECOCIAL YOUNG. THIS YOUNGSTER, SNUGGLING CLOSE TO STAY WARM, IS ONLY A FEW HOURS OLD. BEFORE THE DAY IS OVER IT WILL FOLLOW ITS PARENT AND TWO OTHER HATCHLINGS ACROSS THE ALKALI SALT FLAT OF QUIVIRA NATIONAL WILDLIFE REFUGE IN KANSAS.

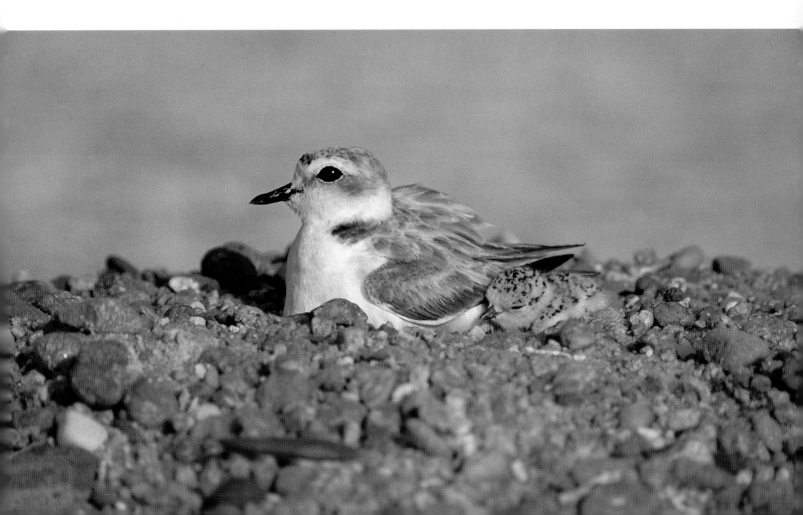

Phalaropes are unusually aquatic shorebirds, usually feeding while swimming rather than while standing at the water's edge in the manner of plovers. Like the other two phalarope species, the Wilson's has "reversed" sexual dimorphism, meaning that females are larger, more aggressive, and seasonally more colorful than the males. They also establish breeding territories, court the duller males, and of course lay the eggs. Otherwise, it falls to the male to complete the job of incubating the eggs and rearing the young. No other North American bird groups have such clear-cut sexual reversals, and very few other birds of the world share this trait. The presumed potential value of such behavior is that given a long enough breeding season, the female might sequentially mate with and lay clutches for several successive male mates to incubate and rear. Two of the three total phalarope species breed in the arctic, where the nesting season may be too short to allow such behavior often. In the Great Plains the Wilson's phalarope nests south regularly to Nebraska and perhaps rarely or locally in Kansas, where the breeding season is appreciably longer. Thus, if polyandry is to occur at all, it should most often occur here.

IN PHALAROPES THE SEXES SEEM TO HAVE COMPLETELY REVERSED ROLES. THE FEMALE **WILSON'S PHALAROPE,** SEEN HERE, HAS BRIGHTER PLUMAGE THAN THE MALE. GROUPS OF AGGRESSIVE FEMALES MAY FLY AFTER A PROSPECTIVE MATE. THE FEMALE LAYS EGGS IN A NEST BUILT BY THE MALE. MALES INCUBATE AND RAISE THE YOUNG WHILE SHE MOVES ON TO ANOTHER PARTNER.

THE WHINNY CALL OF THE MALE **SORA** IS OFTEN THE ONLY CLUE THAT THIS EIGHT-INCH BIRD IS PRESENT. IT SEARCHES THE WATER SURFACE AND BENEATH THE GRASSES, SEDGES, RUSHES, AND CATTAILS FOR PLANT SEEDS, SNAILS, AND AQUATIC INSECTS.

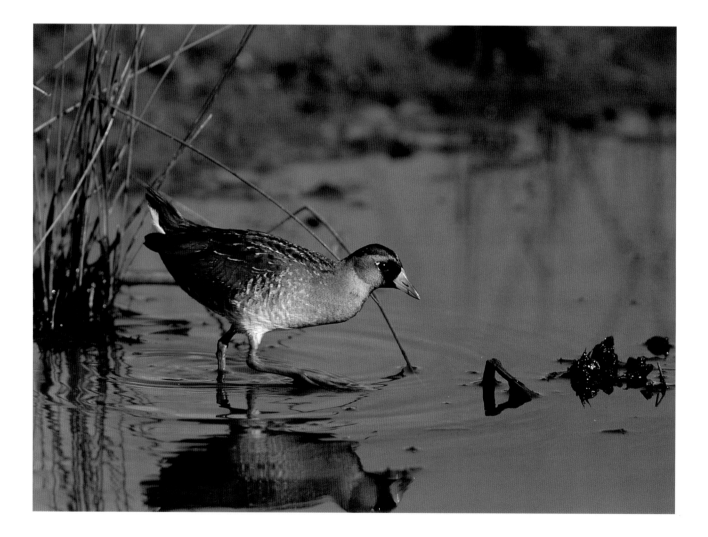

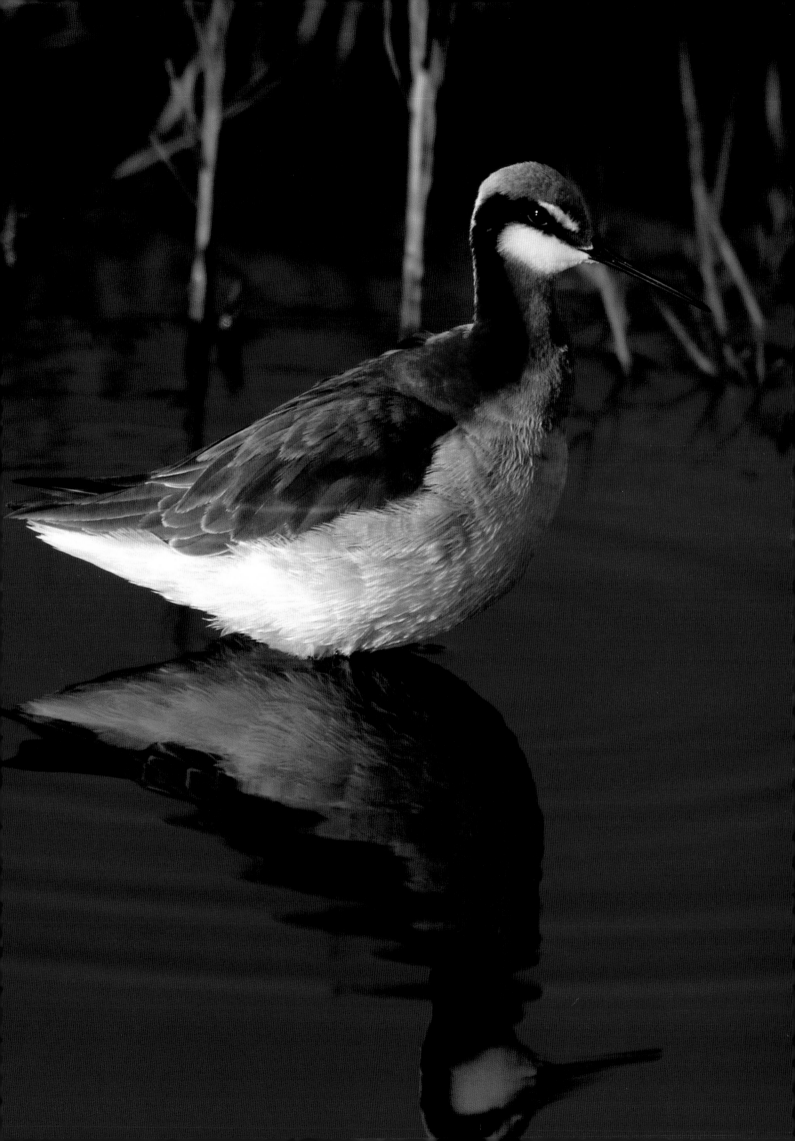

Out on the open water of prairie marshes a variety of ducks and grebes replace the plovers and most other shorebirds. The largest of the grebe species, the western grebe, exudes a certain air of royalty. Western grebes have necks that are unbelievably long and gracefully arched, their eyes are as red as the best Burmese rubies, and on their crowns they wear black caps that during spring are usually cocked up in a jaunty pattern somewhat resembling a three-cornered cap. They move through the water with the silent assurance of all grebes, ready to disappear below the surface in an instant should danger threaten. Although usually silent, during spring the prairie marshes of the Dakotas fairly ring with the tinkling calls of western grebes, resembling sleighbells heard in the distance. Then, if one is lucky, one might see a pair of courting grebes floating easily on a sky-blue marsh lined with golden rushes, alternately dipping their bills and then quickly preening their back feathers in perfect synchrony in an intricate performance never to be forgotten. No other water bird quite so perfectly captures the beauty of prairie wetlands or the very essence of wildness.

THIS **EARED GREBE** HAS ANCHORED ITS FLOATING NEST TO CATTAILS. IT FREQUENTLY NESTS IN LARGE COLONIES, AND THIS IS ONLY ONE OF ABOUT FIFTY NESTS IN A SOUTH DAKOTA WETLAND. THE GREBE IS EXTREMELY AWKWARD ON LAND, WITH LEGS FAR BACK ON ITS BODY.

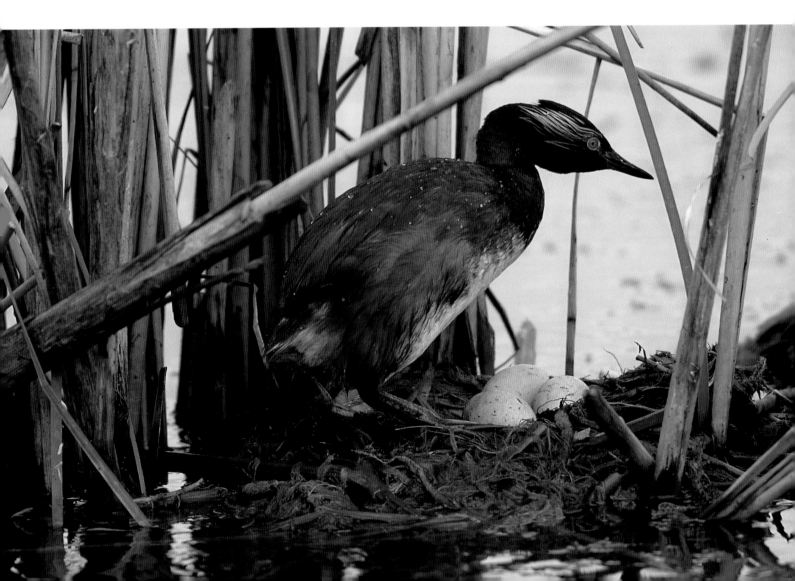

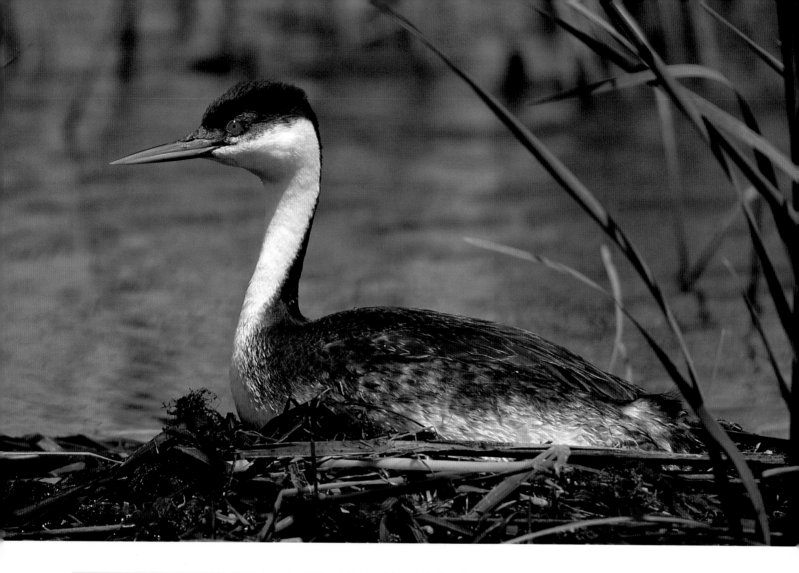

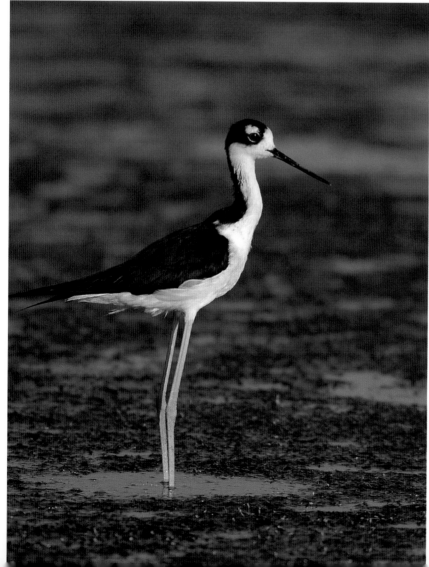

THESE SLEEK DIVING BIRDS HAVE
SHARPLY POINTED BILLS ON THE END OF
LONG, SLENDER NECKS FOR CATCHING
FISH. **WESTERN GREBES** HAVE TOES
WITH LOBES, WHICH PROVIDE MORE SUR-
FACE AREA ON THE POWER STROKE, THEN
FOLD AGAINST THE TOES ON THE RETURN
STROKE. THE BIRDS ARE FAST ENOUGH TO
OUTMANEUVER THEIR FISH PREY.

THE LONG PINK LEGS AND CONTRASTING
COLORS MAKE THE **BLACK-NECKED
STILT** EASY TO SPOT WHEN IT IS STAND-
ING IN SHALLOW WATER. WITH SUCH A
BOLD APPEARANCE THIS BIRD RELIES ON
NOISY, AGGRESSIVE BEHAVIOR TO DEFEND
ITS NEST.

The western grebe might well be considered the last word in aquatic streamlining, but the ruddy duck certainly falls toward the rear of the pack in this regard. Its primary charm lies in its rather rotund shape, including a neck that at times seems larger than its head; legs and feet that are placed so far back on its body that grebelike, it has a difficult time standing on dry land; and a tail seemingly longer and with more spiky feathers than might be needed by any duck in the world. But the ruddy duck is the product of an evolution that has favored diving over flying and swimming over walking. The long tail is associated with underwater maneuvering, the rear-positioned legs and large feet make for effective and rapid diving, and the large neck of the males is inflated with air and tapped with the undersurface of the bill during sexual advertising display. This action produces a soft drumming sound and forces air out of the breast feathers so that a ring of small bubbles is formed in the water around the breast. This strange bubbling display is made even more bizarre by the male's contrasting bright blue bill and white cheeks and his erection of two small feathered "horns" on his black crown, introducing a slightly diabolical aspect into an otherwise generally comical sight.

THE BUBBLING DISPLAY OF A MALE **RUDDY DUCK** IS CAPTIVATING TO WATCH. WITH HIS STIFF TAIL POINTING TO THE SKY AND HIS HEAD HELD HIGH, HE QUICKLY BOBS HIS HEAD SIX TO TEN TIMES WHILE SLAPPING HIS BILL AGAINST HIS CHEST AT THE SURFACE OF THE WATER. THIS ACTION FORCES AIR FROM THE BREAST FEATHERS AND THE RESULTING BUBBLES FORM RINGS AROUND THE PERFORMER.

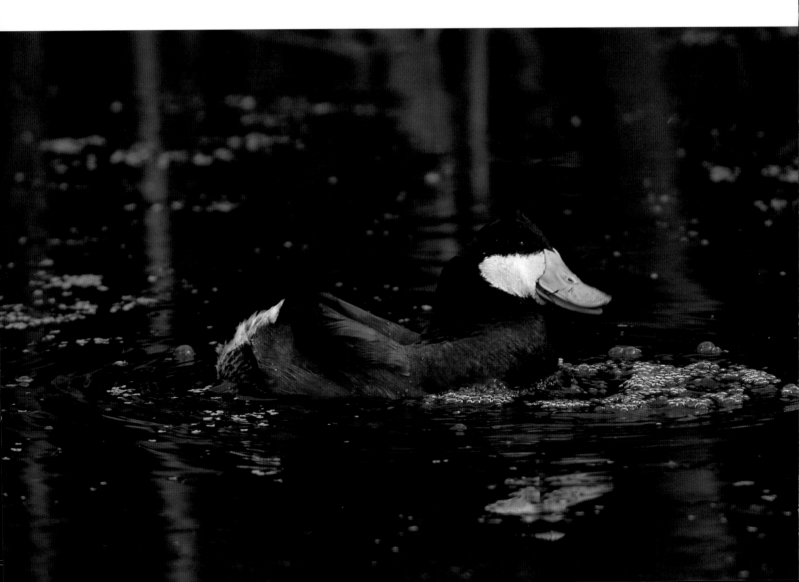

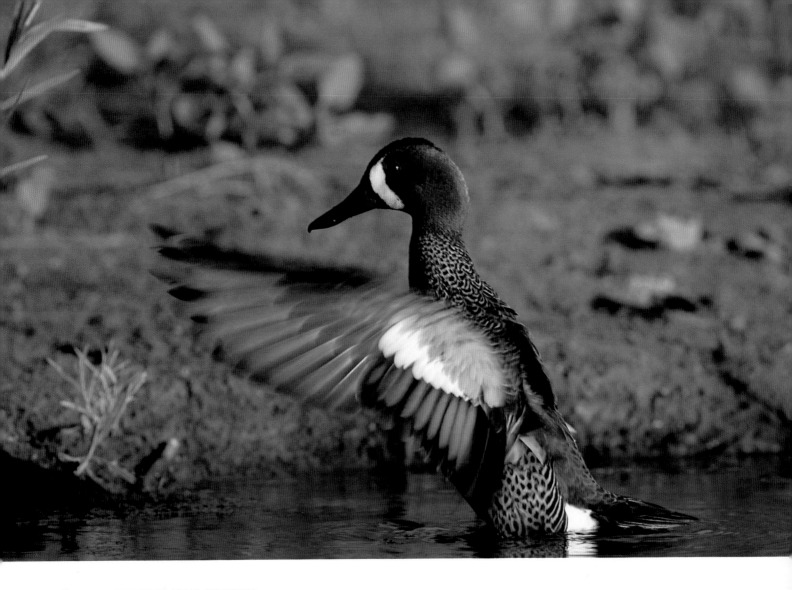

This **BLUE-WINGED TEAL** STRETCHES
AND FLAPS HIS WINGS TO REARRANGE HIS
FEATHERS. ALTHOUGH WELL KNOWN FOR
THE BLUE WING PATCHES, THE COLOR IS
ALSO COMPLEMENTED BY GREEN AND
WHITE. FROM A DISTANCE THE WHITE
FACIAL CRESCENT, SEEN ONLY IN SPRING
PLUMAGE, IS HIS MOST DISTINCT MARKING.

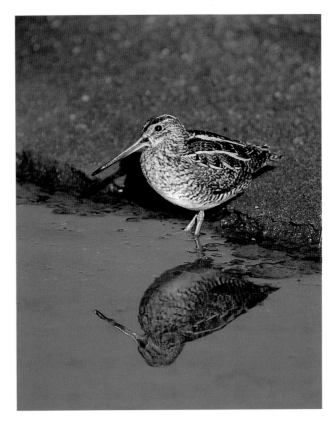

THE **WILSON'S SNIPE** IS USUALLY A
LONER IN THE MARSH. IT FREEZES IN PO-
SITION IF APPROACHED BEFORE ERUPTING
INTO A WILD ZIGZAG FLIGHT AT THE LAST
MOMENT. IT IS ALSO SEEN IN ROADSIDE
DITCHES, WHERE THIS BIRD POSED FOR
AN UNUSUALLY OPEN VIEW.

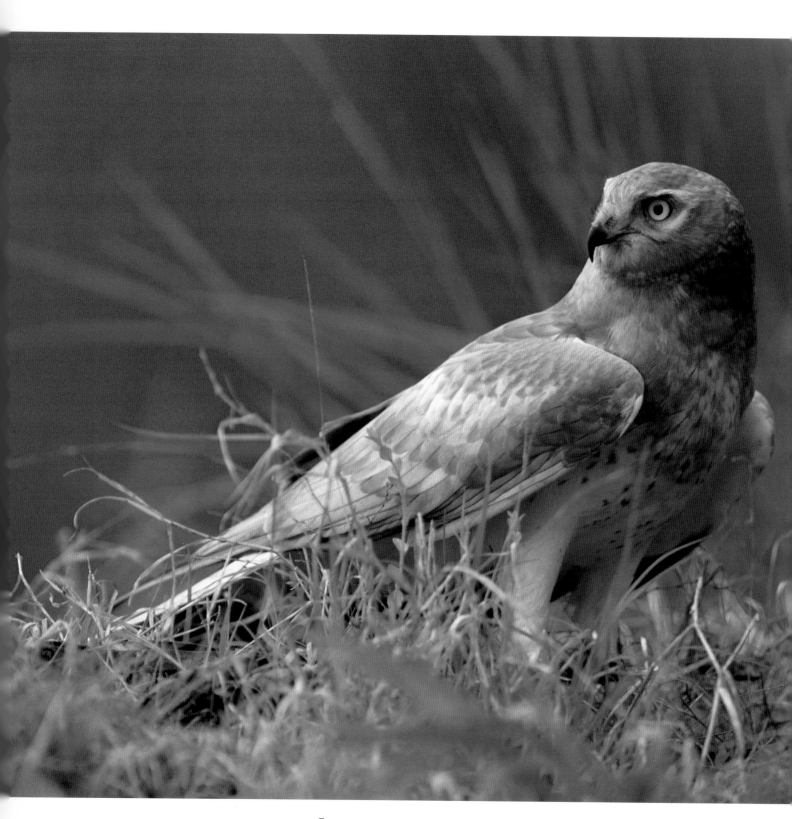

The **NORTHERN HARRIER** was once called a marsh hawk. It commonly hunts grasslands and wetlands. The male, pictured here, is largely gray, and the female is mostly brown. Both have a distinctive white rump.

It is always a pleasure to see northern harriers coursing low over a wet meadow or prairie marsh. They are so graceful in their leisurely flight and so quick to drop down on a small rodent that they are clearly masters of their domain. They are even more exciting to watch in early spring, when males mark out their territories by flying in a long series of steep climbs and sharp dives, so that a near-looping pattern is produced. The generic name for harriers, *Circus*, means circular and refers to this rather acrobatic tendency. The English name "harrier" does not refer to any possible preference for hares as prey but to the determined manner in which the birds might harry their prey until it is finally captured.

The red-winged and yellow-headed blackbirds provide some interesting similarities and differences. The yellow-headed blackbird is essentially confined to the larger and deeper marshes of the Great Plains and the American West, where the birds nest colonially in emergent vegetation. They reach their maximum densities in the glaciated pothole region of the Dakotas and are rare east of Min-

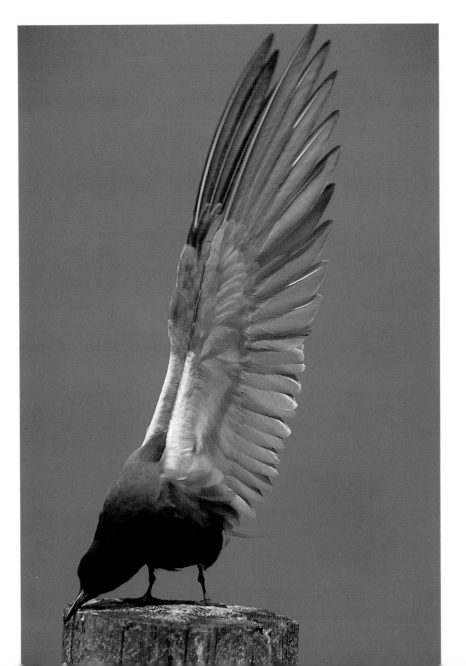

WINTERING ALONG THE COASTS OF CEN-TRAL AND SOUTH AMERICA, THE **BLACK TERN** RETURNS EACH YEAR TO BREED ON THE PRAIRIE POTHOLES AND MARSHES IN THE NORTHERN GREAT PLAINS. AFTER RESTING ON A FLOODED FENCE POST, THIS BIRD STRETCHES HIS LONG WINGS BE-FORE LIFTING INTO FLIGHT.

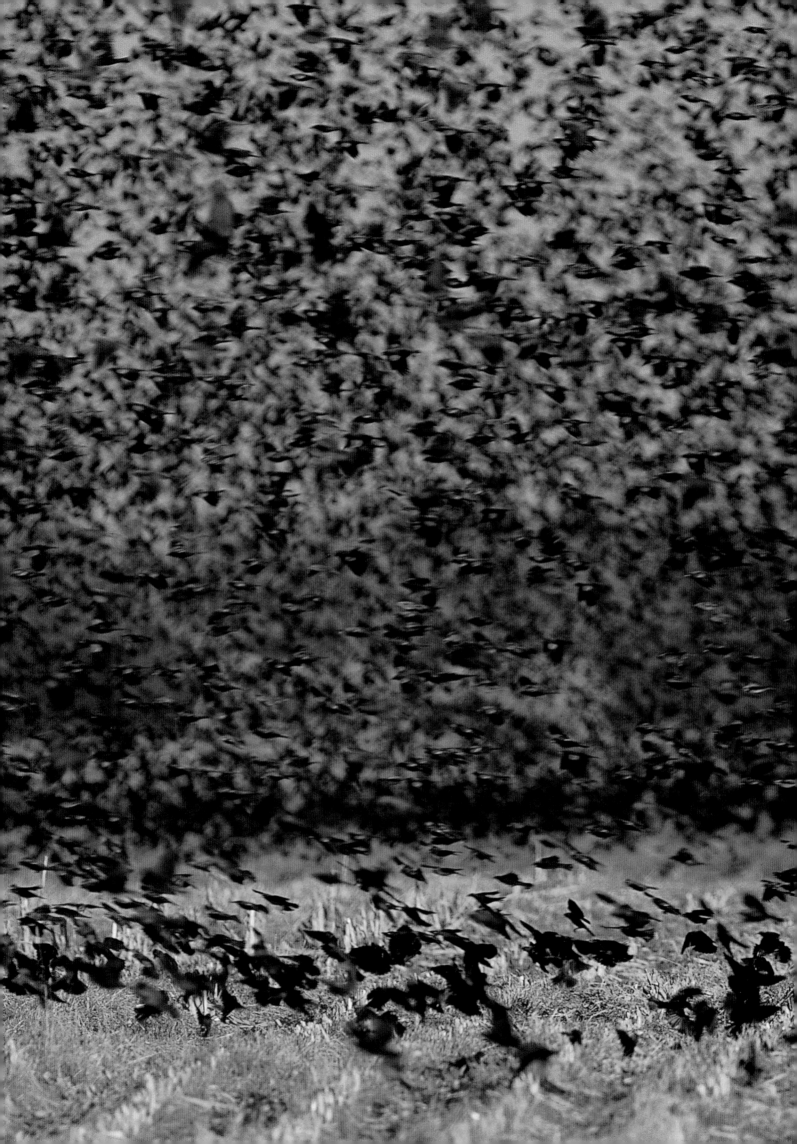

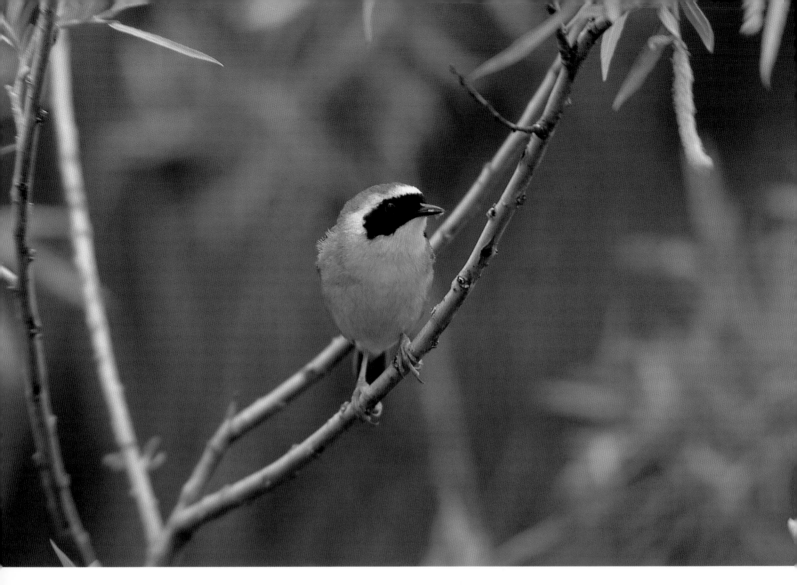

THE **COMMON YELLOWTHROAT** IS THE ONLY WARBLER COMMONLY FOUND LIVING IN CATTAILS. ITS CALLS AND REPETITIOUS SONGS ARE EASILY HEARD, BUT ITS SECRETIVE HABITS MAKE IT DIFFICULT TO LOCATE.

THE BRILLIANT PLUMAGE OF THE MALE **YELLOW-HEADED BLACKBIRD** MAKES IT EASY TO IDENTIFY. THE BIRD HAS A SHOWY DISPLAY AND A VOICE THAT SOUNDS LIKE A RUSTY HINGE.

nesota. The red-winged blackbird, although often a colonial nester in marshes, is much more tolerant of smaller, shallower wetlands and may even nest in roadside ditches with little or no water or in other almost upland situations. Its total nationwide breeding population is unknowably large, but at least from North Dakota through Kansas it ranks among the top five species as to overall breeding ubiquity or commonness, and in Oklahoma there are breeding records for nearly every county. Such are the advantages of broad ecological tolerance. Added to this, during fall and winter millions of red-winged blackbirds migrate through the Great Plains states, with concentrations in some single refuges exceeding 1 million birds. These numbers are so great that federal agencies have considered organizing a mass extermination campaign.

(OVERLEAF) HUGE FLOCKS OF **RED-WINGED BLACKBIRDS** GATHER EVERY AUTUMN AND WINTER. THEIR RED EPAULETS FLASH AS THEY DESCEND ON FIELDS TO GLEAN LEFTOVER GRAIN. FLOCKS LIKE THIS CAN BE COSTLY TO RANCHERS IF THE BIRDS DINE AT A FEEDLOT.

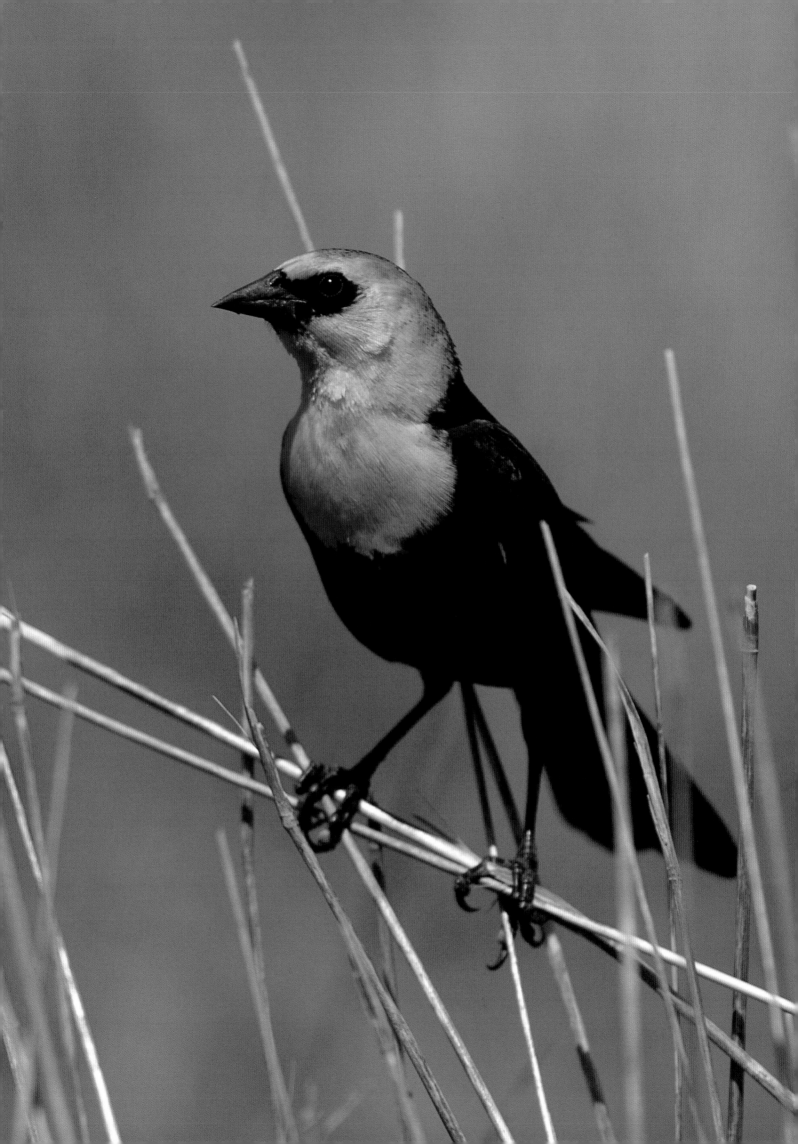

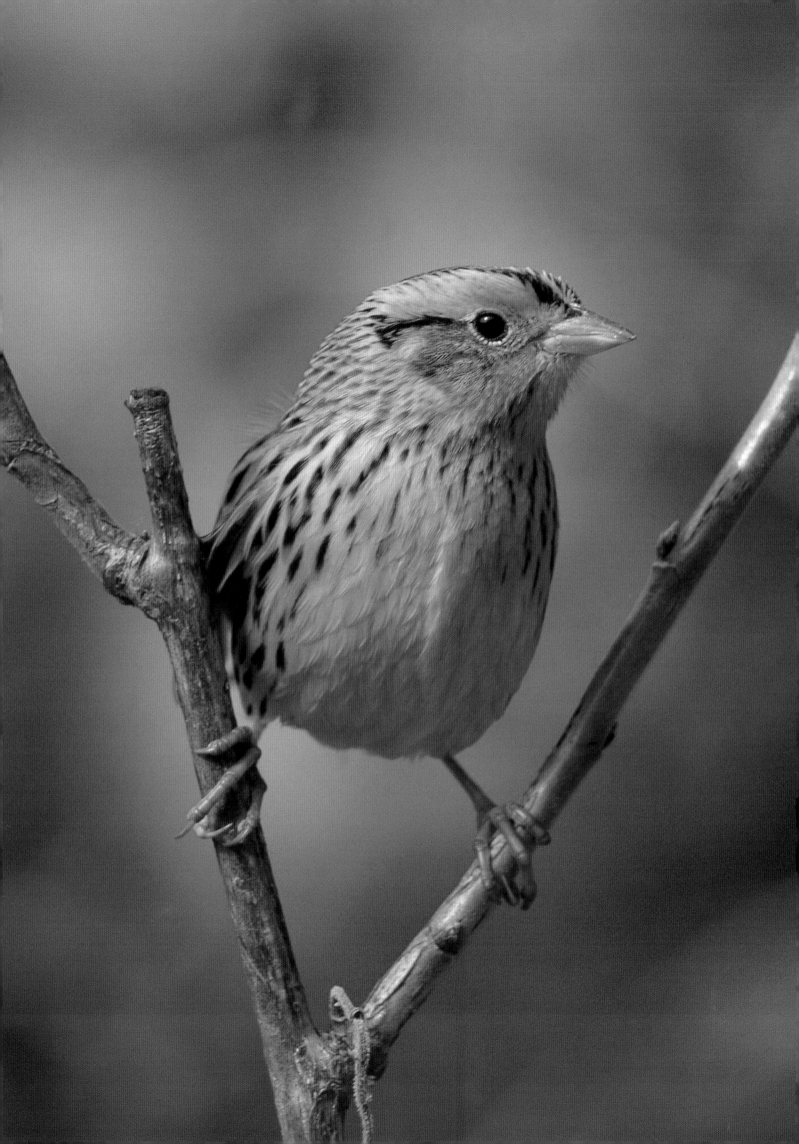

Only dedicated birders put in enough effort to get a good look at a **LeConte's sparrow.** They nest in wet grasslands in the northern plains. They fly a short distance when flushed, then drop out of sight into thick grasses.

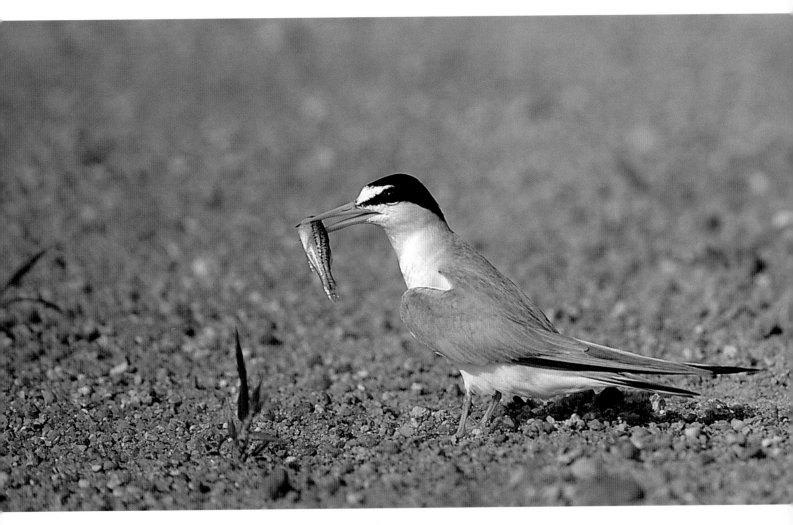

This **LEAST TERN** has returned to its nesting area with a tiny largemouth bass as a gift for its mate. It nests on sandbars and alkali salt flats. The Great Plains race of the least tern is nationally endangered.

Mammals

If beavers can be regarded as the engineers of American forest wet-
lands, then muskrats perhaps deserve the titles of city planners. In the
open plains, where trees are few and far between, the muskrat actu-
ally takes over both roles, constructing not only thoroughfares
through heavy marsh vegetation but also houses of marsh weeds,
roots, and branches. These large constructions, up to eight feet in di-
ameter and four feet high, not only provide safe homes for a muskrat
family but also offer sunning spots for turtles and perching places or
even nest sites for birds such as ducks, geese, and other water birds.
Canals leading from the house to foraging sites are dug out, making
easy swimming routes for aquatic birds. Nests of species such as
grebes, ruddy ducks, and canvasbacks are often located close to such
escape paths, sometimes on the feeding and resting platforms already
constructed by the muskrats.

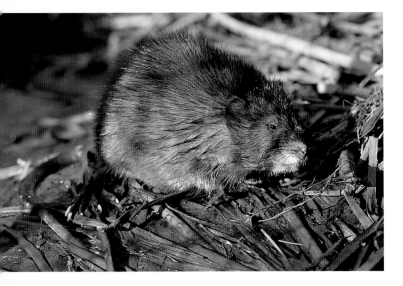

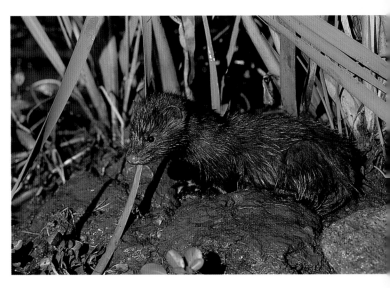

MUSKRATS LOVE CATTAILS. THEY EAT THEM, LINE SLEEPING
CHAMBERS WITH THEM, AND EVEN BUILD LODGES OUT OF THEM.
THEIR TAILS ARE UNIQUE; THEY ARE FLATTENED VERTICALLY AND
SERVE AS A RUDDER WHILE SWIMMING.

THE MINK IS A NOCTURNAL MEMBER OF THE WEASEL FAMILY AND
EXTREMELY QUICK AND AGILE. THEY ARE EXCELLENT SWIMMERS
WITH WEBBED TOES AND PREY ON ANYTHING IN THE MARSH THEIR
SIZE OR SMALLER. THEY ARE A MAJOR PREDATOR OF MUSKRATS.

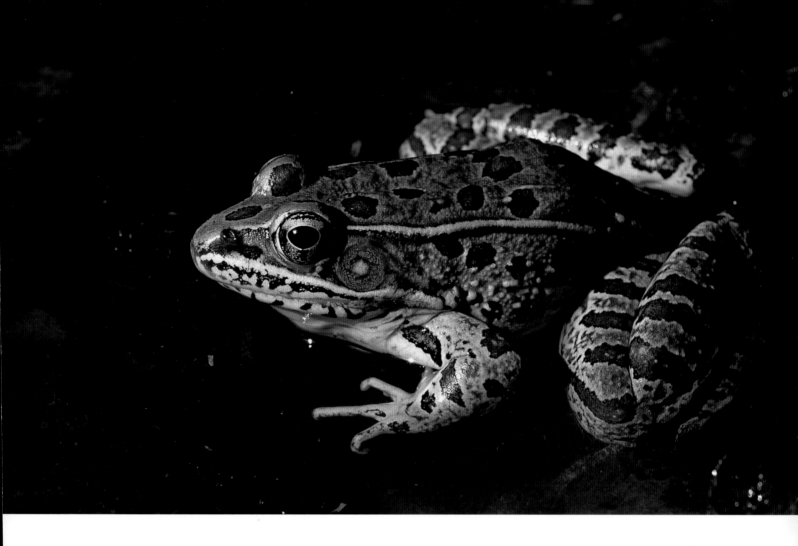

Amphibians

The plains leopard frog is the common pondfrog species that is familiar to almost every child of the Great Plains, or at least those living south of the Platte River. The plains leopard frog is gradually replaced farther north in Nebraska and southern South Dakota by the very similar northern leopard frog, which for all intents and purposes is essentially identical in appearance. Where the two species occur together in Nebraska, the plains leopard frog is generally recognizable by being more tan dorsally; the northern leopard frog is more greenish, with its dark spots more clearly bordered by white. In the plains leopard frog the conspicuous white line extending laterally from the snout down the upper trunk to the tail is typically broken at the base of the hind leg, but it is continuous in the northern leopard frog. The plains leopard frog also has a pale yellowish bull's-eye spot on its round eardrums and a more prominent yellowish jaw stripe. The mating call of the plains leopard frog is a series of two or three guttural notes per second, producing a chucklelike sound; that of the northern leopard frog is more snorelike, lasting about three seconds.

FOUND IN NEARLY ALL AQUATIC ENVIRON-
MENTS, THE **PLAINS LEOPARD FROG**
IS PREY FOR HERONS, RACCOONS, MINK,
SNAKES, TURTLES, AND FISH. FEMALES
PRODUCE SIX THOUSAND OR MORE
EGGS EACH SEASON TO BALANCE THE
MORTALITY RATE.

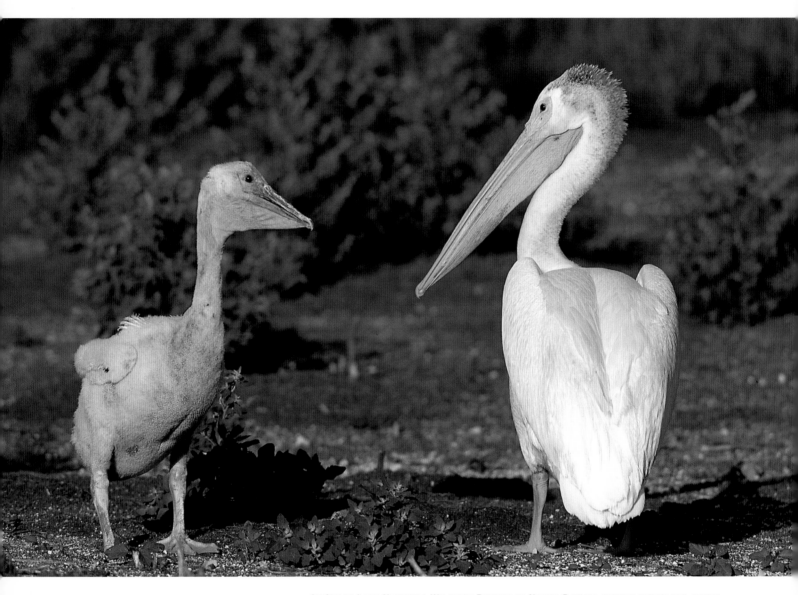

At Chase Lake National Wildlife Refuge in North Dakota, thirty thousand adult **AMERICAN WHITE PELICANS** gather to nest each year. This chick already weighs nearly ten pounds. Parents will fly as far as eighty miles in search of food.

Field Notes

I'd been telling Mary, my wife, that this was going to be a great North Dakota adventure. We had a special-use permit from the U.S. Fish and Wildlife Service to enter the Chase Lake National Wildlife Refuge to photograph a nesting colony of American white pelicans. This is one of the largest breeding colonies in the Great Plains. Recent counts indicated there were about fifteen thousand nests attended by thirty thousand adults and some thirty thousand chicks. High water had flooded their usual nesting island, and the birds were nesting on a long peninsula extending into the lake.

Following the map we'd been given, we found ourselves navigating back roads and pastures in an attempt to bypass the flooded roadways that usually provided access. The last five miles we bounced along a pasture road with foot-tall grass growing between the tire tracks. Mud puddles and flooded sections made it necessary to stop and check on foot before plowing through with my Volkswagen camper van. Along the way we saw a few white-tailed jackrabbits, plenty of bobolinks, and several chestnut-collared longspurs. About a mile and a half from the pelican colony we knew we had driven as far as we could go. The roadway disappeared into the flooded lake, which covered the road for at least 150 yards. Hiking around it wasn't an option. It was time to start wading.

At this point my wife still wasn't convinced that this was something she really wanted to do. I pointed out that she couldn't pass up this unique opportunity to see the pelicans and that the water probably wasn't very deep. She countered by saying that what I really wanted was her help in carrying the camera gear. (She's obviously rather intuitive.) As it turned out, the water was only knee-deep. The trick was to maintain a straight path so that we didn't step off the roadway into the flooded ditch. We both crossed without mishap.

From a small hilltop, we could see the peninsula and the shoreline white with pelicans. From here it was an easy mile hike through the prairie. At the edge of the colony we spent three hours watching and photographing the adults and young. After the chicks are several weeks old, the adults will leave them unattended. The youngsters gather in large groups, or crèches, of hundreds of birds, all looking identical. When the parents return they somehow recognize and feed their own chicks.

After we returned to the van, we spent the next several hours removing the ticks we had accumulated on our hike through the grasses. Over the next twelve hours we removed 103 ticks from our clothes, our van, and ourselves. I will always remember the pelicans. Mary will always remember the ticks.

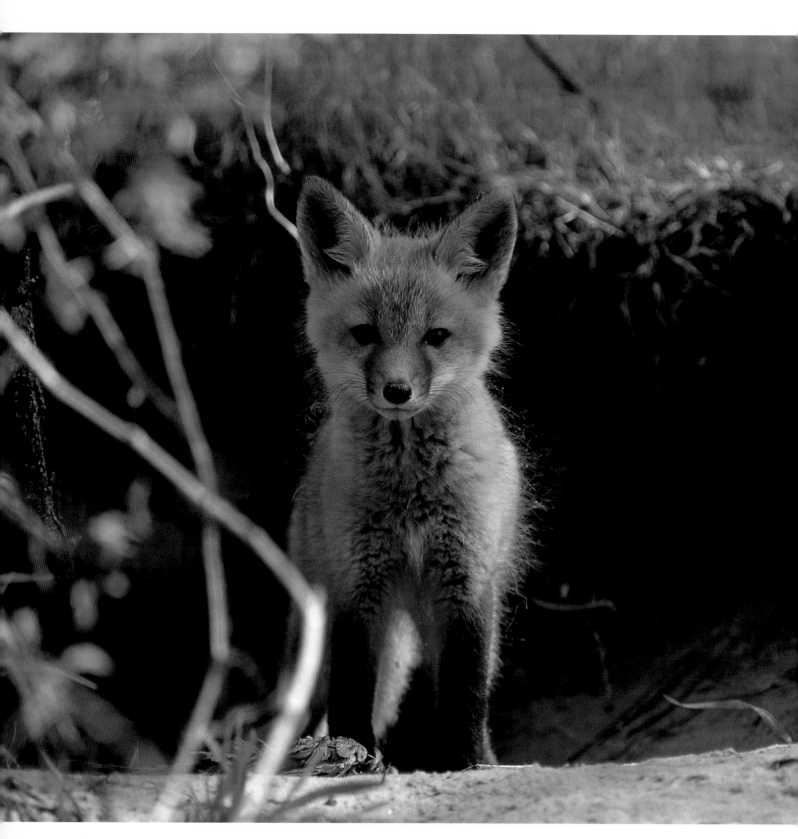

IN RURAL AREAS COYOTES WILL CATCH AND KILL **RED FOXES.** MOST COYOTES ARE RELUCTANT TO ENTER URBAN AREAS, BUT RED FOXES

SEEM TO HAVE ADAPTED WELL. THIS YOUNG PUP IS STANDING AT THE ENTRANCE TO ITS DEN IN A CITY PARK IN WICHITA, KANSAS.

THE WILDLIFE AROUND US

Most of the Great Plains wildlife species and their habitats have suffered from the effects of humans, some to a great degree. Yet others have not only adapted but in a few cases have thrived. To a large degree, these are edge-adapted species, which once mainly occurred along places of abrupt ecological shifts, such as the borders of woods, where they encountered grasslands. Humans have greatly increased the amounts of available edge habitat by opening and fragmenting forests, planting trees in once treeless areas, building highways and railroads, digging ditches, erecting bridges or buildings, establishing farmsteads, and generally civilizing the land.

Many edge-adapted species of wildlife, as well as some otherwise ecologically preadapted species, quickly responded to the presence of humans, including nearly all those birds and mammals that are most often now seen around town, villages, and farms. Thus, we now have chimney swifts that nest exclusively in chimneys instead of trying to seek out hollow trees, purple martins that now nest almost entirely in communal birdhouses, common nighthawks that nest on flat, gravelly rooftops, and barn owls and turkey vultures that nest in abandoned buildings instead of using natural recesses. Various gulls, mice, rats, and opossums now feed largely on urban trash, coyotes have learned that they can survive on rats and mice around farms, and red foxes have found that they can escape coyotes by living in the suburbs. Similarly, American crows have increasingly adapted to city life, where they live fairly free of harassment by hawks by day and nocturnal attacks by great horned owls. Chickadees, mourning doves, American robins, blue jays, and northern cardinals readily exploit the largess of backyard bird feeders, as do the less appealing European starlings, common grackles, house sparrows, and brown-headed cowbirds. Eastern screech owls survive and breed much better in the suburbs than in the country, thereby largely escaping attacks by great horned owls; and cottontail rabbits and fox squirrels have discovered much the same.

Birds

One of the few bright spots in North American conservation efforts has been the peregrine falcon. Although it was brought to the brink of extirpation in North America during the hard pesticide era of the 1940s through the 1960s, a massive federal effort combined with the work of private groups such as the Peregrine Fund has seemingly turned the tide. In fall 2001 I happened to flush a peregrine from a wooded area while driving a country road within ten miles of Lincoln, Nebraska, and a friend saw one perched on a telephone pole in her front yard within the heart of Lincoln that same autumn. If we had reported such sightings about twenty years ago our sanity would have been rightfully questioned. Under a breeding program directed by state and federal conservation agencies and carried out by the volunteer efforts of Raptor Recovery Nebraska, nearly twenty peregrines have been hatched and fledged during the last decade from Woodmen Tower in Omaha, the city's tallest building. Peregrines have even occasionally tried to nest just under the gold-leafed dome of Nebraska's state capitol building in Lincoln, where they have used the nighttime lights that illuminate the tower to locate and prey on night-flying birds such as nighthawks as well as on their usual daytime prey. Although these are the only known nesting sites in Nebraska, they are the first in nearly a century, for in presettlement days the tall cliffs of Nebraska's Pine Ridge region probably provided the only ideal nesting habitats for the species.

Like peregrines, barn owls have different nest-site tendencies now than they had in presettlement times. Then they had to depend entirely on natural cavities, such as tree hollows or recesses in vertical cliffsides, for nest sites. With settlement came the opportunities for nesting in abandoned buildings, barns, and other outbuildings associated with ranches and farms. A ranch or farm with a pair of resident barn owls is lucky indeed; a single barn owl might consume up to one thousand mice in a year, making these birds more effective than barnyard cats in controlling rodent pests. Yet their ghostlike presence and their sometimes blood-curdling nighttime screams do not always make them the most beloved of country neighbors, and barn owls often were unjustly blamed for poultry losses that were more likely to have been caused by great horned owls. For these and other reasons, such as general habitat losses, the barn owl has become ever less frequently encountered in the plains states and elsewhere in North America.

PEREGRINE FALCONS NESTED HISTORICALLY THROUGHOUT MUCH OF NORTH AMERICA WHERE CLIFFS PROVIDED PREFERRED NESTING LOCATIONS. TODAY, THEY NEST ON URBAN CLIFFS PROVIDED BY LARGE BRIDGES AND WINDOW LEDGES OF TALL BUILDINGS.

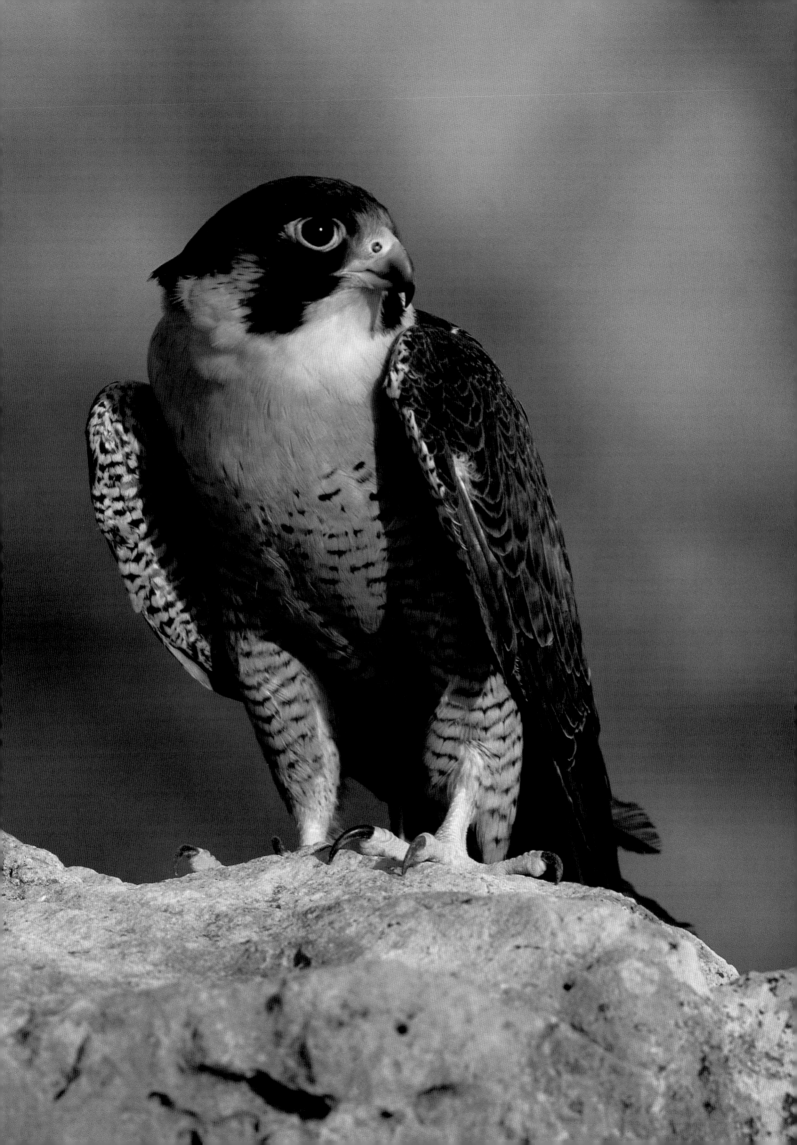

THE APPROPRIATELY NAMED **BARN OWL** FAVORS BARNS, OLD BUILDINGS, HOLLOW TREES, AND HOLES IN EARTHEN BANKS FOR NESTING AND ROOSTING. THEIR INTENSE SCREECHING HAS PROBABLY LED TO THE HAUNTED REPUTATION OF SOME ABANDONED BUILDINGS.

It is somewhat surprising that the mourning dove has never been selected as an official state bird. Few birds have more beautiful voices, few are more elegant, and few are more abundant, at least in the Great Plains states. Based on breeding bird survey and related information, it is likely that mourning doves are the most abundant breeding bird in both Nebraska and Kansas; they may be tied for first place in Oklahoma; they are second-most common in South Dakota; and they are about the eleventh most common in North Dakota. At least in part this remarkable abundance results from the ability of mourning doves to nest almost anywhere. They will nest on the ground in grassland

THE **MOURNING DOVE** IS HIGHLY ADAPTIVE AND IS FOUND ABUNDANTLY IN ALL PARTS OF THE GREAT PLAINS. ITS MELANCHOLY CALL IS FAMILIAR IN BOTH RURAL AND URBAN LOCATIONS.

areas, in bushes where these are the most common potential sites, and in trees wherever they are available. Furthermore, although the birds consistently lay only two eggs per nesting cycle, they begin a new nest cycle almost before their last brood is fledged, so that four or five broods per breeding season might be produced in a good year. Few if any other North American birds seem to tolerate parenthood as much as mourning doves.

Barn swallows are another of the birds that are so familiar to humans living on farms and in cities that we sometimes scarcely seem to notice them. In Nebraska and Kansas they are second only to the mourning doves as to frequency of occurrence in breeding bird surveys. Barn swallows consistently appear in Nebraska about the second week in April, just as spring is also being welcomed with the first flowers of the year. They also remain on their nesting grounds later than the other swallows. Often they are still flying above Nebraska farmyards in early October, trying to gather in just a few more insects before heading south. Cliff swallows and tree swallows typically leave for warmer lands in Central or South America in August or by early September.

ORIGINALLY NESTING ON CLIFFS, **BARN SWALLOWS** FOUND BARNS TO BE SUPERIOR IN MANY WAYS. NOT ONLY ARE WALLS AND HORIZONTAL BEAMS PROTECTED LOCATIONS FOR NESTING, BUT THEY ALSO PROVIDE ABUNDANT INSECTS FOR FOOD.

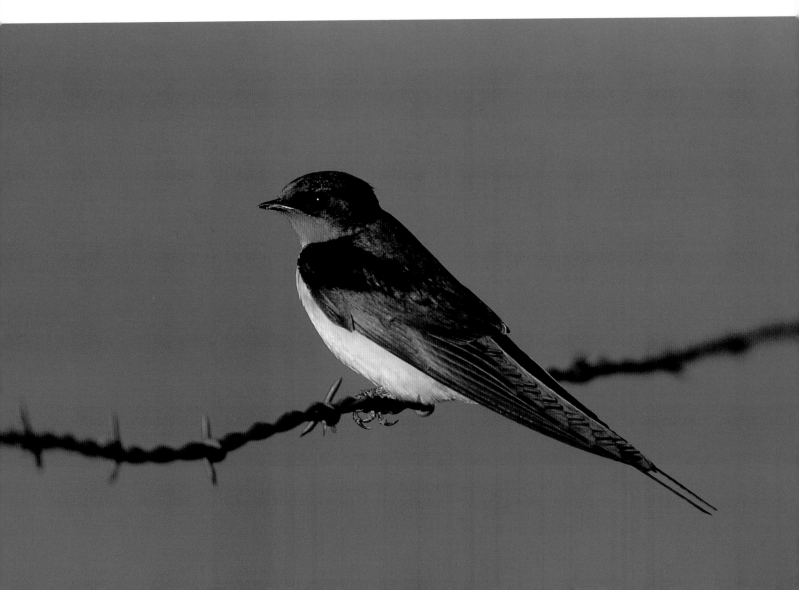

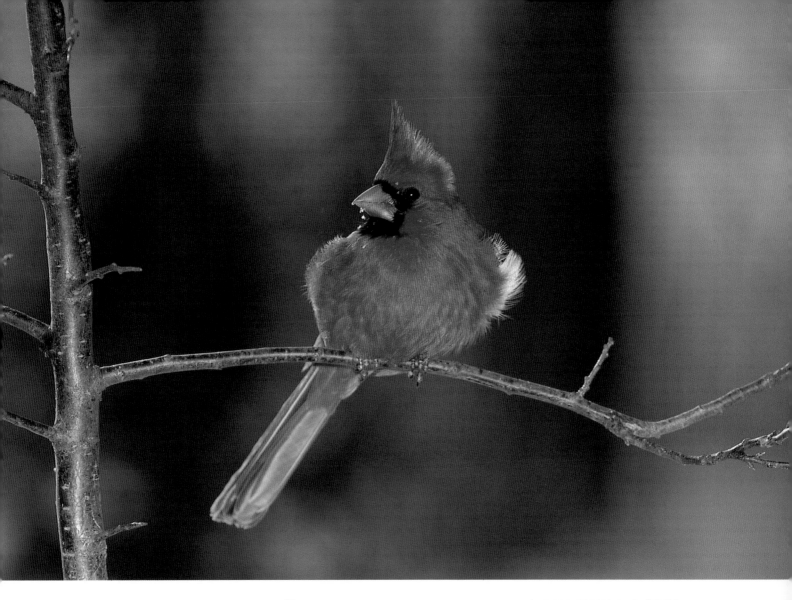

NORTHERN CARDINALS ARE NEARLY EVERYONE'S FAVORITE YARD BIRD. PEOPLE APPRECIATE THEIR BRILLIANT RED PLUMAGE AS WELL AS THEIR CHEERFUL SONG. THEY ARE EASILY ATTRACTED TO LANDSCAPING SHRUBS, BIRD FEEDERS, AND BIRDBATHS.

Few North American birds are so widely recognized, or so obviously loved, as the northern cardinal. No doubt most urban people take up backyard bird feeding in hopes of attracting cardinals and consider satellite species such as chickadees, American robins, house finches, and all the other typical backyard birds as only second-rate. To add to the amazing beauty of the males there is also its wonderful song, one of the cheeriest and loudest of all urban birds. It is also usually the earliest to begin singing in late winter; even by mid-January in Nebraska and Kansas there is a slight chance of hearing a cardinal singing. It is not surprising that cardinals have been chosen as the representative state bird for seven states.

One cannot argue that the common grackle is not beautiful; a male performing his intimidation display, with his chest and neck feathers fluffed, his tail spread and his wings slightly spread, surprisingly resembles a miniature version of some of the long-tailed and violet-black birds-of-paradise. Being able to see such beauty in one's backyard is a reasonable recompense for the fact that grackles are noisy, boisterous birds prone to steal and eat the eggs and nestlings of other songbirds. They also gather with vast numbers of other "blackbirds" during fall migration, descending on both cities and countrysides in search of grain or anything else that happens to be in good supply. By late fall they typically move out of the central plains states into wintering areas mostly in the southeastern states. During Christmas counts of the 1960s and early 1970s they were responsible for the second-highest average overall-abundance value nationally of nearly ten thousand birds seen per party hour. Their maximum breeding densities occur to the east of the Great Plains, as they are much more attracted to woodland edge or savanna habitats than to open grasslands.

THEIR ATTRACTIVE PLUMAGE AND BOLD BEHAVIOR MAKE **BLUE JAYS** ONE OF THOSE BIRDS NEARLY EVERYONE CAN IDENTIFY. THEY ARE HIGHLY INTELLIGENT AND VOCAL. FLOCKS WILL SOMETIMES GATHER TO SCOLD HAWKS, OWLS, OR GROUND PREDATORS.

FROM A DISTANCE **COMMON GRACKLES** MAY APPEAR BLACK BUT UNDER GOOD LIGHT SHOW IRIDESCENT COLORS OF PURPLE, BLUE, AND BRONZE. INSTEAD OF RELYING ON THE HOPPING MOVEMENT OF MANY BIRDS, FORAGING GRACKLES WALK ABOUT THE YARD WITH LARGE STEPS, MAKING THEM APPEAR BOLD AND CONFIDENT.

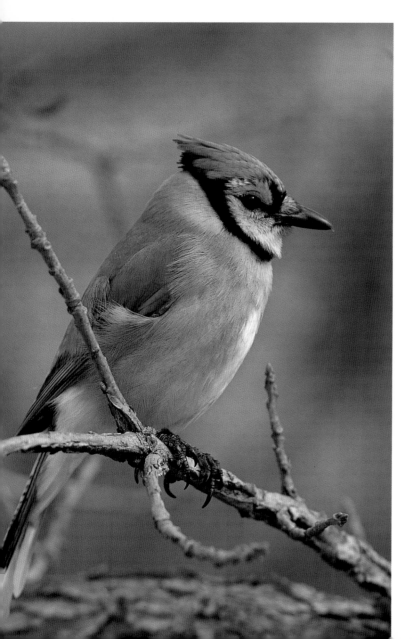

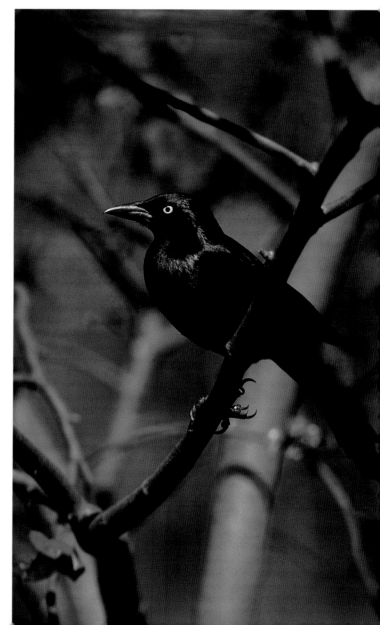

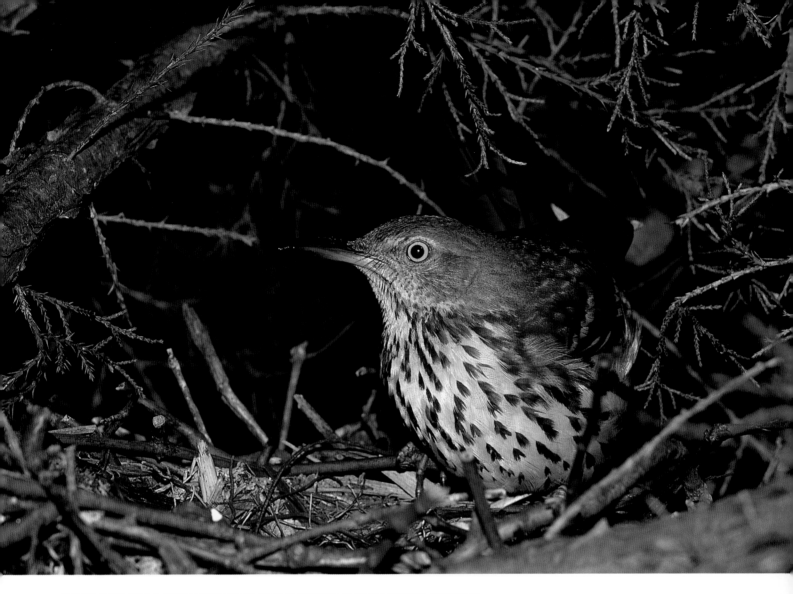

The **BROWN THRASHER** SEEMS TO BE MOSTLY AT HOME IN DENSE SHRUBS. ALTHOUGH RATHER SHY AND SECRETIVE, IT WILL USUALLY SING FROM A PROMINENT PERCH. IT IS CREDITED WITH HAVING ONE OF THE LARGEST REPERTOIRES OF ALL NORTH AMERICAN BIRDS.

As compared with the familiar and well-loved northern cardinal, mourning dove, and barn swallow, the brown-headed cowbird is unlikely to make anyone's list of favorite birds. Considering the five plains states from North Dakota through Oklahoma, it is among the ten species judged most abundant or most frequently reported as breeding in all five and rises to as high as third place in South Dakota. Although the common cuckoo of Europe has evolved a nearly unbelievable number of specialized tricks to help fool its songbird hosts into accepting its eggs and rearing its young, the cowbird has seemingly adopted the viewpoint once expressed by Woody Allen, namely, that 95 percent of success may be achieved by simply showing up. Cowbird eggs have "shown up" in the nests of more than two hundred species of songbirds throughout North America, but their eggs are most frequently laid in the nests of grassland-nesting birds, the ecosys-

tem in which cowbirds first evolved. There is no special trend toward specific egg mimicry; the cowbird egg is of a generalized spotted pattern that vaguely resembles those of dozens of grassland sparrows. The incubation period is not significantly shorter than those of its hosts, and the young show no tendency to mimic the appearance or behavior of the hosts. Instead, they simply scream for food more often and more effectively than do the host young and thus get most of the food that is delivered to the nest by the hard-pressed parents.

BROWN-HEADED COWBIRDS USE A VARIETY OF POSTURAL DISPLAYS. THE UPWARD BILL-TILTING OF THE MALE ON THE LEFT IS A SIGN OF AGGRESSION. THE OTHER TWO ARE IN STAGES OF A BOWING DISPLAY ACCOMPANIED BY A FEW GURGLING NOTES AND A SLURRED WHISTLE.

KILLDEER WILL NEST IN ANY AREA WITH SMALL ROCKS TO HIDE THEIR EGGS, INCLUDING PARKING LOTS AND DRIVEWAYS. WHEN THE NEST IS APPROACHED, THE KILLDEER WILL FEIGN INJURY BY SCREAMING AND DRAGGING ITSELF ALONG WITH ITS WING FLUTTERING AWKWARDLY AS IF BROKEN. ONCE THE INTRUDER IS AT A SAFE DISTANCE, THE KILLDEER WILL FLY OFF UTTERING ITS KILL-DEEER CALL.

Mammals

Our views and attitudes about coyotes have been shaped by far too many childrens' stories and hunters' tales of the wild west—a villain is a basic part of almost any good story. Wolves and coyotes have made admirable villains for as long as there have been good storytellers. Native Americans considered the coyote as a trickster figure, a rather godlike mixture of magician and practical joker. It is a gentler view of coyotes than our nearly universal current one, a wily, cunning, wicked, and all-around unpleasant animal that is best shot on sight. I have seen enough dead coyotes strung up on barbed-wire fences, serving as some sort of gruesome trophies by anonymous marksmen, to last for several lifetimes.

In spite of more than a century of unrelenting persecution, the coyote survives. Its range and abundance actually increased after prairie wolves were eliminated, inasmuch as wolves were one of their few natural enemies. Like crows, foxes, and other intelligent omnivores, the coyote has locally learned it can survive in the shadows of the suburbs and even in larger cities, sometimes eating from trash and avoiding guns by living within city limits. It may eat food set out for dogs and at times may even interbreed with them. All of this may be something of a social comedown for the Native American's classic trickster, but in the last analysis the coyote has seemingly outwitted us all.

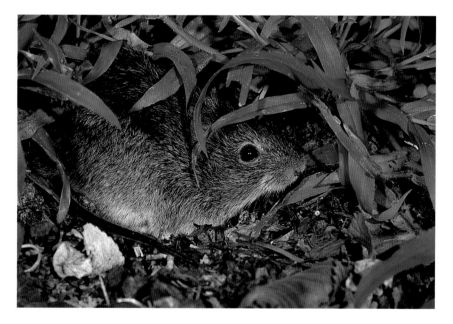

IN THE SOUTHERN GREAT PLAINS, **HISPID COTTON RATS** ARE COMMONLY FOUND IN AGRICULTURAL AREAS. CROPS SUCH AS COTTON AND CORN PROVIDE SUITABLE HABITAT, AS DO OLD FIELDS, HAY MEADOWS, AND GRASSY ROADSIDES.

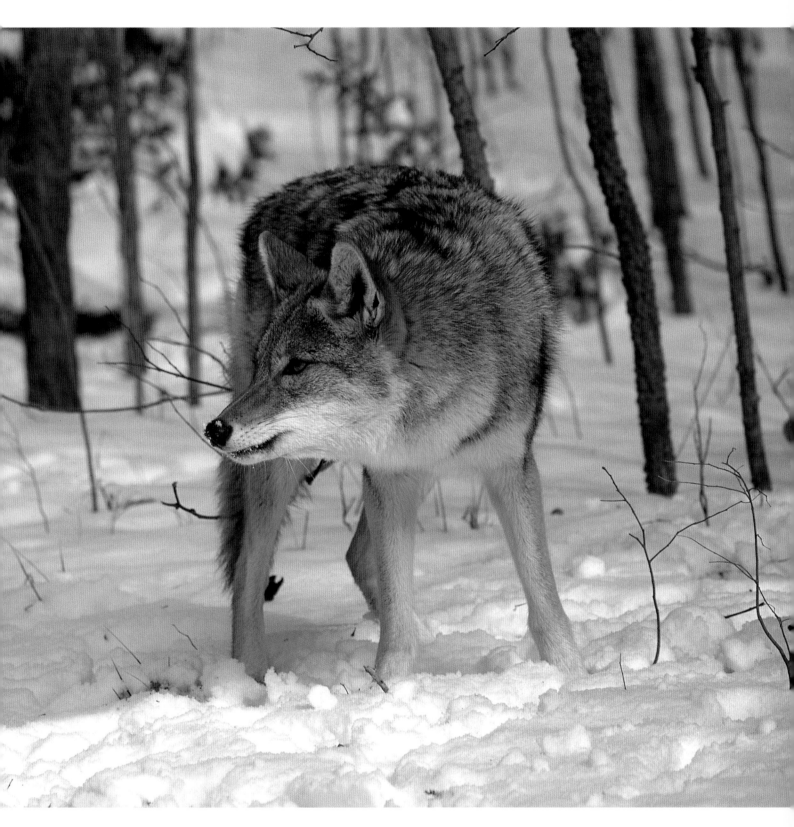

THE **COYOTE** IS A SURVIVOR. IN SPITE OF CENTURIES OF EFFORTS TO REDUCE COYOTE
POPULATIONS, THEY HAVE ACTUALLY EXPANDED THEIR RANGE. ORIGINALLY FOUND ON THE
GREAT PLAINS, THEY NOW LIVE IN ALL BUT THE SOUTHEAST UNITED STATES.

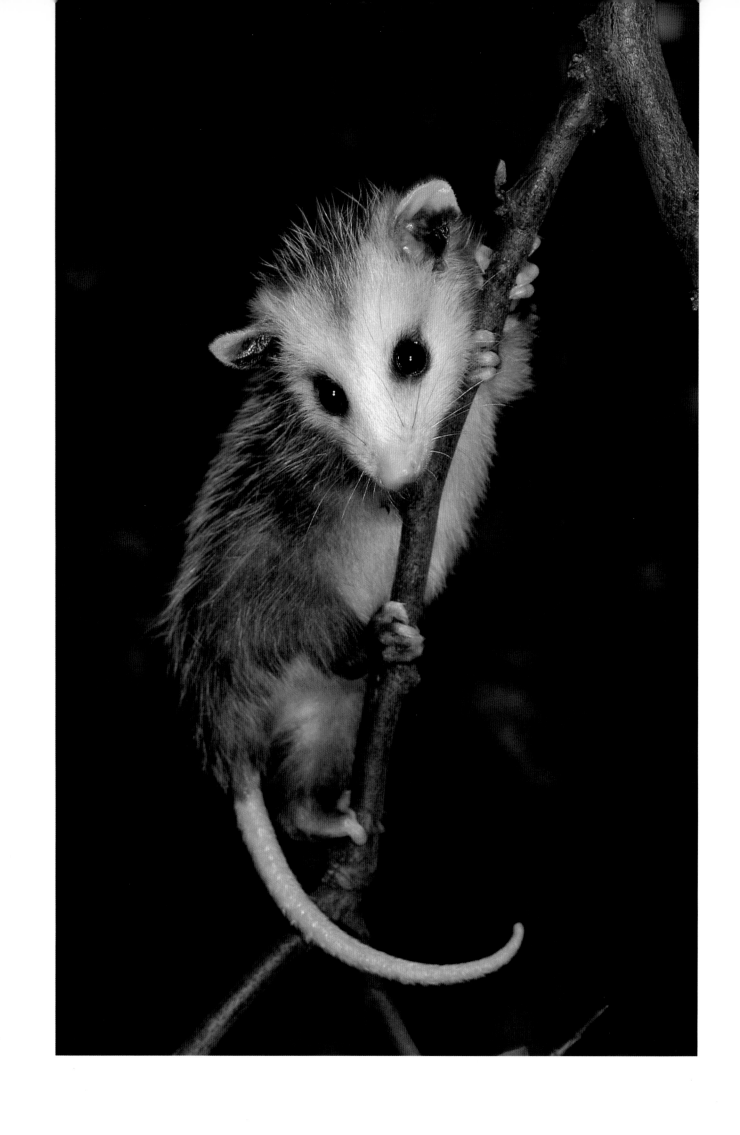

Another seemingly widespread plains animal that somehow manages to remain almost undetected by most people is the eastern spotted skunk. It is a smaller relative of the larger and much more commonly seen striped skunk. It occurs throughout almost the entire region considered here but is replaced by the very similar western spotted skunk in the Black Mesa country of extreme western Oklahoma. As its common name implies, its pelage pattern is one of elongated white spots on a black background. The bushy tail is mostly white, as in the striped skunk, and its Latin species name *putorius* gives some hint of the putrid smell it can discharge.

Because of their effective defense system, spotted skunks have few enemies, of which the great horned owl is probably the major one. Horned owls will attack any skunk without hesitation, but spraying by a skunk may have serious effects, perhaps blinding the owl or at least rendering it almost unable to hunt again. If given fair warning, the spotted skunk will run toward an intruder, stop about ten feet away, then do a quick handstand, and facing away from the enemy, eject a well-directed spray in its face. Thus, skunks are best appreciated from a considerable distance. Furthermore, at least the striped skunk is a major carrier of rabies in the United States, giving additional reason for avoiding close encounters of a most unpleasant kind.

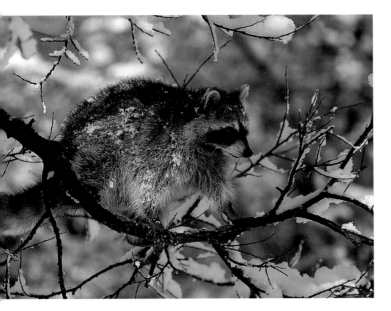

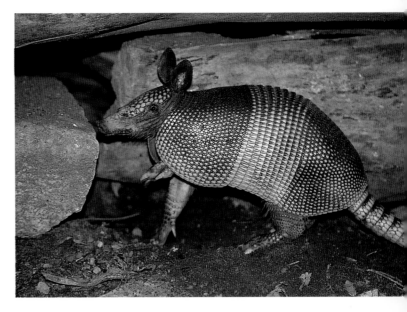

FEW AMERICAN MAMMALS ARE AS COMMON AND RECOGNIZABLE AS
THE **RACCOON**. THEY RAID CORNFIELDS AND HEN HOUSES. THEY
ARE VERY INTELLIGENT AND ROUTINELY RUN IN CITY NEIGHBOR-
HOODS, LOOKING FOR PETFOOD DISHES AND TRASHCANS.

OVER THE PAST DECADE, **NINE-BANDED ARMADILLOS** HAVE
EXPANDED THEIR RANGE NORTH OUT OF TEXAS AND OKLAHOMA
INTO KANSAS AND EVEN NEBRASKA. THEIR HEAVILY ARMORED
BODY IS PROTECTION AGAINST PREDATORS BUT LITTLE HELP
AGAINST VEHICLES. THEY ARE REMARKABLY AGILE AND WILL JUMP
STRAIGHT UP WHEN STARTLED.

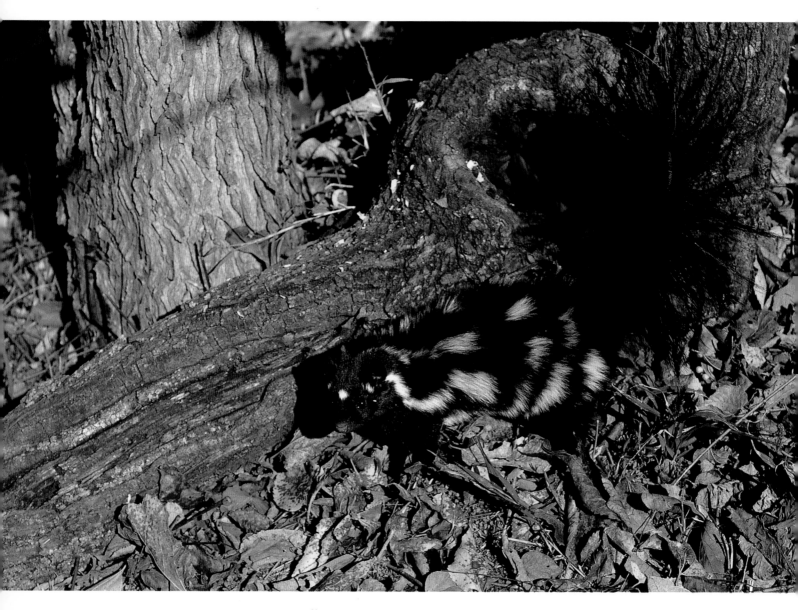

Unlike its lumbering cousin the striped skunk, the **EASTERN SPOTTED SKUNK** is surprisingly agile. Its body is slim and weasel-like, and it can climb trees to escape predators. When threatened it can perform an acrobatic hand-stand, giving it the advantage of seeing what it is shooting.

Field Notes

I'd seen their pictures in books and heard of "civet cats" since I was a kid. A neighbor in my small hometown fired at one in the middle of the night. The next morning everyone was talking about the skunk that got away and the ricocheted shotgun pellets lodged in the leg of the shooter. Twenty-five years later, I received a phone call one Saturday morning from the maintenance supervisor of a local golf course. He'd been using live traps to catch striped skunks, raccoons, and opossums living under the equipment buildings and suspected of digging up the golf greens. That morning he had caught something that looked odd to him, but he was pretty sure it was some kind of skunk. I told him I'd like to see it and would be there shortly. It turned out to be an eastern spotted skunk. It was the first one I'd ever seen, and I didn't want to waste a unique opportunity to photograph an animal that was becoming increasingly rare.

I had driven over in a rusty Toyota pickup with a cover on the back. I put a pile of wood chips in the back and set the trap and the skunk on the chips, using a pitchfork. I covered it with a piece of burlap and then covered the whole works with more chips. I moved slowly and managed to accomplish all of this without the skunk firing a shot. I drove about fifty miles to the Chaplin Nature Center to meet my friend, the director of the center, Gerald Wiens. We built a two-foot tall sheet-metal enclosure around a couple of small trees and a few pieces of hollow logs. Now all we had to do was to get the skunk out of my truck and into the enclosure. Apparently, the skunk was tired of the attention, and while we were still trying to snag the trap with the pitchfork he fired his first shot. The smell of a spotted skunk has been described as "more pungent than the mellow smell of the striped skunk." All I know is it made my eyes water, and I wondered how long it would take to get that smell out of my truck. We eventually got him into the enclosure and out of the trap. Over the next hour we played this game of peeking over the edge of the sheet metal trying to snap a few photos before he stamped his feet and assumed the spraying position by balancing on his front feet with his butt in the air. When he did that, we dove down behind the sheet metal. We also discovered he could climb trees nearly as well as a cat. His shape and movements reminded us more of a weasel's than of the lumbering behavior of a striped skunk. Eventually, we opened the enclosure and gave him his freedom.

About a week later I was coming out of Wichita's city hall, approaching my truck just as a couple got out of their vehicle parked next to mine. They looked around, pointed at my truck, then got back in their car and moved it several stalls away. I waited until they entered the building before I had the nerve to get in and drive away.

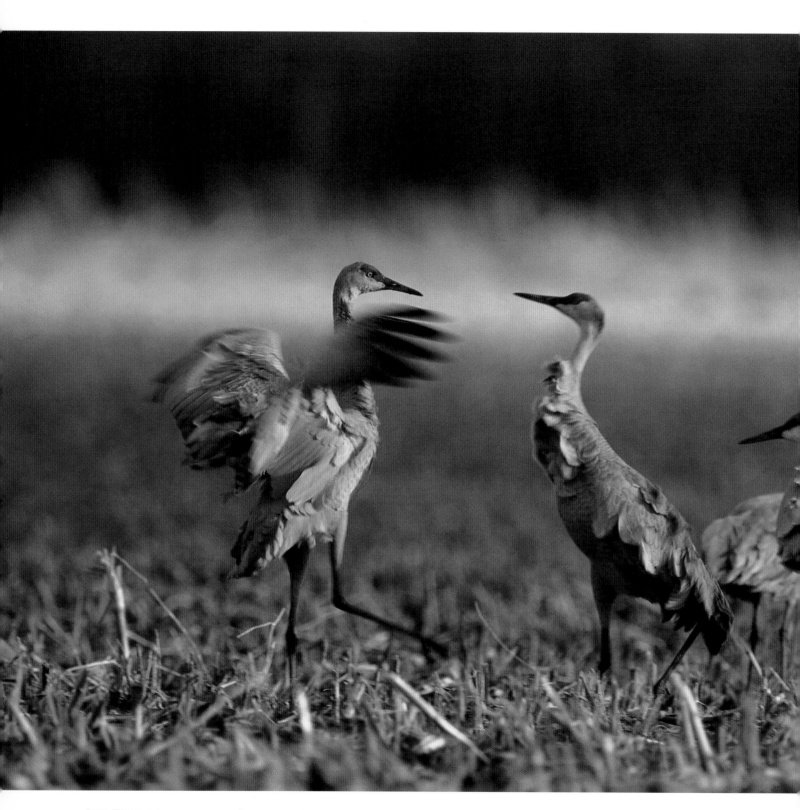

Over 80 percent of the world's **SANDHILL CRANES** gather along the Platte River in central Nebraska each spring. During the day they feed on waste grain and perform an elaborate dance that includes leaping into the air with outstretched wings. Their accompanying bugling is one of nature's most delightful sounds.

THE TRANSIENTS: MIGRANTS AND DRIFTERS

Even for humans life seems far too short, and single seasons are far shorter. Springs come and go so rapidly that summer-blooming prairie roses seem to appear even before the blossoms of pasqueflowers and purple avens have been transformed into wispy filaments of prairie smoke. Yet for a few weeks each spring and fall the Great Plains are visited from the air by uncountable millions of transients. Many move silently at night, with the only clear evidence of their passing the broken bodies of small, nocturnal migrant birds lying at the bases of tall buildings. Perhaps, while watching the pinpricks of light from distant stars, they fail to see those colossal objects in front of them. Others we hear but do not see, as in the choruses of migrating waterfowl flying high above the reflected lights of our cities, intent on reaching some destination beyond our ken. But many are so large or move in such numbers that we cannot overlook them. We come to measure our springs and falls by their regular appearance. These are often the natural guideposts of our lives, as in "the spring we saw the whooping cranes" or "the winter of the snowy owls."

Birds

Late March along the Platte is sheer magic. For more than a month sandhill cranes pour into the valley from Texas and New Mexico, their numbers topping out at nearly one-half million. From then until about mid-April countless cranes make their daily flights out into cornfields and meadows to harvest whatever grain and invertebrates they can find, building up critical fat stores that are essential for their remaining spring migration and arctic breeding. Near sunset each evening the birds begin moving toward traditional roosting sites on sandy islands and barren sandbars. Flocks of one thousand or more cranes fly low over the river, their voices rising and falling in crescendos as they approach, pass overhead, and disappear again in the distance. As the sun sinks ever closer toward the horizon the birds become increasingly nervous, hoping to find a safe landing place before it is wholly dark. Finally, some individual brave crane touches down, to be followed moments later by another, then dozens, and finally hundreds. Eventually, as many as twenty thousand may occupy a single roost, stretched out along a mile or more of the river. After their initial

jostling for position, and the rejoining of any pairs or family members that may have been temporarily separated in the confusion of landing, darkness settles in on the crane roost. In the sun-warmed mid-April days along the Platte, the birds ascend in great slow-motion whirlwinds, their wings lifted by invisible thermals until they are almost out of sight, with only their angelic calls wafting down to betray their excitement, as they head off toward unknowable destinations somewhere along the northern rim of the world.

The whooping crane is the gold standard of American birds; it is at once the tallest, one of the rarest, and certainly one of the most beautiful of all North American bird species. I was already in my sixties before I finally saw a wild whooping crane in Nebraska. And yet, except for their wintering grounds in coastal Texas, the Platte Valley of Nebraska has always represented the most likely place for seeing the birds on migration; still, the chances of actually doing so on a given day are probably little better than hitting a jackpot on a slot machine. The historic changes in whooping crane distribution in Nebraska probably are the result of wholesale and almost unregulated dewatering of the Platte during the twentieth century, greatly reducing its width and allowing woody vegetational growth to develop along its edges and sandbars. Whooping cranes like wider wetlands and less obstructed views than sandhill cranes will tolerate and forage to a lesser degree on upland sites, so their reduced use of the Platte is understandable. These trends in river losses have been at least slowed down by federal mandates for minimum Platte flows to protect whooping cranes and other endangered or threatened species, but much of the damage that has been done to the Platte's historic ecology will be difficult to reverse.

The snow goose once had a wonderful scientific name, *Chen hyperborea*, "the goose from beyond the north wind." It is an image that has always seemed just perfect to me. I remember seeing what appeared to be impossibly high flocks of white geese during fall pheasant hunts with my father and uncles in the late 1930s. When I asked where they had come from or where they were going, I got only inadequate answers. Indeed, the high Canadian nesting grounds of the snow goose, and especially its dark grayish-blue variant, the so-called blue goose, were at that time barely understood. After much study of the breeding grounds, it was learned that not only are the blue goose and the snow goose one and the same species but also that their plumage differences are rather simple genetic variants of one another.

Genetics aside, the sounds and sights of migrating snow geese have followed me throughout my life. Perhaps more accurately I have fol-

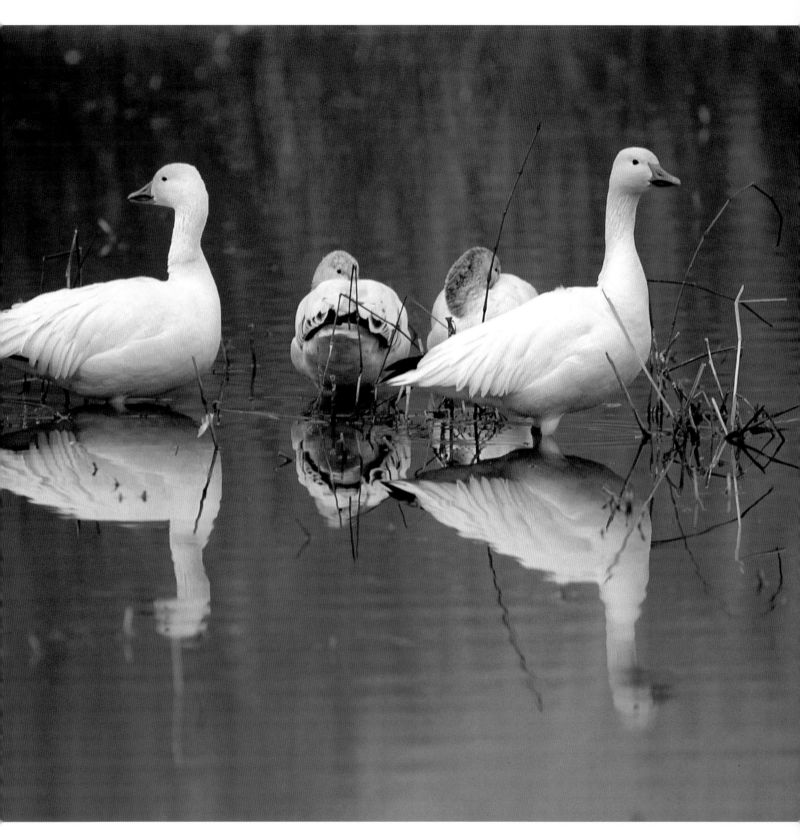

In recent years the exploding population of **SNOW GEESE** has caused serious tundra damage in their high arctic breeding grounds. Snow geese can be found across the entire Great Plains during migration.

lowed them, for they have drawn me to both arctic Canada and arctic Alaska as well as to the birds' wintering grounds from southern California to the Gulf Coast. They are the first of the geese to arrive back into the northern plains in early spring and the earliest to leave on their way farther north. They offer the first, uncertain, evidence that the Dakota winter is nearly over. They constantly push their tolerance limits for cold, snow, and ice; snow geese they are called, and snow geese they are. I once tried to locate the source of an Inuit legend that might provide an explanation as to why the birds are white. Eventually, I found that the native people of the high arctic typically offered folklore explanations only for those animals that are not white!

Swainson's hawks occupy a somewhat uncomfortable niche, situated both geographically and ecologically between the ferruginous hawk of the western high plains and badlands and the riparian woods and upland hardwood forests of the American central lowlands and eastern states that are the domain of the red-tailed hawk. The Swainson's hawk needs both open, relatively shortgrass plains for effective hunting, as does the ferruginous hawk, and moderate-sized trees for nesting, like the red-tailed hawk. Swainson's hawks are substantially smaller birds than either of these two congeners, and in matters of territorial disputes with either are likely to come out second-best.

THE **SWAINSON'S HAWK** IS TRULY A BIRD OF THE GRASSLANDS. IT NESTS IN THE GREAT PLAINS AND MIGRATES TO THE GRASSLANDS OF ARGENTINA. IN BOTH AREAS, GRASSHOPPERS, ITS FAVORITE FOOD, ARE ALSO PLENTIFUL.

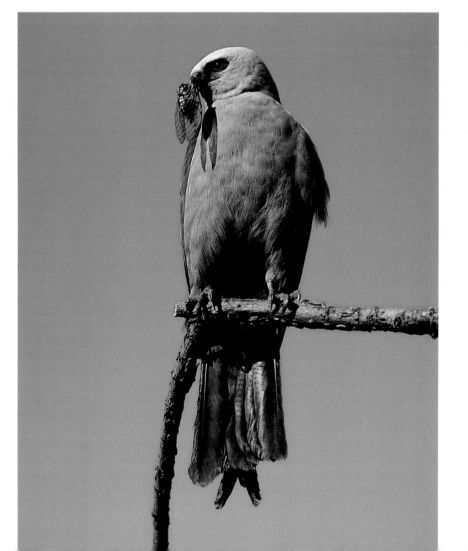

MISSISSIPPI KITES WINTER IN SOUTH AMERICA AND MIGRATE TO THE SOUTHERN GREAT PLAINS TO BREED. THEY ARRIVE IN HIGHLY SOCIAL FLOCKS AND ARE SEEN SOARING ABOVE SMALL TOWNS AND SHELTERBELTS OF WESTERN KANSAS, OKLAHOMA, AND TEXAS THROUGHOUT THE SUMMER. THEY FEED ON INSECTS AND ARE EXPERTS AT CATCHING CICADAS IN FLIGHT.

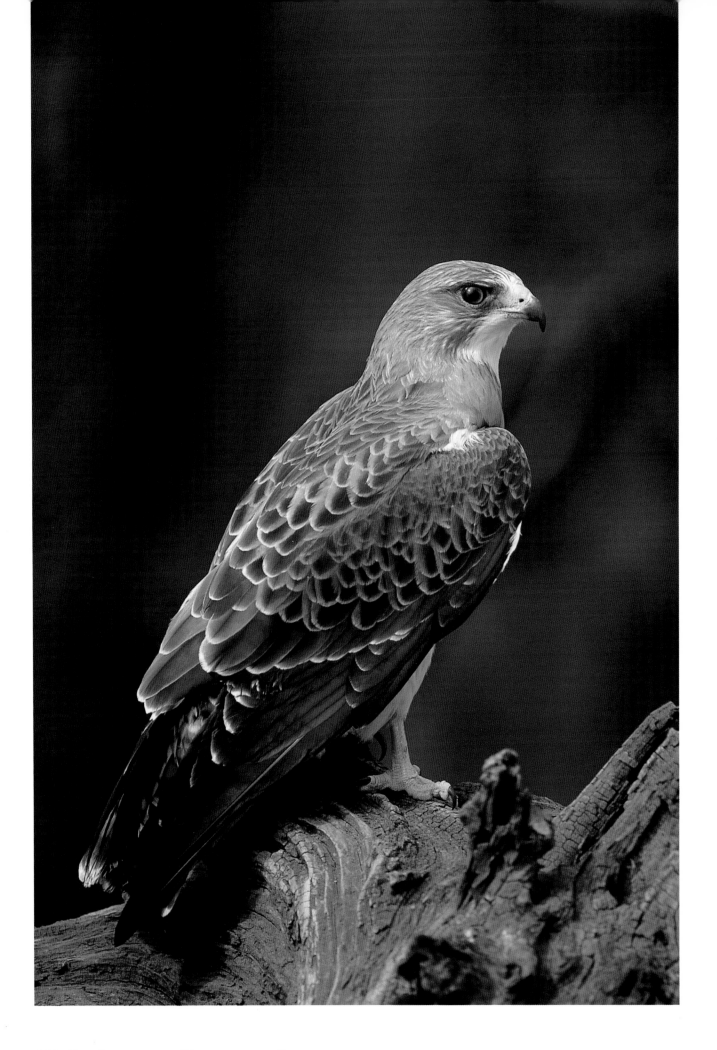

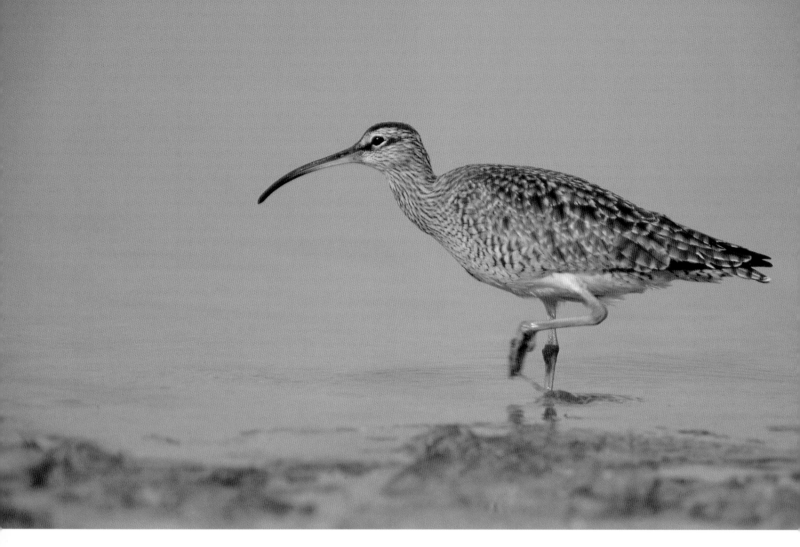

THE **WHIMBREL** NESTS ON THE TUNDRA
OF NORTHERN CANADA AND ALASKA. IT
WINTERS ON BOTH THE ATLANTIC AND
PACIFIC COASTS AND IS FOUND IN THE
GREAT PLAINS ONLY DURING MIGRATION.
ITS LONG, CURLEWLIKE BEAK IS USED
MORE FOR PICKING THAN FOR PROBING.

STANDING ON LICHENS AND WILDFLOWERS IN ITS HUDSON BAY
BREEDING AREA, THIS **HUDSONIAN GODWIT** DISPLAYS HIS
FINEST PLUMAGE. ADULTS MIGRATE SOUTH FIRST, FOLLOWED BY THE
TEN-WEEK-OLD JUVENILES ABOUT A MONTH LATER. INSTINCT ALONE
GUIDES THE JUVENILES TO SOUTHERN SOUTH AMERICA.

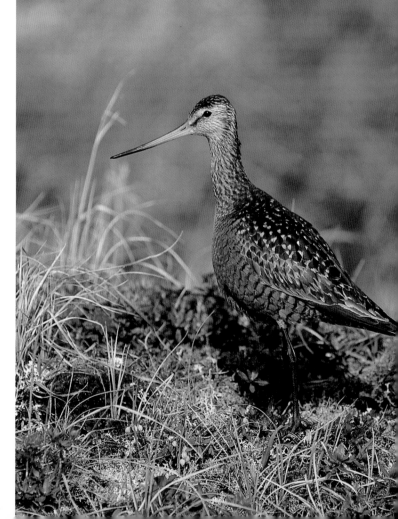

Of these three species, only the Swainson's hawk is strongly migratory, and by late September these birds are grouping into flocks and heading south. They probably do not choose to gather in flocks for social reasons but instead only to select the same topography, visibility, and overall flying conditions, which bring thousands of them into common flight paths. For at least six weeks they funnel southward through Mexico, Central America, and northern South America, stopping little if at all to refuel but instead apparently living on their stored fat reserves. Eventually, they reach the grasslands of southern South America, at the start of the southern spring, when again insect food supplies are becoming widespread. The absence of effective controls on pesticide use in Latin America has been disastrous for Swainson's hawks in recent years, and their populations have declined greatly.

Hudsonian godwits are rather smaller versions of the marbled godwit of the northern plains and have slightly more uptilted bills and a much more chestnut-rufous body, at least during the breeding season. Bird lovers of the Great Plains are most likely to see them only during a rather brief period in late April and early May, as they push northward toward a relatively few known nesting grounds in northwestern and north-central Canada. One of their known nesting grounds is the Churchill area of northeastern Manitoba, where, with whimbrels and a half-dozen other species of sandpipers, they stake out territorial claims along the scraggly spruce tree line that marks the end of the boreal forest and the beginning of Canada's arctic tundra.

If the snow goose is named perfectly, then so too is the whimbrel. There is a hint of the arctic wind in its name, in its wild whistled calls, and in the wistful feeling that I always get when I see them, remembering the Canadian tundra in its full June glory. The name "whimbrel" is indeed thought to be imitative of its call, and its generic name *Numenius* refers to the shape of its slightly decurved bill, resembling that of a new moon.

I once set up a blind to observe a nesting whimbrel near Churchill, Manitoba. The bird was so tolerant of the blind and of my comings and goings that I probably could have dispensed with it completely. I had my blind placed close enough to the nest so that through my telephoto lens, I could easily watch every mosquito that landed on its head and tried to find biting points at the base of its bill or among the short feathers immediately around its eyes. The bird suffered silently through this ordeal day after day, and I think I was as relieved as the female when it finally transformed its clutch of four eggs into four spindly-legged babies. After they dried off and rested for a few hours,

their mother gathered them up and hustled them into the tundra, where they soon disappeared from my view.

Snowy owls seem ready-made for attractive caricature—their faces lack the rather malevolent appearance of an angry great horned owl, and their plumage is so luxuriant and so fluffed out in cold weather as to make them look like avian snow creatures when they are standing on a snow-covered landscape. The adult males show only small flecks of gray on their otherwise immaculate white upperparts, whereas adult females and younger birds of both sexes are more heavily marked with grayish black. In both sexes the enormous eyes glow like golden embers, surrounded by a circular disk of white. The black beak is almost hidden by a feathered mustache, and feathers also extend down to hide their toes and powerful talons. They are on average the largest and heaviest of our owls; females may weigh up to six pounds, which is considerably heavier than any great gray owl and more than nearly all great horned owls. With such size and strength, the birds can kill and dismember young geese, adult ptarmigans, and even arctic hares, which may weigh as much as the owls themselves.

When snowy owls begin to run out of available prey on their tundra breeding grounds, the birds gradually ghost southward. As a youngster I looked forward to late fall pheasant hunts in North Dakota, after the ground had become snow covered, more in the hopes of seeing a snowy owl than of flushing any pheasants. Their seasonal appearance told me that like my beloved snow geese, and like polar bears, arctic foxes, ptarmigans, and arctic hares, some animals may survive in a place where it is safer to be the color of winter than of summer.

I saw only a single gyrfalcon as a youngster in North Dakota. It was one of those three-second views out the side window of our family car, as we were driving in the country on an early spring day. As always, I watched for hawks on telephone poles as they passed my view; they were usually visible just long enough to determine if they were red-tailed hawks or rough-legged hawks. On this particular occasion I saw a pale hawk on an approaching pole and assumed it would turn out to be one of the very pale red-tailed hawks commonly called Krider's hawks. Yet in the moment we passed it I saw the distinct facial mask that identified it as a falcon. It was too late to shout out to my father to stop the car, and moments later it was lost to view. It was like one of those moments later in adult life, when an incredibly beautiful woman is momentarily in view and then is lost in the crowd. All that remains is a flash of memory, to be replayed over and over again in future years but always with the same frustrating result.

SNOWY OWLS NEST IN THE ARCTIC. SMALL NUMBERS OF THESE BIRDS WILL INVADE THE GREAT PLAINS SEARCHING FOR FOOD WHEN LEMMING POPULATIONS CRASH. THEY ARE NOT COMFORTABLE WITH TREES, PREFERRING INSTEAD TO HUNT FROM HAY BALES, ELECTRIC POLES, AND ROOFTOPS.

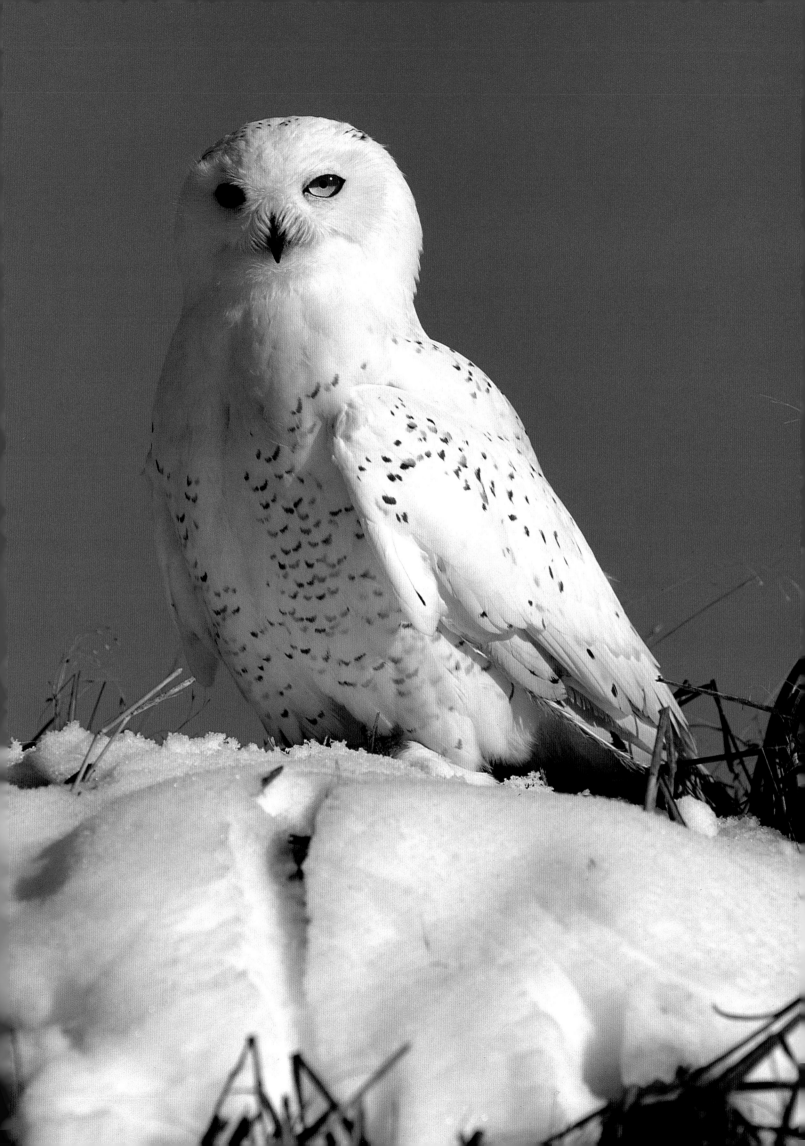

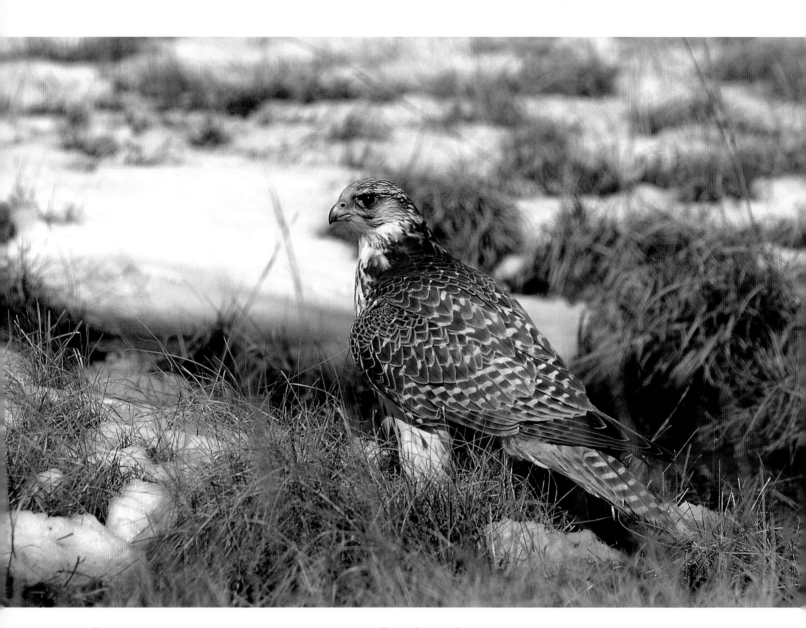

FOUND ON OPEN TUNDRA NEAR CLIFFS, THE **GYRFALCON** IS NORTH AMERICA'S LARGEST
FALCON. DURING WINTER IT IS FOUND OCCASIONALLY IN THE NORTHERN GREAT PLAINS,
WHERE IT DINES PRIMARILY ON BIRDS.

I next saw gyrfalcons in the Alaskan tundra of the Kuskokwim delta, where I was studying eiders. On a rocky outcrop about a mile from my tent, a pair of gyrfalcons was nesting. It was too far to easily walk, for the lowland tundra was more water than land, and in the necessary process of walking around ponds the distance between any two points had to be multiplied two- or threefold. Each day I would cast eyes over toward that promontory but each day also realize that there were more important things to be done near camp. Eventually my days ran out. Even today, gyrfalcons seem to me to be more myth than reality, more supposition than substance.

It is always something of a surprise when, in asking a friend from either coast as to which birds they might most like to see during a visit to the Great Plains, the answer rather frequently given is the Harris' sparrow. Fulfilling such a wish is possible only from late fall to early spring, for these large and attractive sparrows breed along the forest-tundra tree line of central Canada and visit the central portions of the Great Plains only during the colder months. Then they join with white-throated sparrows, American tree sparrows, juncos, and other migrant or resident sparrows but largely avoid the backyard bird feeders of cities and suburbs. Instead, they tend to gather around plum thickets and woodlot edges, foraging on weed seeds. Unlike the rather cheery "Oh, sweet Canada" song of the white-throated sparrow, the prolonged, quavering, and minor-key whistle of the Harris' has a touch of sadness in it, as if it were eager to leave the Great Plains to return to its remote arctic nesting grounds.

HARRIS' SPARROWS MIGRATE TO THE SOUTHERN GREAT PLAINS FROM THEIR BREEDING GROUNDS IN NORTHERN CANADA. THEY REMAIN IN FLOCKS, AND THEIR SONG, A LOUD PLAINTIVE WHISTLE, IS HEARD THROUGHOUT THE WINTER MONTHS.

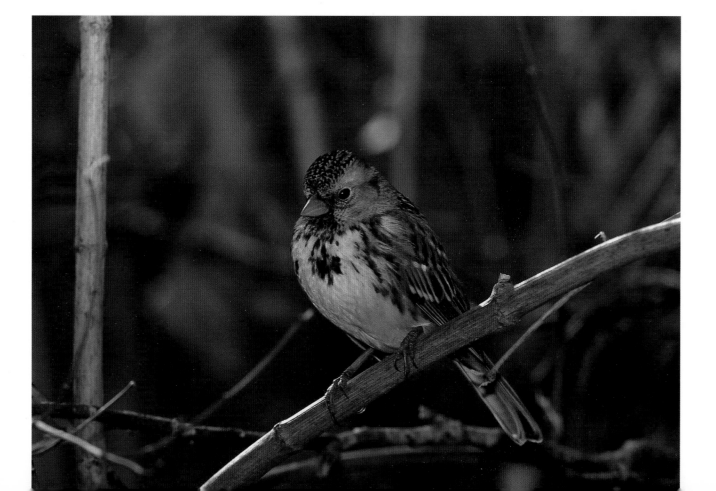

Mammals

Among the nearly two dozen bat species that occur in the Great Plains, the eastern red bat has the broadest overall range, from the prairie provinces of Canada south to Mexico, and its western counterpart extends to South America. It is a medium-sized bat with long, relatively pointed wings, perhaps indicative of its mobility and migratory tendencies, at least at the northern edge of its range. Prior to fall migration, the animals put on considerable fat, just as migratory birds do, and likewise migrate mainly at night. Sometimes they cross large bodies of water, and migrant flocks have not only been seen as far as one hundred miles out in the Atlantic Ocean, but individual bats have also been reported from as far away as Bermuda, nearly six hundred miles from the coast. The red bat is mostly migratory in the northern Great Plains, but some apparently hibernate in certain more southern areas. During hibernation the animal curls up, the well-furred tail membrane pulled up like a blanket to cover its naked nose. I have long wanted to find such a curled-up dormant bat but have nearly abandoned hopes of ever doing so.

For those willing to put in the time and effort, the autumnal calls of elk and bison can still be heard in a few wild places on the Great Plains, and the plaintive notes of Harris' sparrows can enliven a dull winter day. In spring the scents of fragrant prairie roses and prairie clovers may be savored, and head-high grasses of summer can be lightly caressed. There are also still a few places where one can find and sit on a giant glacial-worn and lichen-capped boulder, with nothing but tall prairies visible to the far horizon, and imagine that only twenty thousand or so years ago mammoths might have rubbed their hairy sides against this very rock. Such marvelous moments are not easily gained. But then, nothing wonderful should be cheaply attained; were it so, the prize would seem far less rewarding and the world much less interesting. Each season in the Great Plains brings new potential delights, snowy owls and gyrfalcons suddenly materializing in the dead of winter, uncountable bird migrations flooding the skies each spring and fall, and a riot of summer wildflowers and prairie grasses sandwiched in between as an extra bonus. What better natural world could one ask for?

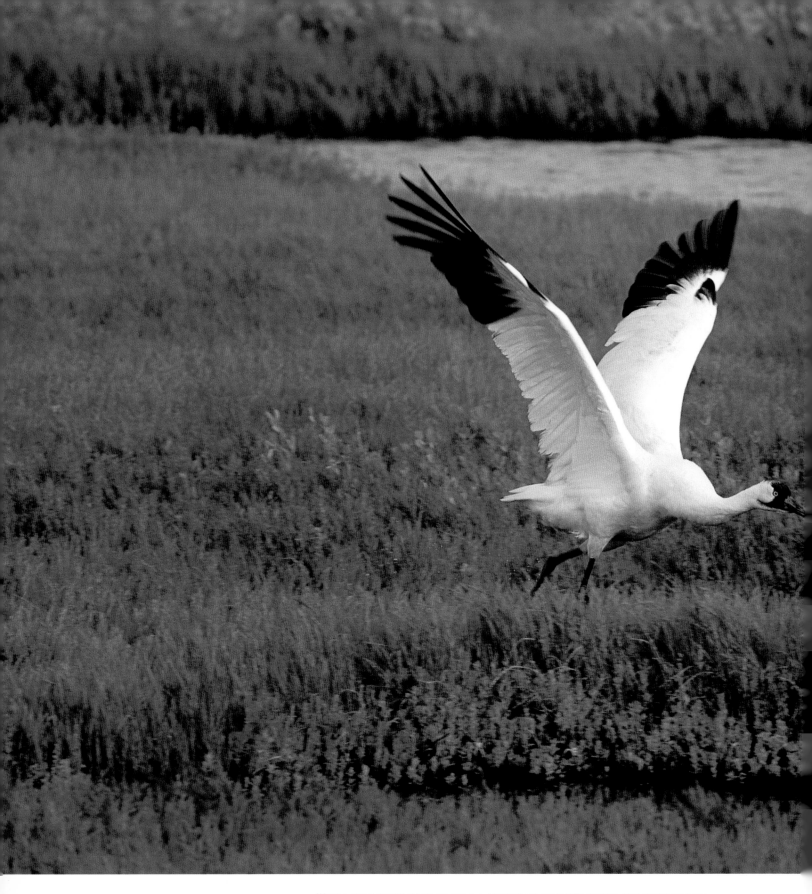

WITH A WILD POPULATION OF ONLY A COUPLE OF HUNDRED BIRDS, THE **WHOOPING CRANE** IS ONE OF NORTH AMERICA'S MOST ENDANGERED SPECIES. ITS TWENTY-SIX-HUNDRED-MILE MIGRATION EXTENDS FROM BREEDING GROUNDS IN CANADA'S WOOD BUFFALO NATIONAL PARK TO ARANSAS NATIONAL WILDLIFE REFUGE IN TEXAS.

Field Notes

The annual migration of whooping cranes take them through the heart of the Great Plains each spring and fall. Even though they're the tallest North American birds, few people ever see them because they're also one of the rarest. I've seen them half a dozen times at Cheyenne Bottoms Wildlife Area and Quivira National Wildlife Refuge. Both of these areas are in the heart of Kansas and offer the birds large wetlands with abundant food. Whooping cranes rarely allow a close approach for a photograph, even with the longest telephoto lens. My past experience during their migration has produced images of small white dots in the middle of the marsh.

From November through March the birds can be found at Aransas National Wildlife Refuge in Texas. Pairs and families of cranes claim feeding and resting territories on the tidal marshes. Even here, viewing them from the roadways provides the same distant view. The best way to see them is from a tour boat.

We arrived at Captain Ted's Whooping Crane Tours in Rockport, Texas, for a 7:00 A.M. departure. The tour lasted three hours and traveled the intercoastal waterway for about fifteen miles. Twenty minutes after departure we saw the first cranes. A group of three feeding birds allowed the boat to drift within fifty yards. They walked slowly and stopped frequently to probe the marsh. Two other cranes took flight another half mile in front of us and flew in our direction. The bird in this photograph looked up, trumpeted, and took flight to meet the advancing birds. The approaching birds turned away, and this bird circled back. On the tour we counted thirty-five cranes, none nearly as close as the first group of three.

ACKNOWLEDGMENTS

Finding the animals displayed on these pages has taken years of fieldwork. It's been great fun and has given me the excuse to explore many National Wildlife Refuges, state parks, wildlife areas, and private farms and ranches across the Great Plains. Some of these animals I've discovered on my own, but I've also had lots of help. No one has helped me more, through advice or encouragement, than my wife, Mary Butel. She is my ideal companion, both at home and on the road. I've enjoyed many great photo trips and discoveries with my friends Gerald Wiens and Thane Rogers and my brother Bill Gress. I also offer my sincere thanks to the people who have provided valuable advice, directions, and assistance: Stacy Adolph, Vanessa Avara, Mark Ball, Chris and Krista Berner, Mike Blair, Roger Boyd, Gene Brehm, Duane Brumit, Ken Brunson, Jim Burns, Bill Busby, Ted Cable, Joe Collins, Charles Cope, Stephen Davis, Bob Dester, Pete Ferrell, Suzanne Fellows, Sheri Fetherman, Karen Graham, Chet Gresham, Nadine Haalboon, Trey Harrison, Lee Hawes, Sharon Heinemann, Dave Hilley, Pete Janzen, John Jave, Phil Kenney, Dwight Klippenstine, Rodger Knaggs, Connie Leger, Joyce Lent, Paul Marinari, Jim Mason, Glenn McMaster, Marc Murrell, Ruth Palmer, Danny Parks, Wade Parsons, Rob Penner, Mark Peyton, Chris Pistole, Alan Pollum, George Potts, Ray Poulin, Mike Rader, Barry Raugust, Jill Reimer, Kory Richardson, Dave Rintoul, Stan Roth, Eric Runquist, Paulette Scherr, Bill Schultz, Carolyn Schwab, Marvin Schwilling, David Seibel, Jim Sellers, Tom Shane, Greg Sievert, Lawrence and Ruth Smith, Karen Smith, Connie Storrie, Bill Taddicken, Paul Tebbel, Max Thompson, Lowell Wilder, Gabe Wilson, and Gene Young. I want to thank Paul Johnsgard for collaborating on this project and for his many other books that help us learn about wildlife and their habitats. And finally, thanks to Fred Woodward, along with the rest of the staff at the University Press of Kansas, for making the publication of this book possible.

—Bob Gress

I must thank a variety of people for their help on this project. The manuscript was read in total by Linda Brown and Dr. George Potts, and at least in part by several others, including an anonymous reviewer. The librarians of the University of Nebraska library system were as helpful as ever, and Dr. Josef Kren always promptly came to

my aid when computer problems arose. The University of Nebraska has continued to support my research and writing efforts, even after my formal retirement. I must also thank the staff of the University Press of Kansas for their keen interest in this project from the very start.

—Paul A. Johnsgard

INDEX AND SCIENTIFIC NAMES OF ANIMALS

Species illustrated by color plates are shown in **bold**, as are the plate page numbers.

PHOTO INFORMATION

Page i, Coyote, Kansas, Canon EOS-3, EF 500mm f/4.5L Canon, Fuji Provia 100.

Page ii–iii, Elk, Fort Niobrara National Wildlife Refuge, Nebraska, Canon EOS-3, EF 500mm f/4.5L Canon, Fuji Provia 100.

Page iv, Great horned owl, Kansas, Canon EOS-3, EF 100-400mm f/4.5-5.6L IS Canon, Fuji Provia 100.

Page v, Snow geese, Squaw Creek National Wildlife Refuge, Missouri, Canon EOS Elan, EF 28-105mm f/3.5-4.5 Canon, Fuji Provia 100.

Page vi–vii, Mule deer, Wyoming, Canon EOS-3, EF 100-400mm f/4.5-5.6L IS Canon, Fuji Provia 100.

Page x, Pronghorns, Montana, Canon T-90, FD 500mm f/4.5L Canon, Fuji Sensia 100.

Page xii–xiii, Bison, Custer State Park, South Dakota, Canon EOS Elan, EF 28-105mm f/3.5-4.5 Canon, Fuji Provia 100.

Page 6, Dickcissel, Kansas, Canon EOS-3, EF 500mm f/4.5L Canon, 1.4X, Fuji Provia 100.

Page 8, Grasshopper sparrow, Flint Hills Tallgrass Prairie Preserve, Kansas, Canon EOS-3, EF 500mm f/4.5L Canon, 1.4X, EF25 extension, Fuji Provia 100.

Page 9, Henslow's sparrow, Konza Prairie, Kansas, Canon EOS-3, EF 500mm f/4.5L Canon, 1.4X, Fuji Provia 100.

Page 10, Eastern meadowlark, Flint Hills Tallgrass Prairie Preserve, Kansas, Canon EOS-3, EF 500mm f/4.5L Canon, 1.4X, Fuji Provia 100.

Page 11, Scissor-tailed flycatcher, Kansas, Canon T-90, FD 500mm f/4.5L Canon, Fuji Sensia 100.

Page 12, Common nighthawk, Flint Hills, Kansas, Canon EOS-3, EF 500mm f/4.5L Canon, Fuji Provia 100.

Page 13, Prairie vole, Kansas, Canon A-1, FD 100mm Macro Canon, dual flash, Kodachrome 64.

Page 14, Franklin's ground squirrel, Manitoba, Canada, Canon T-90, FD 500mm f/4.5L Canon, Fuji Sensia 100.

Page 14, Plains pocket gopher, Kansas, Canon A-1 FD 100mm Macro Canon, dual flash, Kodachrome 64.

Page 15, Massasauga, Quivira National Wildlife Refuge, Kansas, Canon T-90, FD 100-300mm Canon, Fuji Sensia 100.

Page 16, Great Plains narrowmouth toad, Kansas, Canon EOS-3, EF 100mm f/2.8L Macro Canon, Macro Ring Lite MR-14EX, Fuji Provia 100.

Page 16, Western slender glass lizard, Kansas, Canon EOS-3, EF 100mm f/2.8L Macro Canon, Fuji Provia 100.

Page 17, Eastern collared lizard, Flint Hills, Kansas, Canon T-90, FD 500mm f/4.5L Canon, Fuji Sensia 100.

Page 18–19, Greater prairie-chicken, Flint Hills Tallgrass Prairie Preserve, Kansas, Canon EOS-3, EF 500mm f/4.5L Canon, Fuji Provia 100.

Page 20, American kestrel, Kansas, Canon T-90, FD 500mm f/4.5L Canon, 1.4X, Fuji Sensia 100.

Page 22, Upland sandpiper, Flint Hills, Kansas, Canon EOS-3, EF 500mm f/4.5L Canon, 1.4X, Fuji Provia 100.

Page 23, Sharp-tailed grouse, Nebraska National Forest, Nebraska, Canon EOS-3, EF 500mm f/4.5L Canon, Fuji Provia 100.

Page 24, Western meadowlark, Nebraska National Forest, Nebraska, Canon EOS-3, EF 500mm f/4.5L Canon, 1.4X, Fuji Provia 100.

Page 25, Sprague's pipit, Saskatchewan, Canada, Canon EOS-3, EF 500mm f/4.5L Canon, 1.4X, Fuji Provia 100.

Page 25, Bobolink, Lostwood National Wildlife Refuge, North Dakota, Canon EOS-3, EF 500mm f/4.5L Canon, 1.4X, Fuji Provia 100.

Page 26, Clay-colored sparrow, Lostwood National Wildlife Refuge, North Dakota, Canon EOS-3, EF 500mm f/4.5L Canon, 1.4X, EF25 extension, Fuji Provia 100.

Page 26, Savannah sparrow, Manitoba, Canada, Canon EOS-3, EF 500mm f/4.5L Canon, 1.4X, EF25 extension, Fuji Provia 100.

Page 27, Baird's sparrow, Saskatchewan, Canada, Canon EOS-3, EF 500mm f/4.5L Canon, 2X, Fuji Provia 100.

Page 28, Chestnut-collared longspur, Saskatchewan, Canada, Canon EOS-3, EF 500mm f/4.5L Canon, 1.4X, Fuji Provia 100.

Page 29, Short-eared owl, Kansas, Canon EOS-3, EF 500mm f/4.5L Canon, Fuji Provia 100.

Page 30, Richardson's ground squirrel, Sand Lake National Wildlife Refuge, South Dakota, Canon T-90, FD 500mm f/4.5L Canon, Fuji Sensia 100.

Page 31, Western harvest mouse, Kansas, Canon A-1, FD 100mm Macro Canon, dual flash, Kodachrome 64.

Page 32, White-tailed jackrabbit, Saskatchewan, Canada, Canon EOS-3, EF 500mm f/4.5L Canon, 1.4X, Fuji Provia 100.

Page 32–33, Black-tailed jackrabbits, Kansas, Canon A-1, FD 100-300mm Canon, Kodachrome 64.

Page 34, Great Plains skink, Kansas, Canon EOS-3, EF 100mm f/2.8L Macro Canon, Macro Ring Lite MR-14EX, Fuji Provia 100.

Page 35, Northern prairie skink, Kansas, Canon EOS-3, EF 100mm f/2.8L Macro Canon, Macro Ring Lite MR-14EX, Fuji Provia 100.

Page 36–37, Marbled godwit, Lostwood National Wildlife Refuge, North Dakota, Canon EOS-3, EF 500mm f/4.5L Canon, Fuji Provia 100.

Page 38, Pronghorn, Badlands National Park, South Dakota, Canon T-90, FD 500mm f/4.5L Canon, Fuji Sensia 100.

Page 39, Thirteen-lined ground squirrel, Kansas, Canon EOS-3, EF 500mm f/4.5L Canon, EF25 extension, Fuji Provia 100.

Page 40, McCown's longspur, Pawnee National Grassland, Colorado, Canon EOS-3, EF 500mm f/4.5L Canon, 1.4X, Fuji Provia 100.

Page 41, Ferruginous hawk, Kansas, Canon EOS-3, EF 500mm f/4.5L Canon, Fuji Provia 100.

Page 42–43, Prairie falcon, Kansas, Canon EOS-3, EF 500mm f/4.5L Canon, 1.4X, Fuji Provia 100.

Page 43, Mountain plover, Cimarron National Grassland, Kansas, Canon EOS-3, EF 500mm f/4.5L Canon, Fuji Provia 100.

Page 44, Lark bunting, Pawnee National Grassland, Colorado, Canon EOS-3, EF 500mm f/4.5L Canon, 1.4X, Fuji Provia 100.

Page 44, Lark sparrow, Flint Hills, Kansas, Canon EOS-3, EF 500mm f/4.5L Canon, 1.4X, Fuji Provia 100.

Page 45, Black-billed magpie, Kansas, Canon T-90, FD 500mm f/4.5L Canon, Fuji Sensia 100.

Page 46, Burrowing owl, Kansas, Canon EOS-3, EF 500mm f/4.5L Canon, Fuji Provia 100.

Page 48, Black-footed ferrets, Sybille Wildlife Research Center, Wyoming, Canon EOS-3, EF 100-400mm f/4.5-5.6L IS Canon, Fuji Provia 100.

Page 49, Black-tailed prairie dog, Custer State Park, South Dakota, Canon EOS-3, EF 500mm f/4.5L Canon, Fuji Provia 100.

Page 50–51, Bison, Maxwell Wildlife Area, Kansas, Canon T-90, FD 100-300mm Canon, Fuji Sensia 100.

Page 53, Great Plains toad, Kansas, Canon T-90, FD 100mm Macro Canon, dual flash, Fuji Sensia 100.

Page 54, Swift fox, Kansas, Canon T-90, FD 500mm f/4.5L Canon, Fuji Sensia 100.

Page 56, Long-billed curlew, Crescent Lake National Wildlife Refuge, Nebraska, Canon EOS-3, EF 100-400mm f/4.5-5.6L IS Canon, Fuji Provia 100.

Page 57, Loggerhead shrike, Kansas, Canon T-90, FD 500mm f/4.5L Canon, Fuji Sensia 100.

Page 58, Horned lark, Cimarron National Grassland, Kansas, Canon EOS-3, EF 500mm f/4.5L Canon, 1.4X, Fuji Provia 100.

Page 60, Northern grasshopper mouse, Kansas, Canon A-1, FD 100mm Macro Canon, dual flash, Kodachrome 64.

Page 61, Badger, Kansas, Canon T-90, FD 100-300mm Canon, Fuji Sensia 100.

Page 61, Ord's kangaroo rat, Kansas, Canon A-1, FD 100mm Macro Canon, Kodachrome 64.

Page 62, Ornate box turtle, Quivira National Wildlife Refuge, Kansas, Canon EOS-3, EF 100mm f/2.8L Macro Canon, Fuji Provia 100.

Page 62, Six-lined racerunner, Kansas, Canon EOS-3, EF 100mm f/2.8L Macro Canon, Fuji Provia 100.

Page 63, Western hognose snake, Kansas, Canon EOS-3, EF 100-400mm f/4.5-5.6L IS Canon, Fuji Provia 100.

Page 64, Barred tiger salamander, Kansas, Canon T-90, FD 100mm Macro Canon, dual flash, Fuji Sensia 100.

Page 65, Plains spadefoot, Kansas, Canon EOS-3, EF 100mm f/2.8L Macro Canon, Fuji Provia 100.

Page 65, Bullsnake, Quivira National Wildlife Refuge, Kansas, Canon EOS-3, EF 100-400mm f/4.5-5.6L IS Canon, Fuji Provia 100.

Page 66–67, Western kingbird, Kansas, Canon A-1, FD 100-300mm Canon, dual flash, Kodachrome 64.

Page 68, Desert cottontail, South Dakota, Canon EOS-3, EF 500mm f/4.5L Canon, Fuji Provia 100.

Page 70, Greater sage-grouse, Colorado, Canon EOS-3, EF 500mm f/4.5L Canon, Fuji Provia 100.

Page 71, Lesser prairie-chicken, Kansas, Canon T-90, FD 500mm f/4.5L Canon, Fuji Sensia 100.

Page 73, Golden eagle, Kansas, Canon T-90, FD 500mm f/4.5L Canon, Fuji Sensia 100.

Page 74, Common poorwill, Flint Hills, Kansas, Canon T-90, FD 500mm f/4.5L Canon, Fuji Sensia 100.

Page 74, Rock wren, Cimarron National Grassland, Kansas, Canon EOS-3, EF 500mm f/4.5L Canon, 1.4X, Fuji Provia 100.

Page 76, Cassin's sparrow, Cimarron National Grassland, Kansas, Canon EOS-3, EF 500mm f/4.5L Canon, Fuji Provia 100.

Page 77, Roadrunner, Bosque del Apache National Wildlife Refuge, New Mexico, Canon T-90, FD 500mm f/4.5L Canon, Fuji Sensia 100.

Page 78, Hispid pocket mouse, Kansas, Canon A-1, FD 100mm Macro Canon, dual flash, Kodachrome 64.

Page 79, Olive-backed pocket mouse, Saskatchewan, Canon EOS-3, EF 100mm f/2.8L Macro Canon, Macro Ring Lite MR-14EX, Fuji Provia 100.

Page 80–81, Western diamondback rattlesnake, Oklahoma, Canon T-90, FD 100mm Macro Canon, dual flash, Fuji Sensia 100.

Page 82–83, Texas horned lizard, Kansas, Canon A-1, FD 100mm Macro Canon, dual flash, Kodachrome 64.

Page 84, Prairie rattlesnake, Cimarron National Grassland, Kansas, Canon EOS-3, EF 100-400mm f/4.5-5.6L IS Canon, Fuji Provia 100.

Page 86, Great blue herons, Kansas, Canon EOS-3, EF 500mm f/4.5L Canon, Fuji Provia 100.

Page 86, Wood duck, Kansas, Canon EOS-3, EF 500mm f/4.5L Canon, Fuji Provia 100.

Page 88, Northern flicker, Manitoba, Canada, Canon T-90, FD 500mm f/4.5L Canon, Fuji Sensia 100.

Page 89, Downy woodpecker, Kansas, Canon T-90, FD 500mm f/4.5L Canon, Fuji Sensia 100.

Page 90, Red-tailed hawk, Kansas, Canon T-90, FD 100-300mm Canon, Fuji Sensia 100.

Page 91, Eastern screech-owl, Kansas, Canon T-90, FD 100mm Macro Canon, dual flash, Fuji Sensia 100.

Page 92, Eastern kingbird, Kansas, Canon EOS-3, EF 500mm f/4.5L Canon, 1.4X, Fuji Provia 100.

Page 93, Yellow-billed cuckoo, Kansas, Canon EOS-3, EF 500mm f/4.5L Canon, Fuji Provia 100.

Page 94, Eastern bluebird, Kansas, Canon T-90, FD 500mm f/4.5L Canon, Fuji Sensia 100.

Page 94, Indigo bunting, Kansas, Canon EOS-3, EF 100-400mm f/4.5-5.6L IS Canon, Fuji Provia 100.

Page 95, Bobwhites, Kansas, Canon EOS-3, EF 500mm f/4.5L Canon, Fuji Provia 100.

Page 96, Belted kingfisher, South Dakota, Canon EOS-3, EF 500mm f/4.5L Canon, Fuji Provia 100.

Page 97, Striped skunks, Nebraska, Canon T-90, FD 100mm Macro Canon, dual flash, Fuji Sensia 100.

Page 98, Deer mouse, Kansas, Canon EOS-3, EF 100mm f/2.8L Macro Canon, Speedlite 550EX, Fuji Provia 100.

Page 99, Bobcat, Kansas, Canon T-90, FD 500mm f/4.5L Canon, Fuji Sensia 100.

Page 100, Beaver, Manitoba, Canada, Canon T-90, FD 100-300mm Canon, Fuji Sensia 100.

Page 101, Plains garter snake, Kansas, Canon EOS-3, EF 100-400mm f/4.5-5.6L IS Canon, Fuji Provia 100.

Page 101, Red-sided garter snake, Kansas, Canon T-90, FD 100mm Macro Canon, Fuji Sensia 100.

Page 102, Great horned owl, Kansas, Canon A-1, FD 100mm Macro Canon, Flash, Kodachrome 64.

Page 104, American avocet, Quivira National Wildlife Refuge, Kansas, Canon EOS-3, EF 500mm f/4.5L Canon, Fuji Provia 100.

Page 106, Piping plover, Lake McConaughy, Nebraska, Canon EOS-3, EF 500mm f/4.5L Canon, EF25 extension, Fuji Provia 100.

Page 107, American bittern, Quivira National Wildlife Refuge, Kansas, Canon EOS-3, EF 100-400mm f/4.5-5.6L IS Canon, Fuji Provia 100.

Page 107, Snowy plover, Quivira National Wildlife Refuge, Kansas, Canon T-90, FD 500mm f/4.5L Canon, Fuji Sensia 100.

Page 108, Sora, Kansas, Canon EOS-3, EF 500mm f/4.5L Canon, 1.4X, Fuji Provia 100.

Page 109, Wilson's phalarope, Quivira National Wildlife Refuge, Kansas, Canon EOS-3, EF 500mm f/4.5L Canon, Fuji Provia 100.

Page 110, Eared grebe, Sand Lake National Wildlife Refuge, South Dakota, Canon EOS-3, EF 500mm f/4.5L Canon, 1.4X, Speedlite 550EX, Fuji Provia 100.

Page 111, Western grebe, North Dakota, Canon EOS-3, EF 500mm f/4.5L Canon, 1.4X, Fuji Provia 100.

Page 111, Black-necked stilt, Quivira National Wildlife Refuge, Kansas, Canon EOS-3, EF 500mm f/4.5L Canon, 1.4X, Fuji Provia 100.

Page 112, Ruddy duck, Sand Lake National Wildlife Refuge, South Dakota, Canon EOS-3, EF 500mm f/4.5L Canon, Fuji Provia 100.

Page 113, Blue-winged teal, Kansas, Canon EOS-3, EF 500mm f/4.5L Canon, Fuji Provia 100.

Page 113, Wilson's snipe, Kansas, Canon EOS-3, EF 500mm f/4.5L Canon, 1.4X, Fuji Provia 100.

Page 114–15, Northern harrier, Kansas, Canon EOS-3, EF 500mm f/4.5L Canon, 1.4X, Fuji Provia 100.

Page 115, Black tern, Chase Lake National Wildlife Refuge, North Dakota, Canon EOS-3, EF 500mm f/4.5L Canon, Fuji Provia 100.

Page 116–17, Red-winged blackbirds, Kansas, Canon EOS-3, EF 100-400mm f/4.5-5.6L IS Canon, Fuji Provia 100.

Page 118, Common yellowthroat, South Dakota, Canon EOS-3, EF 500mm f/4.5L Canon, 1.4X, EF25 extension, Fuji Provia 100.

Page 119, Yellow-headed blackbird, Sand Lake National Wildlife Refuge, South Dakota, Canon EOS-3, EF 500mm f/4.5L Canon, 1.4X, Fuji Provia 100.

Page 120, LeConte's sparrow, Lostwood National Wildlife Refuge, North Dakota, Canon EOS-3, EF 500mm f/4.5L Canon, 1.4X, EF25 extension, Fuji Provia 100.

Page 121, Least Tern, Kansas, Canon EOS-3, EF 500mm f/4.5L Canon, Fuji Provia 100.

Page 122, Muskrat, Kansas, Canon T-90, FD 100-300mm Canon, Fuji Sensia 100.

Page 122, Mink, Kansas, Canon T-90, FD 100-300mm Canon, Fuji Sensia 100.

Page 123, Plains leopard frog, Kansas, Canon EOS-3, EF 100mm f/2.8L Macro Canon, Fuji Provia 100.

Page 124, White pelicans, Chase Lake National Wildlife Refuge, North Dakota, Canon EOS-3, EF 100-400mm f/4.5-5.6L IS Canon, Fuji Provia 100.

Page 126–27, Red fox, Kansas, Canon T-90, FD 500mm f/4.5L Canon, Fuji Sensia 100.

Page 129, Peregrine falcon, Kansas, Canon EOS-3, EF 500mm f/4.5L Canon, 1.4X, Fuji Provia 100.

Page 130, Barn owl, Kansas, Canon T-90, FD 500mm f/4.5L Canon, Fuji Sensia 100.

Page 131, Mourning dove, Kansas, Canon T-90, FD 500mm f/4.5L Canon, Fuji Sensia 100.

Page 132, Barn swallow, South Dakota, Canon EOS-3, EF 500mm f/4.5L Canon, 1.4X, EF25 extension, Fuji Provia 100.

Page 133, Northern cardinal, Kansas, Canon EOS-3, EF 500mm f/4.5L Canon, EF25 extension, Speedlite 550EX, Fuji Provia 100.

Page 134, Blue jay, Kansas, Canon EOS-3, EF 100-400mm f/4.5-5.6L IS Canon, Fuji Provia 100.

Page 134, Common grackle, Kansas, Canon T-90, FD 500mm f/4.5L Canon, Fuji Sensia 100.

Page 135, Brown thrasher, Kansas, Canon T-90, FD 100-300mm Canon, flash, Fuji Sensia 100.

Page 136–37, Cowbirds, Flint Hills, Kansas, Canon EOS-3, EF 500mm f/4.5L Canon, Fuji Provia 100.

Page 137, Killdeer, Lake Andes National Wildlife Refuge, South Dakota, Canon EOS-3, EF 500mm f/4.5L Canon, Fuji Provia 100.

Page 138, Hispid cotton rat, Kansas, Canon A-1, FD 100mm Macro Canon, dual flash, Kodachrome 64.

Page 139, Coyote, Kansas, Canon EOS-3, EF 100-400mm f/4.5-5.6L IS Canon, Fuji Provia 100.

Page 140, Opossum, Kansas, Canon T-90, FD 100mm Macro Canon, dual flash, Fuji Sensia 100.

Page 141, Raccoon, Kansas, Canon T-90, FD 100-300mm Canon, Fuji Sensia 100.

Page 141, Armadillo, Kansas, Canon EOS-3, EF 100-400mm f/4.5-5.6L IS Canon, Speedlite 550EX, Fuji Provia 100.

Page 142, Spotted skunk, Kansas, Canon A-1, FD 100-300mm Canon, Kodachrome 64.

Page 144–45, Sandhill cranes, Nebraska, Canon EOS-3, EF 500mm f/4.5L Canon, 1.4X, Fuji Provia 100.

Page 146–47, Snow geese, Bosque del Apache National Wildlife Refuge, New Mexico, Canon EOS-3, EF 500mm f/4.5L Canon, Fuji Provia 100.

Page 148, Mississippi kite, Kansas, Canon T-90, FD 500mm f/4.5L Canon, Fuji Sensia 100.

Page 149, Swainson's hawk, Kansas, Canon T-90, FD 500mm f/4.5L Canon, Fuji Sensia 100.

Page 150, Whimbrel, Manitoba, Canada, Canon T-90, FD 500mm f/4.5L Canon, 1.4X, Fuji Sensia 100.

Page 150, Hudsonian godwit, Manitoba, Canada, Canon T-90, FD 500mm f/4.5L Canon, Fuji Sensia 100.

Page 153, Snowy owl, Kansas, Canon EOS-3, EF 500mm f/4.5L Canon, 1.4X, Fuji Provia 100.

Page 154, Gyrfalcon, Kansas, Canon EOS-3, EF 500mm f/4.5L Canon, Fuji Provia 100.

Page 155, Harris' sparrow, Kansas, Canon EOS-3, EF 500mm f/4.5L Canon, EF25 extension, Speedlite 550EX, Fuji Provia 100.

Page 156, Red bats, Kansas, Canon A-1, FD 100mm Macro Canon, dual flash, Kodachrome 64.

Page 158, Whooping crane, Aransas National Wildlife Refuge, Texas, Canon EOS-3, EF 500mm f/4.5L Canon, 1.4X, Fuji Provia 100.